SANDFUTURE

THE MIT PRESS

Cambridge, Massachusetts / London, England

SANDFUTURE

JUSTIN BEAL

for Jane

The building is truly a living man. You will see that it must eat in order to live, exactly as it is with man. It sickens and dies or sometimes is cured of its sickness by a good doctor. Sometimes, like man, it becomes ill again because it neglected its health.... Through corruption, the body of the building rots like that of man. Through excess it is ruined and dies like man.

Filarete, *Treatise on Architecture*, 1464

At night, alone in the plaza, you could lean your body against the chamfered corners of the aluminum facade, roll your head back and look straight up the side of the building. It was like lying on your back in the middle of an aluminum road. It was vast and, in that vastness, more closely resembled a naturally occurring phenomenon than something man-made. And there were two of them. You could stand in the space between them, where the air vibrated with silent energy, and imagine you were standing between the tines of a tuning fork. Clouds would catch on the upper floors as they passed over the city, subtly altering the weather. They were alpine—a pair of aluminum mountains. They induced vertigo. They exceeded haptic experience. They failed as buildings, but they were brilliant as objects.

———

Water climbs up onto the narrow swath of park on the Hudson River's east embankment, washing across the four southbound lanes of the Westside Highway, around the landscaped medians and over the northbound lanes before pooling among the trashcans and hydrants on the corner of Twenty-Seventh Street. From there, the tide flows east in the grooves between cobblestones, carried first by capillary action, then forced from behind by the surge. The surface of the road disappears as the water gradually rises to the level of the concrete curb. It is late in the evening of October 29, 2012. Some water is diverted into manholes and storm drains, but not fast enough to keep pace with the rising tide as the surge pushes massive amounts of seawater up into the South Bay. The current between curbs becomes steadily stronger. The street turns into a wide flat stream. Gradually the water breaches the curbs and flows onto the

sidewalk. Water backs up against thresholds and weather-stripping and sandbags, finding its way through gaps, into buildings where it crosses polished concrete floors, seeps between floorboards, pools in electrical outlets, and bloats the papered edge of sheetrock walls. Once inside the building, the water seeks its own level, finding new spaces to fill, descending staircases, and cascading through trapdoors into the cellars below. The basement spaces are not watertight. Circulation vents, air returns, and unsealed ceiling plenums allow air—and now water—to flow freely between underground rooms. In HVAC parlance, these spaces are "in communication"—as water fills one section of the basement, it fills them all. Every door to the street is the source of a small tributary that runs into a cavernous cellar—an underground swimming pool the size of a city block.

Approximately two thousand square feet of this basement was under lease, along with the corresponding ground-floor space directly above, to a small art gallery owned by Nina and her business partner Danielle. Accessed through a large trapdoor in the floor of the gallery's viewing room, their underground space held all the back-of-house fittings typical of the trade—pegboards with spirit levels, spackling knives, tape measures, rolls of low-adhesive masking tape, hex keys, white cotton gloves, and utility knives hanging in neatly organized rows, gray steel shelves stacked with digital projectors and media players with international adapters, large rolls of acid-free glassine, customs forms, ammonia-free Plexiglas cleaner, a tube of mascara, a box of tampons, a lint roller, aluminum Z-clips, brass D-rings, foam blocks, an expired Oyster card, boxes of dead-stock artist publications, and stickers printed with "empty" or "fragile" or "do not open with knife" in thick bold capitals. There were prints stored in steel flat files and paintings in

stacked plywood crates with stenciled graphics or filed neatly in carpeted storage racks, each with labels explaining details of provenance. The insurance company had suggested that all work be lifted no less than eighteen inches above the basement floor in anticipation of a possible unprecedented weather event. In an abundance of caution, Nina and Danielle had doubled the figure and secured all the work at least three feet above the floor.

I had just moved back to New York from Los Angeles to live with Nina and I had spent the days leading up to the storm unpacking books and trying to find room to hang shirts in her apartment's crowded closets. As the night wore on, the water level in the basement quickly passed eighteen inches, then thirty-six, then seventy-two. It lifted the solid wood stair to the basement upward, uncoupling it from its hardware and setting it adrift. When water rushed between the drawers of the flat file, air pockets trapped at the back of the metal cabinet forced the massive file off the ground completely, causing drawers to slide open and release their contents into the encroaching tide. Later, when the surge receded, these cabinets would look as though they had been dropped from two stories—drawers buckled under their own weight in a heap more than twenty feet southwest of where they had begun. When the water flowing through the trapdoor into the basement had nowhere else to go, it backed up on the first floor, submerging the bottoms of office chairs, filing cabinets, bookshelves, and power strips. By this point it was a brackish mixture of salt, sewage, dirt, motor oil, and trash rinsed from the street and the cavernous basement spaces no one had seen, much less cleaned, in decades. The tide continued to rise, pushing a grimy high-water mark on the storefronts to sixteen inches above street level. It would reach as high as fifty inches elsewhere in the neighborhood.

Seven days earlier, on October 22, in the western Caribbean Sea, a low-pressure system turned into a tropical depression, gaining energy as it moved northward. By nightfall it had developed into a tropical storm. Six hours later, near the Greater Antilles, tropical storm Sandy became a hurricane before making landfall near Kingston. By Thursday the storm had crossed Jamaica, rapidly gaining strength. Sandy was upgraded to a Category 3 hurricane before hitting Santiago de Cuba hard and causing extensive damage. Cuba slowed the storm to Category 1 as it passed through the Bahamas, but early in the morning of October 29, a ridge of high pressure over Greenland caused a negative North Atlantic Oscillation that forced Sandy to take a hard left turn and accelerate again before it hit the eastern seaboard just northeast of Atlantic City. With an official designation of "post-tropical cyclone with hurricane-force winds," it was not particularly powerful, but Sandy had a massive circumference, one of the largest wind fields ever recorded.

The high-pressure system surrounding the storm created a depression on the ocean surface that forced the water level higher in the relatively low-pressure eye of the storm. The elevated mass of water pushed toward the shore like a plow. Several hours later, as the plow made landfall, the east coast of New Jersey and the south shore of Long Island acted like two sides of a funnel that directed the swell up under the Verrazzano Bridge to the Upper Bay of New York Harbor and into the East and Hudson rivers, rolling over the low-lying landfill of Battery Park City at the southern tip of Manhattan. As it moved inland, the water inundated Breezy Point and the Rockaways, Coney Island, parts of Staten Island, and Manhattan's Lower East Side, flooding streets, tunnels, and subway lines. With

nowhere left to go, the surge pushed up the Hudson, gathering where the river narrows as it turns slightly eastward at the island's elbow just above Twenty-Third Street, backing up into Hoboken and spilling over into the low-lying portion of Chelsea, flooding its piers and a dozen acres of Manhattan's West Side.

When the tide waned in the early hours of October 30, the streets drained back into the river. In that intense copper calm, the city looked oddly normal, even cleaner, perhaps, than usual, but beneath the street, basements and subway tunnels, like subterranean industrial tide pools, remained full of oil-slicked water. At the gallery, the water had settled less than a foot below the wood floor at street level. The basement was a briny pool just over eight feet deep. The denser items—a cast-concrete sculpture, two cordless drills, a marble plinth, a projector, boxes of hardware and screws, a bicycle—sat on the basement floor, barely visible through the dark water. The more buoyant items, a flotsam of fluorescent bulbs, polystyrene packing peanuts, and a single sculpture the size and shape of a Butz-Choquin Optimal 121 tobacco pipe, carefully cushioned in bubble wrap, bobbed on the surface.

One of those evenings after the hurricane, Nina went home early to file insurance paperwork. It was too dark to continue working in the basement, so I walked from Chelsea to the southern edge of Central Park. A hard drive from the gallery had been damaged in the flood and she needed to salvage the invoices and production receipts it contained in order to complete insurance claims. It was nearly ten o'clock, but this Apple Store, the highest-grossing retail space on earth, is never closed. I was told it was a hardware malfunction, not data corruption. Good news. I bought a cable and ascended the stair that spiraled

back to street level like a pinwheel cursor spinning out into a third dimension. Standing on the curb, forty-six feet above sea level on the dry plateau of bedrock, a passerby might not have had any idea that a storm had just turned the life on the margins of the city upside down, that people had drowned inside their own homes in Rockaway Park or Staten Island or had their lives interrupted in ways that they would never recover from.

The flooding in the lower-lying parts of the city served as a reminder of how wealth is distributed in New York in accordance with topography—a reminder that beneath all the intricate dynamics of zoning and economic mobility, brutally simple geographical facts exert their own influence on the city's composition. When epidemics of yellow fever and cholera spread across the low-lying wetlands of downtown Manhattan two hundred years ago, those who could afford to sought refuge up here above the miasma of the tidal estuaries. As the city's population quadrupled, an expanse of uptown land was cleared for Central Park, imagined by Frederick Law Olmsted as the "lung of the city," but tuberculosis continued to thrive in the overcrowded tenements built on marshy downtown landfill. Mayor Fiorello La Guardia created a public housing system to rid those tenements of the tuberculosis that killed his wife and child, but Robert Moses wrestled it from his control and began systematically moving the city's poorest citizens to its margins under the guise of urban renewal. A fear of disease and high water has had a fundamental impact on the composition of the city. Many of its most vulnerable citizens still live on its most vulnerable land, while the highest concentrations of wealth remain uptown, where the island's bedrock gradually rises above sea level like the arched spine of a whale surfacing in the lower Hudson.

The storm crippled infrastructure and foretold a century of environmental havoc, and yet for that first week after the water subsided, I was preoccupied with the task of carrying ruined sculptures out of a wet basement. In the days following the surge my brain had performed a sort of leveling that allowed the two events to exist in parallel. I knew it was a false equivalency, that pouring every ounce of energy I had into saving inanimate objects while real bodies, real people were facing catastrophic loss, financial ruin, and bureaucratic injustice did not make sense, but the urgency of salvaging those objects, each one tethered in my mind to the person who had made it, felt necessary in the moment.

I walked east with an assortment of cables nested in neat white boxes. I had been following plans for a new residential tower on the corner of Park Avenue and Fifty-Sixth Street that would soon be the tallest building on the eastern seaboard. The proposed structure, designed by the Uruguayan architect Rafael Viñoly, would have four impossibly slender facades with deep-set square windows arranged in a rigid grid—a scheme based, according to a press release, on the pure geometry of the square—and it would rise over a quarter of a mile on a footprint the size of a baseball diamond. No building so slender—fifteen times taller than wide—had ever been built in Manhattan before.

The design had been made public over the summer with a series of images of a solitary tower rising above a city permanently awash in warm millennial coral light, a light the color of the *Financial Times* or a Fragonard petticoat, a contemporary rococo. The renderings almost looked real, though something about the surfaces and edges seemed too smooth, too sharp to be built in a reality subject to disruptive forces like gravity and humidity and human error. One image in particular—of a master bathroom, with an

asymmetrical soaking tub at the foot of a giant square window framing a helicopter view of Manhattan at sunset, the sky a warm gradient of pale pinks and blues—quickly became the most circulated image of the project. Viñoly's office used a drone to photograph the view from each apartment before anything was built, so while the interior in this image is computer-generated, the view—the Empire State and Chrysler buildings, One World Trade and the harbor on the horizon—is real, even if no person had yet stood there to witness it.

For now, the building was little more than an emergent foundation—a finished subbasement with an incipient core sketchily outlined in rebar. Spray-painted glyphs marked the pavement where new utilities would be delivered underground, scribbles of fluorescent yellow for gas and blue for water. From across the empty street I could see a neat row of cranes parked behind a chain link fence and a security guard who watched me watch him across a big dry hole in the middle of the island.

———

Nina and I met in a small bar that I opened with two other artists in Los Angeles. It was October and hundreds of acres east of the city were on fire. The sky was the color of a bruised leg. Nina had come to the bar with several friends of mine who were artists represented by the gallery she and Danielle owned in New York. I knew something about her role in their lives. She was adored. A kind art dealer is a gift not easily taken for granted, and her presence among that group of familiar faces was captivating—her ease, her unimposing confidence, tangles of unwieldy black hair and blue scarf, the flash of a chipped tooth when she laughed

and a slight flush in her cheeks from the wine, huge granite-blue eyes turning once or twice to look back at me. As the others began to head home, Nina realized that she had locked her keys in her car, so she sat with me while I closed out the register and reset the bar. Outside, the wind had shifted as the air cooled and clouds of smoke were rolling down from the fires in the hills. By the time the tow truck arrived, broad gray flakes of ash were collecting on the hood of her car like lichen.

Some time later I was back in New York installing a sculpture—a pair of tall cylinders cast in concrete and black rubber—and sleeping on a friend's couch. Nina and I had made a dinner plan by text, but she called an hour before and told me she had a headache. I assumed this was just an excuse, a polite rebuff. I went to the airport early and caught a standby flight back to California. We did not speak again for six months.

———

The Eastern Airlines Terminal at Logan Airport was the first building I remember recognizing as architecture. On a Saturday morning when I was seven, I accompanied my grandfather, as I often did on weekends, to walk a bag of recyclable bottles to the supermarket around the corner from his apartment in Boston. He would let me pass the empty bottles of Beefeater and Schweppes to the clerk and keep the change. Elmer was barrel-chested with broad features and a wisp of black hair, which he combed right-ward over an otherwise bald, sun-spotted head. He was a chemical engineer, the descendent of Swiss farmers in western Pennsylvania who had worked his way up through the ranks to an executive position at a series of companies

that manufactured metal and plastics. He was a prolific but good-tempered drinker who squinted when he laughed and laughed often. He was also a grandfather ten times over and in retirement lived a lifestyle not unlike that of his kindergarten-age progeny—falling asleep on the couch before dinner and waking with the sun. We spent a lot of time together in those hours between dawn and breakfast—eating raw oysters with small forks or making Masai spears out of broomsticks and grapefruit spoons. That morning, instead of returning directly to the apartment as was our routine, Elmer hailed a cab. The car wound across the Common and into the Sumner Tunnel and emerged at Logan on the other side of the harbor, where it pulled up under a broad concrete canopy emblazoned with a logo I knew from the small gifts—decks of playing cards and stiff plastic combs—Elmer brought home from business trips.

The broad concrete terminal was sleek and confident, elegant but unapologetically overzealous and grand, perched atop a pedestal with slender light poles, lollipop trees, and tall arching columns holding an oversized canopy high above an elevated open drop-off area. It looked new in a way that buildings in Boston seldom did. Like Elmer, the terminal seemed out of place in such a taciturn city.

We stepped out of the cab and an unfamiliar man in a white shirt shook my grandfather's hand. He leaned down and handed me an Alcoa paperweight in the shape of a small aluminum ingot, before guiding us out through the back of the terminal to a small plane standing on the tarmac. A 747 landed over our heads. I held the ingot in my pocket. In the distance the runways gave way to marshland, then harbor, then the checkered water tower above the veteran's hospital on the horizon. Elmer hunched to board the small plane and I followed. A woman brought out a tray with two

18

tumblers of scotch and a small glass bottle of ginger ale. We took off and made a long gradual loop over Boston Harbor. Elmer and the man discussed something while I pointed out landmarks—the Citgo sign behind Fenway Park, the toll booths on the Tobin Bridge, the old John Hancock Building and the taller new one and the profile of the old man's face hidden in the brush strokes on the gas tank in Dorchester. When we got back to the apartment, my mother and grandmother were sitting at the kitchen table drinking coffee with two policemen whom they had called when we failed to return from the supermarket hours earlier.

Shortly before Elmer died, the Massachusetts Port Authority announced plans to tear down the terminal building. The architecture critic Robert Campbell wrote a eulogy in the *Boston Globe* titled "An Act of Architectural Hubris Meets its End":

> They're tearing down the old Eastern Airlines Terminal at Logan. I don't think this one is going to upset the community of architectural preservationists. Although you never know. Maybe they'll decide it's an important example of the Spun Sugar school of architecture of the 1960s. The former Eastern—it's long been known as Terminal A—is an elephant in drag. It's so huge it can hide a thousand parked cars, like bats, up among its roof beams where they're practically invisible. Yet it's clothed in architectural lace: delicate curving white arches that give it the look of an Oriental temple, or maybe an old Fannie Farmer candy box. The architect of this piece of architectural confectionary was the late Minoru Yamasaki. How times do change: Yamasaki once made the cover of *Time* magazine. He was praised, in his heyday, for bringing a touch of elegance to modern architecture, although all he usually did was build a box and paste some arches on it. It was Yamasaki who designed the equally dainty, even more gargantuan World Trade Center towers in

19

Manhattan. When terrorists recently bombed those towers, many regarded the deed as a long overdue act of architectural criticism. Now, here in Boston, Massport will assume the role of aesthetic terrorist.

———

When Nina finally called me back, she acted as though no time had passed at all. She was coming to Los Angeles for an opening and invited me to join her for dinner afterward. She ended up staying with me for the weekend and all of the following week. I asked as little as possible about what had happened in the months since we had last seen each other. We woke up every morning and moved through the motions of a normal day as if we had known each other for years. She sat in the studio and orchestrated shippers and framers from her phone while I poured oily black rubber into wide plaster molds. She took meetings at the bar while I set up for the evening. The following Monday, Danielle called and asked when Nina was coming back. I drove her to the airport the next morning.

Nina and Danielle's gallery was on a quiet block of west Chelsea flanked by two massive buildings. To the south stood the Starrett-Lehigh Building, home at the time to American brands like Martha Stewart, Tommy Hilfiger, and the Department of Homeland Security. The gallery was on the north side of the block, on the ground floor of the smaller, but still enormous, Terminal Stores Building, built at the turn of the century as a train garage and warehouse—a brick fortress with corbeled towers and a tunnel along its east-west axis for loading and unloading the train cars that used to run on the tracks that are now the High Line.

In the weeks following the storm, the block was lined with apple-green ServePro trucks—a traveling carnival

of license plates that diagrammed the movement of the peripatetic disaster remediation industry—tornados in Oklahoma, wildfires in California, hurricanes in Florida. This is a growth sector, expanding incrementally as warming temperatures increase the frequency of *forces majeures*. The army of private contractors and mercenary janitors in khaki pants and wrap-around sunglasses, veterans of Iraq or Katrina or Halliburton, arrived in a caravan and unloaded pumps, vacuums, generators, and air circulators from the backs of vans and trailers and spoke only to the landlord. By the time they had set up, the building looked like a body on life-support, with hoses and wires winding from every door and window out onto the cobblestones.

I spent most of that month underground in a full-body Tyvek suit, tall black rubber boots, a respirator with two hot pink particulate filter cartridges, a battery-powered headlamp, and elbow-length rubber gloves. The basement vibrated with the buzz of halogen work lights and air filters tethered to gasoline generators on the sidewalk. Each piece of art had been placed in the basement with care, with gloved hands, gentle movements, and attention to surface and structure. Such formalities were no longer necessary. Now each object could be moved as you would lift a bag of topsoil or an old door, with a grunt or a shove. I pulled long bands of orange silicon rubber up out of the basement, each as thick as a brick and cracking on the corners from the cold. There were spindly rebar armatures of oversized haunches and torsos, already touched by rust after the cardboard mâché, which had once given them a papery fleshy mass, was carried away with the receding water. I knew all of this work—each object containing untold hours of labor by people with whom I had also spent untold hours long before I met Nina. Among these artists were colleagues

and classmates, the photographer who gave me my first teaching job and the friends who had introduced me to Nina. I knew where most of this work was made, where it was printed or cast, the people who processed the film or worked in the foundry. I had seen many of these pieces in studios in various states of completion or in the galleries or museums through which they had passed on their way here. Now, the act of hoisting each waterlogged piece over my shoulder and carrying it up a ladder and out onto the street gave it a new mass. Feeling the physical weight of each object, the deadweight, on my own body, I could not help but think about what an absurd way of communicating this was—making big cumbersome fragile things and sending them out into the world to be looked at.

I turned off my headlamp and sat on a crate in the dark. I pulled the respirator down around my neck and took a deep breath of fetid air. The jeans and wool sweater I wore under the Tyvek were soaked through with sweat and I could feel the lactic acid hardening in my veins. I added a pair of pliers to a small trove of salvageable objects—a hammer, a padlock, a ruler—which I had piled in a bucket next to the crate. I tried to remember the space as it had been, a quiet cargo hold hidden beneath this massive block-sized building. A few months earlier I had taken a cab from the airport to the gallery. With a thin excuse to Danielle about a crate that needed to be moved or a painting that needed to be wrapped, Nina first showed me the trapdoor in the back room that led to this basement. It smelled like books and concrete. We had sex, our hands and mouths still clumsily unfamiliar with each other's bodies, and then lay on our backs on a pile of packing blankets, watching the floorboards creak under the weight of a visitor pacing above us.

When I imagine a work of art being destroyed it is almost always by fire—the spontaneous combustion of linseed oil in rags or nitrate film in storage vaults, Orwell's memory hole or Savonarola's bonfire of the vanities. Pinochet burned Gabriel García Márquez. The Nazis burned Thomas Mann. Franz Kafka burned ninety percent of his life's work and requested that more be burned upon his death (it was not). Vladimir Nabokov and Emily Dickinson left similar instructions. Herman Melville burned his manuscripts and letters. Agnes Martin may or may not have burned all of her paintings when she left New York. Frank Lloyd Wright's home and studio, Taliesin, burned to the ground after his cook locked Wright's mistress, her two children, and several carpenters in a dining room, doused the house with kerosene, lit it on fire and attacked anyone who escaped with a hatchet (there are still letters in Wright's archives with singed edges). A prison guard burned the only manuscript of Jean Genet's *Notre-Dame des Fleurs* so that Genet had to write it again from memory. Malcolm Lowry saved *Under the Volcano* from his burning cabin but lost *In Ballast to the White Sea*. Guy Montag burned libraries in *Fahrenheit 451* and Don Quixote's priest and barber burned the romances that turned the hidalgo mad. Nearly three hundred sculptures and drawings by Auguste Rodin were lost in the smoldering ruins of the World Trade Center.

Water feels like a less formidable foe. It drips and dribbles, sluices and sprinkles. Fire rages. A conflagration tears through material with indiscriminate fury, while an inundation rolls passively through channels of least resistance, moving deliberately, inevitably, but without the promise of the catharsis of physical transformation.

Minoru Yamasaki, known to nearly everyone who knew him as Yama, was born on December 1, 1912 in a cold-water tenement overlooking Puget Sound in Seattle. Minoru's father, Tsunejiro, an immigrant from Toyama, Japan, worked as a stock room manager at a shoe store, and his mother, Hana, was a piano teacher. In 1926, when Minoru was a sophomore in high school, his maternal uncle, an architect named Koken Ito, made a visit to Seattle. Koken returned to Japan to practice, but his visit left an enduring impression on his nephew. Minoru entered architecture school at the University of Washington just weeks before the 1929 stock market crash. To pay his tuition, he spent summers working in salmon canneries in Alaska.

Nearly a third of Yamasaki's autobiographical introduction to *My Life in Architecture* (1979)—until recently the only comprehensive English-language book on his work—is devoted to these summers. These were the stories he chose to tell about himself. The men in the canneries, primarily of Japanese and Filipino descent, worked around the clock, six days a week, for $50 a month. The labor was grueling and the living conditions were squalid—the men slept a hundred to a room on straw mattresses soaked in kerosene to keep the bedbugs at bay. Some contracted gonorrhea from local prostitutes and beriberi from a lack of proper nutrition (Yamasaki blamed this malnutrition for many of the health problems that would plague him later in his life). Exhausted workers routinely lost hands and fingers on ten-hour shifts shoving fish into a butchering machine known among the managers as the Iron Chink. One year Yamasaki got his drawing hand caught in a canning machine and it took the crew two hours to extract his

fingers. At the end of each summer, after three months of punishing labor, Yamasaki would return to school in Seattle in the unventilated hold of a ship where he slept on a hammock hung among racks of salted herring.

In writings and interviews Yamasaki often referred to these summers as instilling in him the strong work ethic and appreciation of physical labor that form the foundation of his own personal mythology. In *A Life in Architecture*, he wrote that "when I looked at the older men around me in the canneries, destined to live out their lives in such uncompromising and personally degrading circumstances, I became all the more determined not to let that be the pattern into which my life would fall."

In architecture school his colleagues called him Sockeye. He was a strong student, but the intellectual environment was isolated and the Beaux-Arts curriculum was quickly becoming outmoded as modernism took hold in Europe. "No one there, not even the teachers, knew what was going on in the architectural world," Yamasaki recalled. "We didn't even know about the Barcelona Pavilion." Ludwig Mies van der Rohe and Lilly Reich's pavilion was just one of the seminal projects completed while Yamasaki was finishing his degree—a list that also includes Richard Neutra's Lovell Health House, Eileen Gray's E-1027, Buckminster Fuller's Dymaxion House, and Alvar and Aino Aalto's Paimio Sanatorium.

———

The low-lying street where I had been building out a studio for myself before the storm was on another margin of the flood zone. It was a short block, bounded at one end by an expressway underpass and at the other by an outlet of the

Gowanus Canal, populated at street level almost entirely by scrap metal recyclers and marble wholesalers. The metal, collected by scavengers or contractors between jobs, is bundled and sent in bales to the scrapyards outside Guangzhou in ships that would otherwise return to China with an empty hold, inverting the logic by which cobblestones once came to America as ballast in ships returning from Europe. Most of the marble on the street, faux-Carrara used for the new residential towers sprouting on the avenues around the studio, comes largely from China's southeast coast, so it is tempting to imagine a closed circuit of ships shuttling back and forth through the Panama Canal, moving metal eastward and marble westward—a barter of one heavy material for another based on the inputs and outputs of trade surplus and residential development. When the street beneath my studio flooded, the stacks of unhewn marble and bales of rusty metal remained the same, and business proceeded more or less as usual. My studio was two flights up, in a floor-through space that had most recently been occupied by a cabinet maker, or so I assumed by the sawdust between the floorboards. The name was still stenciled above the police lock on the front door—

SEPULVEDAS CUSTOM CABNETS AND FURNTURE

I had spent August pulling century-old copper wire wrapped in fraying thread out of old conduit and trying to make sense of a labyrinth of circuits left behind by the previous tenants—networks of red and blue wires like illustrations of circulatory systems. When I found the end of a circuit, I would cut it at the box on one end and follow the conduit to the other end as it dipped and turned, tracing the outline of walls and appliances that were no longer there. At the other end I would tease out a bit of wire, wrap

a few inches of it around the handle of a wrench and with the full weight of my body, pull the entire length of wire out. Every time it felt like pulling a piece of string through a body, through intestines or arteries, beneath skin. I dragged a trash bag full of copper wire downstairs and traded it for $174 in small grimy bills. I walked around the corner and spent the cash on three cases of high-output cool white T5 fluorescent light bulbs and covered the studio ceiling with a grid powerful enough to obliterate the shadows of any sculpture standing beneath them.

———

Yamasaki arrived in New York in September 1934. The bottom had dropped out of the construction market as the country fell into the Great Depression and architectural work was scarce. He took a job wrapping Noritake china for a Japanese import company and taught watercolor at night. He enrolled in a master's program in architecture at New York University, but never completed the degree. After the Oregon State Capitol was destroyed by fire, Yamasaki worked briefly on a redesign competition with Francis Keally, and that relationship eventually led to his first stable job working for Githens & Keally on plans for the 1939 World's Fair and the austere art deco Brooklyn Public Library.

From Githens & Keally, Yamasaki moved to Shreve, Lamb & Harmon, the architects of the Empire State Building. There he was assigned to the team working on the Parkchester apartments, a massive middle-income housing estate in the Bronx sponsored by the Metropolitan Life Insurance Company. Parkchester was among the first American applications of the "tower in the park"— tall high-density buildings surrounded by communal

green areas, based on European modernist models like Le Corbusier's unrealized Radiant City—and it was considered so innovative that it was showcased at the World's Fair. After working on Parkchester for three years, Yamasaki and his brother Ken applied to rent an apartment in the complex only to be turned away by discriminatory management.

In the autumn of 1941 Yamasaki met Teruko Hirashiki. Teri was the child of Okinawan immigrants in California and, like Yamasaki's mother, a gifted piano player. She had moved from Los Angeles with a full scholarship from Juilliard. On Friday December 5, just three months later, they married in a hastily planned ceremony and spent the night dancing at the Hotel Astor roof garden. On Sunday the Imperial Japanese Navy bombed Pearl Harbor. On Monday the United States declared war on Japan and the political landscape shifted dramatically under Yamasaki's feet. The most prominent Japanese American architect in New York at the time, Yasuo Matsui, a principal designer on both the Bank of Manhattan Building and the Starrett-Lehigh Building, was rousted out of his bed, arrested, and taken to Ellis Island. Unlike Yamasaki, Matsui was born in Japan. He was held at Ellis Island for two months and spent the rest of the war under house arrest, prohibited from flying or owning a camera. Yamasaki's American citizenship, at least on the East Coast, afforded him more security, though he remained under investigation by government agencies suspicious of the timing of his wedding to Teri.

A more profound anti-Japanese hostility was fomenting on the West Coast. In February 1942, Franklin D. Roosevelt issued Executive Order 9066 calling for the "mass removal" of nearly 120,000 people of Japanese descent on the Pacific Coast, over 72,000 of whom were United States citizens. At the Santa Anita racetrack north of San Diego, stables were

converted into makeshift cells for prisoners, and north of Los Angeles hundreds of tarpaper shacks were built in the barren Owens River Valley town of Manzanar. The majority of Japanese residents living in Seattle were sent to the Minidoka War Relocation Center in southern Idaho's high desert. Yamasaki's parents, forced to sell everything the family owned for a fraction of what it was worth, were able to avoid internment by crossing the country to move into the small one-bedroom apartment Minoru shared with Teri and Ken on First Avenue and Eighty-Seventh Street.

With everything else on hold, Shreve, Lamb & Harmon was contracted to design the Sampson Naval Training Station, a massive facility on the shore of Seneca Lake in upstate New York. Based on his experience with the firm, Yamasaki was given a lead role overseeing all aspects of the project, and quickly established himself as a competent manager who could keep a massive project on schedule and on budget. Yamasaki found himself with more responsibility than ever before, but the landscape in which he was working had fundamentally changed. Anti-Japanese hostility was more pronounced outside of the city, and on at least one occasion military police refused him access onto the base, the vast majority of which he had designed.

Despite the complicated circumstances of his employment, Yamasaki was politically active during the war years, helping to rehouse displaced Japanese Americans on the East Coast and working alongside Isamu Noguchi as co-vice-chairmen of the Arts Council of the Japanese American Committee for Democracy. An April 1944 article in the *Brooklyn Eagle* recounts a story of Yamasaki and his colleague Eddie Shimano going to Washington, DC to petition on behalf of a hostel for displaced Japanese Americans, only to be dismissed by New York Congressman

John J. Delaney who said he would not want him for neighbor and asked why he should be expected to "accept the scum and take care of them?"

Yamasaki worked on Sampson for nearly two years. When the base was completed, there was no more work at Shreve, Lamb & Harmon. Yamasaki departed the firm with a letter from project manager Irvin L. Scott confirming his role in "various United States Government defense jobs" and stating that, "since December 7, 1941, due to Mr. Yamasaki's racial ancestry, his eligibility for employment on Government Projects has been the subject of investigation by various Governmental Agencies, all of whom have approved the continuance of his services as an American citizen on these projects."

Yamasaki found his next job at Harrison, Fouilhoux & Abramovitz. When he was hired in mid-December, Wallace Harrison gave him a $25 bonus and took him for drinks at Rockefeller Center. Yamasaki welcomed the transition to a more forward-looking, modern firm. Harrison was an innovative designer and an adroit politician—tall, broad-shouldered, and charming, he was a confidant and advisor to Nelson Rockefeller and Robert Moses and a friend to Marc Chagall and Fernand Léger. He sat at the center of the committee that planned Rockefeller Center and the 1939 World's Fair, for which he designed the iconic *Trylon* and *Perisphere* sculptures, and he would soon be the director of planning for the United Nations and the master planner and supervising architect for LaGuardia and Idlewild airports. Though the extent of Harrison's influence on the physical appearance of contemporary New York is largely underappreciated, his pragmatic, prolific, unpretentious and, in contrast to more academic European models, distinctly American approach to

modernism was not lost on Yamasaki. Harrison was the kind of architect Yamasaki aspired to be.

In his final years in New York, Yamasaki made two of his most enduring friendships. While moonlighting as a drawing teacher at Columbia he met George Nelson, and the two men went on to collaborate briefly under the name Nelson & Yamasaki, Architects. The collaboration was cut short when Nelson took a post as head designer for Herman Miller, but he and Yamasaki remained close. Yamasaki also became friends with Douglas Haskell, who would go on to edit *Architectural Forum* and who remained an outspoken advocate of his work. The Yamasakis had their first child, Carol, in February 1944. Yamasaki spent his final months in New York working for the industrial designer Raymond Loewy, but he was frustrated with the work, writing later, "the idea of designing a skin around a machine whose form had already been decided was distasteful to me." When a recruiter approached him with a lucrative offer from a prominent office in Detroit, he decided it was time to leave New York.

———

In the weeks following the storm, the city was an overcast grisaille, as if the receding water had drained the buildings of color. The floor of Nina and Danielle's gallery was tiled with warped and bloated objects, and the four halogen lights running on a generator outside made the room feel like a triage tent. We kept the heat off to discourage mold and worked quietly in rubber gloves and winter coats. Photographs were removed from waterlogged frames and stacked on improvised drying racks—their condition and edition numbers noted. Canvas was removed from

stretchers. Photographs can be reprinted, but a wet painting is a worthless object because the moisture trapped between paint and canvas will eventually destroy it from within. The damage to sculpture varies depending on material. Some pieces cast in resin or concrete survived the flood unscathed, while six sculptures of busts crudely rendered in paper pulp vanished without a trace.

Once the condition of every piece had been documented for the insurance company, it had to be formally "destroyed" and rephotographed as a guarantee to the insurer that no work on the claim could reenter the market. I watched as Nina and Danielle, twinlike in puffy black coats and thick wool caps, cut each photograph into pieces, smashed each ceramic sculpture with a hammer, slashed every waterlogged canvas with a knife.

Among the damaged works were eight photographs taken by John Divola in an abandoned house on Zuma Beach in Malibu in the late 1970s. Divola spent two years documenting the house as it was gradually transformed by weather, vandalism, and his own painterly interventions. The Zuma series ended abruptly one day when Divola returned to find the house burned to the ground. Forty years later, the photographs have an eerie likeness to images of New Orleans after Hurricane Katrina with spray-painted x-codes and blooms of black mold on the walls of destroyed homes. I bought one of Divola's small Polaroids from Nina when we first met. I could hardly afford it at the time, even with the steep discount she and Danielle offered me, but I wanted to be taken seriously. I gently pulled two of the eight large dye transfer prints that had been in the basement out of their wracked frames and set them aside on a plywood table in the gallery's back room. They were ruined—it was only a matter of time

before the sea salt corroded the chemical composition of the print—but I was not ready to throw them away yet. By mid-November the basement was clear and nearly all of its contents had been transferred into a series of red forty-yard dumpsters on the curb.

———

Early one morning I walked back up to the construction site where the renderings of 432 Park were beginning to take form. It was the kind of clear winter day when atmospheric pressure traps exhaust from traffic just above the street and carbon monoxide wafts invisibly at eye level, bending the air into clear whirlpools. Behind a plywood construction barrier surrounding the site I could see the orange safety netting luffing slightly with the wind passing through the hollow structure. There was a tall white tower crane on site now. The core of the building had reached the sixth or seventh floor and the open window cavities looked like a newly cast ruin. The fresh concrete was curing from streaky gray to a uniform matte white.

The formwork was still only as tall as it was wide, a hollow perforated cube, like Aldo Rossi's ossuary at the San Cataldo Cemetery in Modena, if it were intended for the living. The tower was slowly taking form and new plans and elevations showed the distinctive structural voids in more detail. Every twelve stories two rows of deep-set window openings would remain unglazed, leaving a double-height open-air colonnade behind which the building's mechanicals will be housed inside a massive two-story concrete cylinder. The core's circumference would be about two thirds of the building's width, giving the overall impression of a concrete drum rising within an exterior lattice cast in

a concrete so fine it looks like travertine. On the mechanical floors the space between the empty window openings and the concrete drum would be left entirely open so the unenclosed voids would create wind drag to help stabilize the narrow tower. Without this added drag, the sway would have been intolerable for residents. For now, the half dozen finished floors looked like abandoned formwork, openings cast in shadow by the morning sun.

In Viñoly's early drawings, 432 Park, devoid of any ornamentation or other indication of scale, looks like something more easily described with the language of art than the language of architecture. Viñoly cites Josef Hoffmann's perforated Wiener Werkstätte trashcan as an inspiration, but early critics preferred to compare the form to a Sol LeWitt *Cube Structure*. It is a strikingly minimal composition, not a conceptual minimalism intended to evade interpretation and deflect content, but a maximal minimalism designed to communicate luxury and sophistication. Viñoly claims that the building has "no décor," that it is purely an exercise in form and proportion, but that is, of course, a demure denial of the design's hypersensitivity to contemporary taste. The denial of decoration is the décor or, as Rem Koolhaas put it in *Junkspace*, "minimum is only maximum in drag."

———

By the time Yamasaki arrived in Detroit in November 1945, the war was over. The Japanese government had surrendered abruptly after the United States bombed Hiroshima and Nagasaki during Yamasaki's final weeks in New York. His new position came with a substantial increase in salary, but when he and Teri began to look for a home in the

affluent suburbs of Birmingham and Bloomfield Hills, they found themselves unwelcome. Spurned by restrictive covenants and racist neighborhood associations, the Yamasakis ended up buying an old farmhouse in the unincorporated township of Troy. Detroit was in many ways the epicenter of design culture in the United States at the time, and Yamasaki found a more welcoming reception among the progressive community of artists and architects affiliated with the Cranbrook Academy of Art. He soon became close with contemporaries including Eero Saarinen and Florence Knoll. He met Alexander Girard, with whom he collaborated at least once, and Harry Bertoia who would become a lifelong friend. The Yamasakis' second child, Taro, was born shortly after they arrived in Detroit, and they had another son, Kim, two years later.

In January 1947, St. Louis' prolific planning commissioner Harland Bartholomew produced a comprehensive plan focused in part on clearing the city's densely populated slums, which had been plagued by a history of cholera outbreaks and devastating fires, to make way for a more prosperous downtown. Bartholomew, evoking a metaphor which, in the history of American urbanism, has so often carried a racist undertone, described St. Louis' slums as a "cancerous growth" that might "engulf the entire city if steps are not taken to prevent it." When Harry Truman passed the American Housing Act in 1949 and gave cities federal funding for slum clearance, newly elected mayor Joseph Darst created the St. Louis Housing Authority and set out to implement Bartholomew's plan—a surgical operation through which blight could be cut from the diseased fabric of the city like a tumor.

Postwar urban renewal was in this sense as much about demolition as construction. Federal funding required that

one substandard housing unit be subtracted for each new apartment—demolition was written into the law. Like many mayors, Darst looked to New York, where high-rise developments, such as Parkchester, provided successful models for housing more people for less money, while also exorcising the nineteenth-century city of its crowded tenements. Hellmuth was well connected to St. Louis' political inner circle and Yamasaki had firsthand experience working on Parkchester, so Hellmuth, Yamasaki & Leinweber were well positioned to secure their first public housing commission, a small complex of six buildings known as Cochran Gardens. It was a success, and in 1950 the city hired the firm to design a significantly larger housing complex on fifty-seven acres in the DeSoto-Carr neighborhood on St. Louis' lower north side—a massive thirty-three-building development with nearly three thousand apartments surrounded by open green areas. The project was named Pruitt-Igoe for two famous Missourians who had never met—Tuskegee Airman Wendell Pruitt and US Congressman William Igoe. Public housing was still segregated at the time, so the complex was to be bisected, with the Pruitt sector to house black residents and the Igoe sector white.

Yamasaki diligently applied what he had learned working on Parkchester to Pruitt-Igoe. The tower-in-the-park model, originally proposed by architects like Le Corbusier as a panacea for the overcrowded, disease-ridden European cities of the Industrial Revolution, provided him with an adroit synthesis of the Housing Authority's desire for clean, cost-efficient reform and the legitimizing influence of progressive European planners. In one of several lectures extolling the virtue of high-rise housing, Yamasaki evoked the same ubiquitous surgical metaphor: "Slums are the

cancer of our cities and the only time to stop a cancer is now. If we don't these cancers will kill our cities."

Yamasaki tailored his towers to the scale of the surrounding city and proposed a variety of mixed-height buildings and row houses, insisting that no building exceed seven stories. Austere as it was, his proposal still exceeded the federal government's maximum cost per unit and the Housing Authority pushed back. By the time the project was presented for federal approval, Yamasaki had been forced to extend the towers to a uniform height of eleven stories and eliminate the row houses, despite his concern that the increased density would fundamentally alter the design. In an attempt to foster interaction and cultivate a sense of smaller communities within the towers, Yamasaki devised a system of "skip-stop" elevators that served only four anchor floors located on the first, fourth, seventh, and eleventh stories. Each light-filled internal concourse, through which residents would pass to reach the levels directly above and below, was intended to function as a small neighborhood, a welcoming public space outfitted with wide breezeways and services like laundry rooms, garbage chutes, and children's play areas.

As construction progressed, the anchor floors remained, but the overall design was severely undermined by relentless value engineering on the part of the Housing Authority, combined with inflated local construction costs and austerity measures imposed by the Truman administration during the Korean War. One by one, public toilets, playgrounds, and metal safety grilles were eliminated, windows were made smaller, steam pipes were left uninsulated, and specified materials were exchanged for cheaper alternatives. Before construction on Pruitt-Igoe was even finished, Yamasaki had come to terms with how compromised the

final project had become. Less than a year after the last residents moved in, Yamasaki described the project to the New York Architectural League as "tragically insensitive," admitting that a recent visit to the site had impressed upon him the "deplorable" mistakes he had made. Despite his own misgivings, critics applauded Yamasaki's design, and an *Architectural Forum* article titled "Slum Surgery in St. Louis" praised the project as "the best high-rise apartment" of 1951.

———

Migraines do not follow the binary logic of switches or triggers. They seem instead to be governed by more chaotic algorithms, spirals and synergies, feedback loops, and compounding cycles—the non-Euclidian geometries of the brain. Nina's headaches are what are referred to as common, rather than classic, because she does not experience an aura, the short period of visual disturbance frequently associated with the onset of migraine. Common migraines are widely considered to be more painful than classic migraines, and Nina's had been gradually increasing in frequency and intensity for years. No doctor seemed able to say why. By the time we met, the headaches came as often as four or five times a week, so that any day was as likely to be spent with a headache as without.

It was not until we lived together that I appreciated how incapacitating these headaches could be. How they flourished not in the moments of peak intensity, but in the valleys. How they arrived in the quieter lulls of the day, before work or after lunch, and then slowly tightened their hold until they presented her with no option other than to seek out some dark spot, to sleep, to close down entirely.

In 1968 Joan Didion wrote "In Bed," a concise and remarkably thorough five-page essay on her own experience with migraine, which she defines as a "complex of symptoms, the most frequently noted but by no means the most unpleasant of which is a vascular headache of blinding severity, suffered by a surprising number of women, a fair number of men," which, "gives some people mild hallucinations, temporarily blinds others, shows up not only as a headache but as a gastrointestinal disturbance, a painful sensitivity to all sensory stimuli, an abrupt overpowering fatigue, a strokelike aphasia, and a crippling inability to make even the most routine connections." Approximately fifteen percent of the population is affected by migraines, which tend to impact one side of the head at a time and are two to three times more prevalent (and generally more painful and longer lasting) among women than men. Migraine has been documented, more or less in its current form, for at least 2,000 years. Hippocrates and Aretaeus wrote about a specific kind of severe headache which Galen later named hemicrania, or half-head, from which the contemporary word migraine is derived.

The fact that Didion's essay and Oliver Sacks' comprehensive book *Migraine* were published fifty years ago and remain the most compelling pieces of writing on the subject is an indication of the pace of progress in migraine research. The underlying mechanisms of migraine are still not fully known. When Didion wrote "In Bed" migraine was thought to be a purely vascular disorder, the pain it caused the result of a dilation of cranial blood vessels. It is now considered a neurovascular phenomenon, involving nerve pathways and chemicals in the brain, where the pain comes from neurogenic inflammation rather than vasodilation alone. Contemporary research suggests that migraine

is a problem of brain function rather than brain structure. In other words, if the brain were a computer, migraine would be a software problem, not a hardware problem—a crash of the human operating system.

For as long as I can remember, my relationship with my own body has been defined by struggles of endurance—daily limit tests of how far my brain could push my body to sleep less, to read more, to run faster, to indulge or to abstain, to withhold or to release. I have always imagined my body as a tool to be pushed as far as it can go, to be stretched to the limits of its tolerance in order to make up for what feels like lost time, to work harder than everyone else, to assuage the anxiety of falling short in one way or another.

Nina's reality is, at least in this sense, fundamentally opposite—her relationship to her body is constantly framed by the prospect of collapse into a shadow state that is present even when it is absent. To understand Nina's headaches is to try to comprehend the experience of living inside a body that is as often as not struck down by the failure of its own circuitry. This is circuitry that can be compromised by small stresses to which I had been largely oblivious—the dissonance of dinner conversation over background music, the aggression of street noise, the piercing brightness of a phone screen, or the noxious gas that escapes a burner before it sparks into blue flame.

———

In St. Louis, Hellmuth, Yamasaki & Leinweber were taking on projects of astonishing scale. The National Personnel Records Center in a suburb of St. Louis was a Department of Defense facility with over a million square feet of storage space for the service records of over fifty-two million

men and women in federal civil and military service. At the time it was built it was one of the twenty biggest buildings in the world. In the final stages of the design phase, after a debate among librarians and archivists about the relative merits of sprinkler systems (which might irreparably damage paper records in the case of a false alarm), the Corps of Engineers decided to proceed without sprinklers. The project was completed significantly under budget, bolstering Yamasaki's reputation as a cost-conscious designer who could deliver a handsome product on time, even at a mammoth scale.

Yamasaki was prospering. His next high-profile project was a soaring concourse for the Lambert-St. Louis Airport Terminal that combined three pairs of concrete barrel vaults into an easily legible metaphor for flight. Yamasaki's design was driven by the material possibilities of new stressed concrete technology that allowed for structures to be taller and thinner than previously thought possible. Lambert was clearly influenced by the sculptural formalism of Pier Luigi Nervi and the Latin American modernists Oscar Niemeyer and Félix Candela, who had achieved expressive forms by pushing this new technology to its limits. Lambert also marks the moment when Yamasaki's style most closely aligned with that of his friend and colleague Eero Saarinen, who had recently experimented with this concrete technology in the Ingalls Rink at Yale and the Kresge Auditorium at MIT and would begin work on his two major airport projects —the main terminal at Dulles and the TWA Terminal at JFK—shortly after Lambert was completed.

Lambert was featured as one of six buildings, including the Seagram Building and One Chase Manhattan Plaza, in Arthur Drexler's show *Buildings for Business and Government* at MoMA. It was a breakout project

for Yamasaki, but five years of relentless travel between Detroit and St. Louis and the stress of running a firm in two cities had taken a physical toll. Yamasaki wrote very little about his health, but secondhand accounts of his life recorded by friends and journalists suggest that the persistent stomach pains that had first appeared during his summers in Alaska had steadily worsened with the stress of managing a growing office.

In December 1953, when Lambert was still under construction, doctors discovered that Yamasaki's stomach was severely ulcerated and that he was bleeding internally. He underwent emergency surgery and remained in the hospital for eight weeks while surgeons removed two thirds of his stomach. Recounting the story to a journalist years later, Yamasaki recalled lying in the hospital bed feeling so close to death that he "overheard his own mother tell his three children that he would not pull through." When Yamasaki recovered, he and Leinweber parted ways with Hellmuth to focus on projects in Detroit. The split also meant the loss of Yamasaki's chief assistant on Lambert, the talented young architect Gyo Obata, who stayed on in St. Louis along with Hellmuth and their associate George Kassabaum.

———

By January Nina and Danielle were ready to reopen. They were emotionally battered, but lighter and nimbler for having jettisoned nearly all of the gallery's antediluvian history. A slight change in paint texture at knee level on the walls where the sheetrock had been replaced was the only remaining physical trace of the high water, but a protracted lawsuit with the insurance company was a persistent reminder of the damage the flooding had wrought.

Those months had changed things with Nina. The trepidations of a new relationship, which had until now played out almost entirely over long distances, had given way to a comforting sense of inevitability. We were closer now. An intimacy that had felt tenuous at times had solidified into something substantial. At the time of the storm, I was still a relative newcomer to the circle that had orbited these two women for the last decade. The urgency of my emotional connection to the gallery during those weeks had as much to do with the work languishing in the basement and the friends who had made it as with Nina, but now I saw the gallery more completely as something of Nina's and Danielle's that needed to keep moving forward.

The high water had done little to stop the progress of development in the low-lying flood zones that wrap the waterfronts of Lower Manhattan and Brooklyn and the broad swath of landfill west of Tenth Avenue on which most of Chelsea is built. Development continued apace as if the city had not just endured two hundred-year storms in fourteen months. In the marginal neighborhoods of the outer boroughs, like the one where I worked, clusters of new residential buildings were going up where no one had wanted to live before, on the narrow scraps of land wedged between highways, light industry, and toxic waterways, while rebuilding in the parts of the city most severely damaged by the hurricane remained mired in insurance disputes and bureaucratic paperwork—literally and figuratively sandbagged.

———

I stood in front of a floor-to-ceiling window in a new Chelsea apartment building and surveyed the half-finished landscape of upturned decking and exposed trestles below for

an uncomfortably long time. It was October 2008 and, in the weeks leading up to my first show in New York, a financial disaster was looming. The subprime mortgage crisis was deepening and the ripple effects of defaults and foreclosures in Florida and Arizona had begun to rattle investor confidence. Banks were failing, Obama was filling stadiums, and I was trying to distinguish myself from another influx of young artists in New York.

Earlier in the day, as we installed my work, the gallery hummed with the high frequency of fluorescent light and the nervous energy of immanent retail catastrophe. The opening was subdued and followed by dinner in an impeccable new apartment overlooking the unfinished High Line. Cable news droned in the background while we ate, ears tuned to any word about the surging young candidate or the crumbling financial system. My friends had gone downstairs to smoke, and as I stood alone at the window I resolved that my work for this show was pretty mediocre, regrettably uptight, and that at some level I should be thankful for the market free fall because it lowered the pressure on the work to sell.

The sculptures I was making at the time—melons cast inside blocks of plaster, a heavy slab of glass supported by lemons, or an aluminum frame wrapped so tightly in plastic that it began to bow under pressure—grew almost entirely from questions about how bodies interact with buildings, how rigid architectural structures struggle to accommodate unpredictable human occupants, and how bodies push back against the materials that contain them. The sculptures for the show were minimal assemblages of glass, aluminum, and concrete penetrated by roughly cast urethane objects and waxy cucumbers. Glass was smudged with fingerprints; machined aluminum was

discolored by the reaction of the metal to oily human hands; and cucumbers rotted slowly under fluorescent light. The work implied repression. It was suggestive, but ungenerous. The press release made claims about "the sublimated desire of functional objects" and "the inevitable awkwardness of the body's metonymic relationship to design," but the connections felt more tenuous to me than they ever had before. Things had been moving too fast since I finished graduate school that summer and I had, somehow, already overextended myself. I recalled a studio visit leading up to the show when the gallerist, who was now smoking below the kitchen hood rather than going downstairs, told me the worst thing about being an artist is that you only get one chance. I hoped she wasn't right, but she wasn't usually wrong.

———

During Yamasaki's recovery, a commission from the State Department to build a US consulate general in Kobe required him to go to Japan. The United States had remained an occupying force in Japan through 1952, and the selection of a Japanese American architect to design the consulate was a strategic diplomatic decision (documents describing the project referred to Yamasaki as a "goodwill ambassador"). Yamasaki had not been to Japan since he was in high school. Like many first-generation Japanese Americans who had come of age during the Second World War, Yamasaki's relationship to his own ancestry was complicated. He had spent a significant portion of his career working for the military agencies of a government that officially considered his own parents enemies of the state—the same government that sent the neighbors he grew up

with in Seattle to internment camps and reneged on the promise of fundamental rights made to tens of thousands of American citizens of Japanese ancestry. Yamasaki had moved his family to a city whose most comfortable neighborhoods turned him away and where, as his firm grew, the press often went out of its way to assure readers that he was "as typically American as the big Chrysler he drives" and that he and Teri may "look Japanese but they're not. They're contemporary American." In the media, Yamasaki's story was invariably framed as one of successful assimilation—a model for the model minority—but a legacy of racism lingered just below the surface. Many of the documents in his archive, including a newspaper clipping announcing the opening of a new office building that ran on the same page as a cartoon of a caricatured Japanese businessman, suggest a more complicated reality. Like many of his fellow Nisei, Yamasaki struggled to find an identity as a citizen of a country at war with his ancestral home—a condition his friend Isamu Noguchi would later describe as the "peculiar tragedy" of a generation "accepted neither by the Japanese nor by America. A middle people with no middle ground."

Yamasaki's surgery had taken a toll on his body, and his doctors urged him to take some time off. In 1954 he extended a trip to Kobe and spent four months traveling extensively in Europe and Asia. He visited Paris, Venice, and Rome, but three of the most influential encounters of Yamasaki's sabbatical occurred during his time in northern India. The partition of 1947 had dislocated millions and divided the state of Punjab in half, leaving the former capital Lahore on the Pakistani side of the border and the new Indian state of East Punjab without a capital. Prime Minister Nehru ultimately entrusted Le Corbusier with the design of a comprehensive urban plan that would embody India's progressive

46

new identity as an independent republic. Chandigarh was the first modernist city built from the ground up, and Le Corbusier conceived the master plan with an anatomical overlay—the city center as a heart, a network of parks as the lungs, and a grid of roads comprising the circulatory system. At the city's head, Le Corbusier consolidated the government in three massive concrete buildings—the High Court, the Secretariat, and the Assembly Building. Yamasaki found the capital too imposing for a nascent democracy. He compared the High Court to "a great pagan temple, where man must enter on his knees." Reflecting on his impression of the capital, he later told *Time* magazine that "a building should not awe but embrace man. Instead of overwhelming grandeur in architecture, we should have gentility. And we should have to wish mentally and physically to touch our buildings." This tactile impulse, the idea that "good architecture makes you want to touch it," became a recurring theme throughout his career.

Discouraged by the brutality of Chandigarh, Yamasaki went south to Fatehpur Sikri and Agra. In the context of 1950s American architectural discourse, the spectacularly ornate Taj Mahal was an irredeemable anathema—a sentimental monument devoid of function that embodied all the excess and emotion reviled by the modernist establishment—yet it resonated profoundly with Yamasaki. He would later write that "in the realm of proportion and the symphony of beautiful detail to perfect concept I believe it is without peer. A kind of sculpture, a building without utility, but as a monument, it is nevertheless pure joy to behold. Structural honesty, the lesson we hold so dear in modern architecture, is ignored." He recounted sitting "for hours wondering what could be changed, what could be added or removed," but finding nothing.

47

From Agra, Yamasaki went on to visit Edward Durell Stone's US Embassy, another instrument of Eisenhower-era diplomacy and an early attempt to merge Mughal ornament with modernist form, still under construction in New Delhi. Stone began his career as an ardent modernist—his work was included in the MoMA's seminal *International Style* exhibition in 1932 and he was commissioned to design the museum's first permanent home in 1939—but the embassy marked a dramatic stylistic turn. This was a new kind of building—a long low structure raised on a platform above a reflecting pool, a glass box with a flat roof and slender columns, wrapped in a decorative screen that clearly evoked the intricate latticework of the traditional *mashrabiya*. It was an unapologetically ornate and ornamental building, and when photographs of it were first published Stone became a pariah among the most dogmatic modernists.

There are remarkably few sketches in Yamasaki's archive, but there are dozens of drawings in a wire-bound notebook of the embassy under construction, with a pronounced emphasis on the way the long horizontal roof floats above the intricate *brise-soleil*. Stone's attempt to reconcile the decorative history of Mughal architecture with the clean lines of the International Style made an enduring impression on Yamasaki. Two years later, designs by Stone, Yamasaki, and Saarinen would be selected as finalists in the competition for the US Embassy in London, though it was Saarinen who ultimately got the job.

One summer in college I made a nearly identical trip to Chandigarh on a travel grant. En route, my path crossed Yamasaki's at a number of points, including the Taj Mahal, Fatehpur Sikri, and Stone's Embassy in New Delhi. By the time I got to Chandigarh, forty-seven years after Yamasaki,

a city had grown up around the hulking buildings he had found so out of scale, and the citizens had responded with their own vernacular hybrid of modernism and pragmatism. One afternoon, after another day spent failing to gain access to the Secretariat building, I went to see a psychic who had been recommended by a friend in New York. He took my basic astrological markers but based most of his assessment on my hands. He spent an eternity looking at my palms and fingers. He told me I was going to work with my hands and that I would work very hard, but that people would not understand what I was trying to do. I wished instantly that I could unhear it, that I could stand up and walk back into the baking sun as if it had never happened.

———

When he returned to Detroit Yamasaki published two articles in *Architectural Record*. The first, "Toward an Architecture for Enjoyment," printed in August 1955, is essentially a travelogue of his time abroad. It is a sincere and intuitive piece of writing, quite distinct in tone from cool modernist manifestos like Le Corbusier's *Towards a New Architecture*, to which its title clearly refers. While he does not mention Le Corbusier's capital complex in Chandigarh by name, it no doubt informed his position that "in the democratic atmosphere which we are so fortunate to enjoy, there is little room for the kind of emotions generated by these monumental qualities."

In the same essay, Yamasaki frames modernism as an unfinished project that sits on "the threshold of an era that promises true greatness," but remains impeded by a preoccupation with four central "fallacies" (a construction clearly borrowed from Geoffrey Scott's book *The Architecture*

49

of Humanism)—function, economy, originality, and hero worship. Yamasaki openly criticizes the monotony of the International Style and instead celebrates the ornate perfection of the Taj Mahal. He proposes that architecture is "the effort of mankind to instill into his constructed environment the quality of aspiration toward nobility which will inspire him in the pursuit of happiness," and that in order to achieve such an end its practitioners must prioritize humanity and democracy over utility and economy.

The second article, "Visual Delight in Architecture," printed three months later, is organized around the thesis that "delight and reflection are ingredients which must be added to function, economy, and order to complete mature modern architecture." Upon his return home, Yamasaki found that delight, in particular, was conspicuously absent from the architecture of his native country—"in America, conceived delight in architecture is seldom known." He also found very little of what he deemed another key quality —surprise—or as he put it, "the pleasure of the unexpected." The word "serenity" does not appear in either article, though it gradually takes the place of "reflection" in future writings where the trio of "surprise, serenity, and delight" become the de facto motto of his mid-career work. Though these articles were largely received by his peers as a critique of the International Style and a defense of ornamentation, they were, more accurately, a call for a reimagination of contemporary architecture through a humanist lens based on Yamasaki's conviction that modernism was still evolving and not yet a complete project.

The principles laid out in Yamasaki's two *Architectural Record* articles take their first physical form in two very different buildings—the McGregor Memorial Conference Center in Detroit and the Reynolds Metal Building in

the suburb of Southfield. McGregor sits in the center of Yamasaki's master plan for the Wayne State University campus. It is essentially a pair of identical two-story travertine boxes separated by a glazed atrium that runs lengthwise between them. The east and west facades are comprised of two colonnades with slender white marble columns rising to meet larger triangular valences on both levels. The same triangular motifs are repeated on the interior colonnades that open over the narrow central atrium and the honeycomb of trilateral skylights above. The entire structure is raised on a pedestal and bordered on two sides by broad rectilinear lily ponds with platforms for sculpture.

McGregor was considerably more decorative than anything Yamasaki had designed before, and this new direction was greeted with suspicion in a profession still deeply invested in the ethics of functionalism. Yamasaki's old friend Douglas Haskell wrote a largely positive piece in *Architectural Forum*, but cryptically captioned an accompanying photo "Minoru Yamasaki's romantic college hall: as dangerous as Venetian Gothic; more rewarding than gingerbread." Yamasaki's peers were less forgiving. Paul Rudolph found the "meaningless elaboration of structure" in Yamasaki's new work to be "mannerist." In *Complexity and Contradiction*, Robert Venturi called it an "architecture of symmetrical picturesqueness." Reyner Banham called it "epicene" and I. M. Pei called it "mere artistic caprice." Gordon Bunshaft later told *Time* magazine that "Yamasaki's as much of an architect as I am Napoleon. He *was* an architect, but now he's nothing but a decorator."

———

In Los Angeles one evening I was installing a sculpture in a storefront on the east side of the city. The piece was a long plywood box, my height, slightly wider than my shoulders and about twenty-four feet long. An open steel frame lifted the box off the ground and the entire wood form was wrapped in a gloss black polyethylene stretch film (a thicker and more durable variation of the material used to secure shipping pallets). I wrapped the piece dozens of times, using the full weight of my body to maintain tension in the wide roll of polyethylene while I circled the plywood armature until it was completely concealed and the piece resolved itself into a shiny, tensely textured black monolith hovering slightly above the floor on its steel base.

The gallery was just a block from the sunken concrete basin of the Los Angeles River, which also ran directly behind my studio a mile or two to the north. Every night, the same great blue heron tracked the path of the river from Vernon north to Glendale as the sun set, and I stood waiting to see him from this unfamiliar vantage point. When he appeared moments later, I immediately recognized the slow powerful strokes of his wings propelling his huge body forward through the air. As he passed out of view, I heard what sounded like a gunshot from inside the gallery. As I turned, two more loud cracks issued from within the sculpture. I did not understand what was happening until I saw a corner of the plywood box buckle under the tension of the stretch wrap. With a sequence of splintery snaps, the entire sculpture gave way, folded in on itself, slumped on its pedestal, and fell forward on the floor. The cumulative elastic force of countless polyethylene molecules pulling back together after I had gradually drawn them apart was enough to crush the plywood box like a crumpled milk carton.

The regional headquarters of the Reynolds Metal Company opened slightly later, in 1959, and came about within the context of a specific condition of the postwar economy. During the Second World War the overall production rate of raw industrial materials in the United States had increased dramatically. The aluminum industry, in particular, had quadrupled production of raw aluminum to meet the demand for military aircraft. When the war ended, aluminum producers were working to find new markets in the construction and automotive industries. Alcoa, by far the biggest manufacturer of raw aluminum, hired Harrison & Abramovitz to imagine new uses of aluminum, and in 1952 the partnership led to a thirty-story aluminum-clad headquarters in Pittsburgh—a building-sized advertisement for the versatility of aluminum. As other manufacturers began to embrace the idea of using architecture to physically demonstrate the application of novel building materials, the emerging typology came to be known as the "product building."

Reynolds commissioned Skidmore, Owings & Merrill (SOM) and Gordon Bunshaft to plan a main executive office in Virginia and invited Yamasaki to design a regional headquarters to showcase the versatility of aluminum to executives of the automotive industry in Detroit. When Yamasaki's building was dedicated in 1959, executive vice-president David Reynolds described it as "a headquarters of aluminum knowledge."

The building sits like a three-dimensional billboard on a prominent site above a highway that runs directly into the heart of the automotive industry in downtown Detroit. Every element of its design—the hexagonal louvers, the

elaborately detailed reception desk, the black anodized columns—existed, in the words of David Reynolds, to "extoll the excitement of aluminum as a versatile modern material." This excitement presented Yamasaki with a unique opportunity to short-circuit the traditional rules of modernism at a moment when he was trying to push his own work in a new direction. In a "product building" like this, the particulars of a program were secondary because the building's primary utility was to demonstrate what a material could do. The function of the building was to display aluminum, so any amount of ornament could be considered functional. Truth to material demanded versatility rather than authenticity. Throughout the project, the extravagant use of aluminum—thick and thin; perforated and solid; unfinished, painted black, and anodized gold— was never entirely decorative precisely because it was so explicitly demonstrative.

The best photographs of the Reynolds building and Yamasaki's other Midwestern projects were all taken by his friend and neighbor in Troy, the photographer Balthazar Korab, whose cinematic black-and-white photographs captured the drama and texture of late modern American architecture with an eye trained by years spent working in the offices of Le Corbusier and Eero Saarinen. For the Reynolds building, however, Korab shot on color film, and his images of the building capture the warmth of the material and the alchemy of Yamasaki's intention— aluminum becomes as refined as gold, as substantial as steel, as malleable as plastic. In one detail of the exterior colonnade the gilded rings glisten in the warm afternoon light and the clean lines of the columns are refracted among the pink water lilies in the water below. Another photograph, shot from the roof, captures the intricate pattern

of the aluminum screen organized in neat vertical bays descending toward the reflecting pool. Yamasaki clearly recognized the potential of the traditional *mashrabiya* to be simultaneously functional and decorative, and the specific pattern of his aluminum screen—two offset grids of circles—appears to be a direct quotation of the ornamental latticework at the Fatehpur Sikri palace, an early example of the incorporation of modernized Islamic motifs in his work.

———

By the time Nina and I met at the bar, I had finally managed to earn a living making art. Things were happening. A second show had done better than the first. One opportunity led to another, collectors were buying the work, then the interesting collectors were buying the work, then museums. I felt good, but I could also feel myself slipping into repetition, buckling, as I had always assured myself that I would never do, to the pressure to produce work that could sell. The objects coming out of the studio were beginning to feel less sincere, less authentically my own, and the more embedded ideas were getting thinner—diluted first by the translation of thought into material and then stretched further to accommodate a demand for pieces, to which I was not yet accustomed.

As I settled back into work again after nearly three months spent dragging waterlogged objects from basement to dumpster, I felt unsure about what to do next. I had lost interest in making objects. The materials I was accustomed to working with—rubber, concrete, glass, aluminum, plaster—felt cumbersome and the process of bringing new objects into the world seemed tedious and

unnecessary. I felt conflicted about making things that took up space and releasing them from my control only for them to end up unspeakably compromised somewhere— quarantined in climate-controlled storage or arranged among furniture in an uptown apartment. I wanted to work with a more immediate medium, something more efficient, something that is not heavy when you move it or fragile when you drop it, that does not fade in the sun or warp when it gets humid or fill your sinuses with fine particulate matter that burns the back of your throat or tear down through the skin and muscle to the bone of the second knuckle of your left index finger if you momentarily lose focus. I wanted to work with a material that could move between people without special handling or communicate an idea without taking up space. I gave myself a year to complete pieces for two upcoming exhibitions and then I would stop making objects for a while.

By the end of December, I had finished. It was as complete a body of work as I had ever made. I was happy with the sculptures and I was also happy to see them go. It was an unusually warm morning. Everything was neatly stacked in crates by the studio's freight elevator. I opened the windows and sat on the fire escape, waiting for the shippers to arrive. Beyond the expressway I could see one dusty blue tower of the Verrazzano Bridge on the horizon. When the truck arrived, I took the elevator downstairs. The younger-looking of two art handlers, a redhead wearing running shorts and a pale pink button-down several sizes too large, shook my hand. He said his name was Alamo. I introduced myself. The other guy backed the truck up into the loading dock and we rode up to get the crates. Alamo's friend was studying me as the elevator rattled back upstairs. When we stopped at my floor he said "you don't look like an artist."

For the next few weeks this comment rattled around in my head. What did an artist look like? What did I look like? The more I thought about it, the more I came to understand how I had always avoided identifying as an artist by hiding behind the figure of the architect, a complicated two-sided image I had constructed from experience and fiction— from professors and friends and characters in novels and films. I did not want to be an architect, but I felt comfortable in the archetype. It was an image that had currency in the art world at the time when I entered it, and I had used that to my advantage. It was also an easy mask for me to put on, because it is one that is still, to an astonishing degree, almost uniformly white and male and inflected by one sort of privilege or another, which is to say, it was easy for people to look at me and see an architect. If this arrangement included a degree of artifice, it was not insincere. I had studied architecture. I had worked briefly as an architect. I spoke the language. I was fascinated by what an architect was and was not, and part of the satisfaction of assuming this identity was the knowledge that it was only a mask. A real architect is stuck working in the realm of representation. She does not make buildings; she makes drawings and models and renderings and diagrams of buildings. She relinquishes control at the precise moment that idea becomes form, and I, at least until now, had been steadfast in my commitment to make objects.

There were architects I knew—my mother's high school boyfriend who gave me a summer job building basswood models, and a tall, kind friend of my father who abandoned a career as a lawyer to design houses. There were also the more famous architects, but just like the not-so-famous ones, their personalities seemed predetermined by what everyone else expected of them, by a cultural

preconception of their role and by a feedback loop of fact and fiction. Ayn Rand imagined her uncompromising *Übermensch* as an architect and based Howard Roark on an autobiography Frank Lloyd Wright mostly made up. E. L. Doctorow, knowing a compelling character when he saw one, wrote the real Stanford White into *Ragtime*. In *Light Years*, James Salter's architect, Viri, breaks down during a production of the play that lies at the foundation of all architect myths, Henrik Ibsen's *The Master Builder*. "It was like an accusation. Suddenly his life, an architect's life as in the play, seemed exposed. He was ashamed at his smallness, his grayness, his resignation." The stories tangle together into a knot. Architects are creative, but measured; passionate, but ethical; they project a righteous confidence and entitlement inflected with privilege. They are all adulterers. On the surface they are intelligent, ambitious, attractive, guided by conviction and purpose, but inside they are tortured, unfulfilled, full of conflict and shame, their good intentions distorted into something monstrous.

Cinema reinforces the architect archetype with a specificity remarkable even in a medium enamored with stock characters—Henry Fonda in *Twelve Angry Men*; Albert Finney in *Two for the Road*; Sam Waterston in *Hannah and Her Sisters*; Donald Sutherland in *Don't Look Now*; Paul Newman in *Towering Inferno*; Gabriele Ferzetti in *L'Avventura*. The only black architect in a major Hollywood film—Wesley Snipes' character Flipper Purify in Spike Lee's *Jungle Fever*—is, as his name suggests, a caricature of assimilation given a profession that signals "whiteness" (as in, nothing could be *more white* than being an architect).

These mythological architects are doomed to a tragic arc over which they have no agency. Faced with his own adulterated design, Howard Roark has no choice but

to dynamite the Cortlandt Homes. In *Hiroshima Mon Amour*, Eiji Okada plays an architect who has been conscripted into the Japanese army after the bombing of Hiroshima, and in Peter Greenaway's film *The Belly of an Architect* the fictional Stourley Kracklite throws himself off the top of the Altare della Patria—ending his life as Ibsen's master builder did, by falling from a building.

———

A flight attendant shook my shoulder. We were landing in Detroit. It was early Monday evening, and the archive would not be open again until morning. I knew from my correspondence with the archivist that there were forty-eight document boxes in Yamasaki's archive at Wayne State University. The archive was open from ten to four on weekdays and I had four full weekdays in Detroit—forty-eight boxes, four days, six hours a day. I did the math on a Delta napkin—two boxes an hour or thirty minutes a box, less enough time for a couple of trips to the bathroom on the ground floor and one trip to get coffee at the student center a block away. The contents of each box varied dramatically, I had been told, so some might take longer than others, but if I kept a pace of two boxes per hour, I would get through it all by the end of the day on Friday. I would eat a big enough complimentary hotel breakfast in the morning so that, with the exception of the early afternoon coffee run, I could work straight through until four. At four, when the archive closed, I would then take the rental car to see the dozen or so significant Yamasaki buildings in and around Detroit, which I had divided into four clusters based on geography. Research would begin tomorrow. It was late afternoon already, and by the time I got my car I had enough daylight

left to see one building. Thirty minutes later I pulled into an empty frost-heaved parking lot on the side of a highway north of downtown Detroit.

The pines and crabapples planted along Northland Drive when the Reynolds Metal Regional Headquarters opened sixty years ago were now mature trees, but the remainder of the manicured lawn, the lilacs, and the boxwoods had long since been paved over. A family of Canada geese patrolled the worn asphalt along the southern boundary of the parking lot. The slender terrazzo entrance stair had been replaced with code-compliant concrete steps and thick guardrails, and the shallow lily pond that once wrapped around the building was now filled with dirt. The windows were boarded over and a makeshift plywood door was padlocked shut.

After Reynolds Metal moved out in the 1980s, the building had been converted into a Bally's Total Fitness. The arcade of columns on the first floor was backfilled with sheetrock and tile to make locker rooms and the triple-height atrium had been cut in half, leaving the ground floor, once lit from all sides, dark and cavernous. The building was owned by the Baptist Abyssinia Church of God in Christ, but they had put it on the market after rumors surfaced that the abandoned mall across the highway might be converted into a medical complex. An online real estate listing attributed the design to "Detroit architect Minoru Tamasaki." Despite years of neglect, the aluminum rings were still in good shape. From the ground, the screen that wrapped the building had remarkable thickness and depth, but I knew from Korab's pictures that when it was lit from the inside at night, the rings, thin in profile, nearly disappear. Before I left, I chipped a small piece of terrazzo off the crumbling stair and put it in my pocket.

By the end of the first day in the archive I had made it through seven boxes. I was moving slightly slower than I had hoped, but my pace quickened when I realized that I could photograph denser or potentially redundant texts with my phone and read them later. I would be back on schedule by the end of day two. I had booked a room downtown in the Renaissance Center, a menacing seven-tower complex designed by the architect and developer John Portman that sits like a chrome citadel on the bank of the Detroit River. The Renaissance Center is the last of Portman's three massive Hyatt Hotels—along with the Peachtree Center in Atlanta and the Bonaventure in Los Angeles—infamous for accelerating the decline of American urban centers by turning their back on the city and creating their own center of gravity at the expense of the surrounding urban fabric. Years ago I had holed up in the Bonaventure for three days to finish my graduate thesis and I thought perhaps I could find a similar focus here.

My body was aching from hours hunched over the archive table. I asked the concierge where I could get a drink and she directed me to the glass cab of an express elevator with two buttons—*lobby* and *bar*. I glided swiftly up the outside of the building, looking out over the flat expanse of Windsor, Ontario. The doors opened behind me revealing a panoramic view of Detroit beyond the bar. I ordered a martini and looked out over the city—a checkerboard of densely populated blocks and abandoned lots.

The alcohol was softening the muscles in my back and I felt the building sway slightly in the wind blowing down off the Canadian prairie. Three more days and thirty-something more boxes. I knew I could come back, but this time I wanted to consume the archive in one pass, to hold all the available information in my mind simultaneously.

I ordered a hamburger with a second martini and a friend texted me a photograph of Andy Warhol on the top floor of the Hotel Pontchartrain with the Renaissance Center looming in the distance. I scanned the skyline for the window where Andy might have stood. I thought of Jonas Mekas and Warhol watching the sun set on the Empire State Building, and how they filmed *Empire* at sound speed and projected at silent speed, so it took longer to watch than it took to make.

To the east of the Pontchartrain is Yamasaki's first skyscraper, the corporate headquarters for the Michigan Consolidated Gas Company—a steel-frame tower hidden beneath a white concrete facade with narrow elongated hexagonal windows arranged into vertical bays that culminate in feathery finials at the top. At street level a double-height colonnade opens onto an elevated marble plaza with two reflecting pools—long since filled in with dirt, like those at Reynolds. The influence of Mies' Lake Shore Drive apartments on the ground floor is clear, and the astonishing likeness of the bronze nude by Giacomo Manzù standing in the larger of the two reflecting pools to Georg Kolbe's Teutonic nude for the Barcelona Pavilion betrays the depth of Mies' influence on Yamasaki's early work. Like Marcel Breuer, Walter Gropius, Louis Kahn, Paul Rudolph, and I. M. Pei, Yamasaki submitted a losing bid for the headquarters of the Canadian distiller Seagram in New York, and after Mies won the competition, Yamasaki conceded that the elder architect's building was the one building in the United States he wished he had designed himself.

Farther north I could see another building by Mies— the high-rises of Lafayette Park, a seventy-eight-acre complex of townhouses and green space arranged around two towers, rising above the trees. In 1956, after the

groundbreaking for Lafayette Park, Yamasaki invited Mies to his house for dinner. In various interviews he proudly recalls getting drunk with the world's greatest architect. I settled my tab and tried to call Nina from the glass elevator. She was already asleep.

I had spent a week alone in Yamasaki's archive and I was unsure if I knew him any better than before I arrived in Detroit. There was so much material inside those cardboard file boxes—hundreds of letters recorded on flimsy yellow transfer paper, invitations to the White House from Ford and Carter, a certificate for an intensive engineering class on aerial bombardment protection, a telegram from the St. Louis Japanese American Citizens League congratulating him on the success of Lambert, and a lenticular postcard of the twin towers rising out of the sand beside the Pyramids in Giza beneath a psychedelic moon—but the information contained within them added up to less than I had hoped. There was an intimacy that came with the smell of old newsprint, with holding the same pieces of paper this man once held or seeing the ballpoint indentation of his signature on contracts. A few personal letters gave glimpses of how friends saw him, but for the most part Yamasaki's own correspondence was perfunctory and guarded.

There are few great photographs of Yamasaki, but the handful that capture his powerfully expressive face in detail are among the most generous documents in the archive. A fresh-faced associate in suspenders, pencil in hand at an inclined drafting table. A still young-looking Yamasaki in a gray suit and gold bowtie standing between his partners Leinweber and Hellmuth behind a model of the massive Pruitt-Igoe scheme. The principal of a growing firm, confident and in control behind his desk, with the sleeves of his white shirt rolled to his elbows and a thin gold watch on his

left wrist. Then, not so many years later, an older man with ragged teeth and a gaunt face under an ill-fitting hardhat at a ribbon-cutting ceremony. From this point forward, he is nearly always pictured surrounded by lumbering businessmen and politicians—Los Angeles mayor Tom Bradley or president Lyndon Johnson—who tower over his slight frame.

Before the archive opened on the third day I went to campus early to visit the McGregor Memorial Conference Center. McGregor was named a National Historical Monument in 2015 and it has become a mascot of the resurgent local interest in Yamasaki's work. It is the most iconic of the three buildings Yamasaki designed on the Wayne State University campus, where the archive is housed, and it serves as the cover image of a photo book called *Yamasaki in Detroit: A Search for Serenity* that was the first of several recent attempts to revisit his legacy in Detroit.

McGregor photographs well but in person it is underwhelming. It feels trapped in the moment it was conceived, as if Yamasaki were trying to jam every influence and impulse from his months of travel into a single structure without a unifying vision. There are glimpses of ideas that eventually get resolved in the later projects—the interior of Robertson Hall at Princeton or the facade of the Dhahran International Airport—but they have not been worked out yet and here they fall flat. In particular, the triangle motifs of McGregor seem arbitrary and the ornament feels superfluous. The tall narrow lobby is awkwardly proportioned. The building sits on a pedestal overlooking a sunken court filled with an elaborate reflecting pool, drained in anticipation of some kind of maintenance that afternoon. The building fails to communicate the same conviction as the ideas laid out in Yamasaki's two *Architectural Forum* articles. The writing made sense in a way that little about this building did.

If there is any question about the impact Yamasaki's new direction had on his status among architectural taste-makers, his correspondence from the time makes it plain. Before 1958, Yamasaki was in active communication with critics like Bruno Zevi and Jane Jacobs and a list of peers that included Mies, Buckminster Fuller, Josep Lluís Sert, Richard Neutra, Paul Rudolph, and Philip Johnson. But by 1959 his connection to the architectural establishment appears to gradually fall off, and his correspondence is increasingly limited to clients and collaborators with an occasional letter from older friends, including Douglas Haskell, Harry Bertoia, and George Nelson. His most active correspondence from this point forward appears to be with his former employee Hayahiko Takase (Taka) and his friend and former collaborator, the Italian architect Manfredi Nicoletti, whose letters provide some of the few glimpses in the archive into Yamasaki's private thoughts.

Yamasaki was not unaware of the criticism of his new work. There is a letter in the archive from Taka, who had recently moved to New York to work for SOM, that includes something of a warning—the architects at SOM were saying that McGregor was "very beautiful, very elegant, very delicate, but not strong." In his reply to Taka, Yamasaki directly questions the validity of strength as a precondition for good architecture. He later addressed this criticism more formally in a speech to the Royal Institute of British Architects: "In America and in the rest of the world there are a few very influential architects who sincerely believe that all buildings must be 'strong.' In explaining the word 'strong' in this context, the definition seems to connote 'powerful'—that each building should be a monument to the virility of our society. These architects look with some derision upon attempts to build a friendly, more gentle kind of building."

As criticism of Yamasaki's new direction was growing, an irreverent young critic named Ada Louise Huxtable wrote in *Art in America* that "if modern architecture may be said to have already established a tradition, Yamasaki is shattering it." With remarkable sensitivity to the moment, she acknowledged how "to a generation of architects trained on doctrines of 'ornament is crime,' 'form follows function,' and 'less is more,' this is close to aesthetic transgression." Huxtable takes pains to defend a practice which, while "deliberately decorative, and among professionals, highly controversial," is also "sensitive, conscientious, exploratory, delicately sensuous, and very beautiful." Within months Huxtable would assume her post as the first full-time architecture critic at the *New York Times*, and for the next decade she would remain a stalwart supporter of Yamasaki's work.

Huxtable, however, was increasingly in a minority, for the delicacy and ornamentation of Yamasaki's work did not fit easily into the dominant narrative of American architectural history, which has generally organized itself around the central virtue of "strength." This narrative was largely the construction of architectural historians like Vincent Scully, who arranged the history of American architecture into a seamless monolithic mythology of powerful, grounded structures rising up from the earth—the Aztec pyramids at Teotihuacán, the stone skyscrapers of Chicago, and the austere concrete minimalism of Louis Kahn. While not the only story of American architecture, Scully's is a monumentally influential one. Scully taught at Yale for over sixty years and published dozens of books based on his lectures. The breadth of his influence on the architects, critics, and historians who first saw modern American architecture through his eyes is formidable.

Scully's lectures were the first architectural history courses I ever took, and I have felt at times as though the entirety of my architectural education was built on the foundation of his worldview, not only because he taught me, but because he taught so many of the people who wrote the books I read or taught the courses I took. Scully, nearly eighty by the time I encountered him, with ruffled gray hair and tattered tweed, was the physical embodiment of patriarchal professorial knowledge. He would stand before an enormous auditorium filled to capacity with students and bombard us with a syncopated sequence of side-by-side images cast on the screen behind him from dual slide projectors. Each lecture began quietly on a solid historical footing—the Acropolis or a Pueblo village—and built gradually through a progression of steps so deliberate that they felt not only logical but inevitable. He would bang his broomstick pointer on the floor emphatically or clench the dais and fight back tears as the lecture reached its inevitable crescendo, advancing images by shouting "slide" at the graduate student in the projection booth like a sea captain barking orders at his crew. His delivery transformed the loose threads of architectural history, embroidered with references to art and literature, into matters of thrilling political and intellectual urgency.

Like any academic canon, Scully's chronology tells a story, but it is also just a story and one that, favoring cohesiveness over completeness, puts undue emphasis on certain accomplishments while omitting others entirely. Despite their shared interest in the architectural virtues of empathy and democracy, Yamasaki did not fit into the story Scully was trying to tell, so he was largely erased from it. Scully dismissed the McGregor Conference Center as a "twittering aviary" and largely ignored everything that

came after it. The more time I spent with the work, the more I understood the extent to which I had to unlearn Scully's particular version of history before I could even begin to look at Yamasaki objectively. Yamasaki's marginalization was not entirely Scully's doing, but the idea of "strength," deployed in the context of a history that exists almost exclusively within highly coded spaces of privilege, whiteness, and masculinity, inevitably carries the associations of all of its implied opposites. If a building is not strong, it is, by implication, frivolous, spindly, decorative, feminine, weak, mannered, exotic, or queer.

———

Yamasaki's exposure to Japanese architecture while working in Kobe had a profound influence on his own practice. It was a moment when many Western architects were traveling to Japan for the first time, eager to witness first-hand an architectural tradition that seemed so clearly to anticipate European modernism. Yamasaki had been to Japan before, but this time the experience resonated at a more personal level. He describes one encounter, with an exquisitely detailed and carefully composed dining room in a Tokyo restaurant, with particular emotional intensity. Reflecting on the time he spent in Japan, Yamasaki later wrote, "everyone has a complex. It took the ulcer to show me what mine was—that I was Japanese." It was an experience, he recalled, that "you don't recover from, especially when you feel a part of it."

Though the trip may have reframed Yamasaki's relationship to his ancestral home, the experience did not provide simple answers. One of the few contexts in which he expresses his feelings on the topic is in the notes for

an essay to be titled "Bread and Rice Grains" in which he directly criticized his fellow Nisei, whom he saw as burdened by a self-imposed inferiority complex that too often left them content to live a "parasitic existence" in menial positions with no opportunity for upward mobility. He detected a sense of resignation beneath a word he heard so often growing up—*shikataganai*, "it can't be helped." The essay was never published, but the drafts give a sense of how Yamasaki envisioned himself in relationship to a generation of peers who, in their struggle to survive at a basic level, had lost the "understanding of progressive civilization" that he considered to be "the very essence of that which makes the Japanese people superior in many ways to others of this world." He compares the compromises too often made by his fellow Nisei to "tasting the skin of the fruit without delving into the richness within."

Despite his appreciation for Japanese culture, Yamasaki remained distant from his professional peers in Japan. While the American construction industry was booming after the war, Japanese architects found themselves faced with a monumental reconstruction project. Japan's urban centers had been decimated by the American military. In a single two-day firebombing campaign, the US Air Force destroyed sixteen square miles of Tokyo and killed an estimated 100,000 civilians, to say nothing of the immeasurable impact of the atomic bombs detonated over Hiroshima and Nagasaki the following summer. All told, over a hundred square miles of urban infrastructure were destroyed. And yet the scale of this tabula rasa meant that architecture in postwar Japan was characterized by a powerful sense of ambition, even daring, perhaps best represented by the nascent metabolist movement and its central figure, Kenzo Tange. In 1960— the year the metabolists presented speculative designs for

an extension to Tokyo over its bay—Tange and his associates invited Yamasaki to the World Design Conference in Tokyo, along with Louis Kahn, Paul Rudolph, Jean Prouvé, Alison and Peter Smithson, and Bruno Munari. The context might seem to have presented a natural opportunity for Yamasaki—an energetic exploration of a more humane future of architecture based around the problems related to the rebuilding of Japan—but he appears to have made little effort to maintain the connection. In one image of a panel at the conference, Yamasaki looks impatient and bored. After the Kobe consulate was finished in 1962, Yamasaki did not design another building in Japan for twenty-four years.

———

432 Park's four-thousand-square-foot model apartment, fitted out while the rest of the building was still being completed, was decorated with a gold leaf Yves Klein coffee table and an Ellsworth Kelly painting. A glossy large-format magazine, produced to advertise the project, included a rendering of another apartment furnished with Eileen Gray's legendary lacquer Dragons armchair that made headlines when it sold for over $28 million in an auction of Yves Saint Laurent's personal collection. The tower's selling point is not market value but *symbolic value*, that illusive (and elusive) quality that defies economic logic. It is a boutique minimalism, steeped in the codes of art and fashion with cues designed to communicate to the buyer that an object exists in a space beyond price.

In her 1989 essay "Room at the Top? Sexism and the Star System in Architecture," Denise Scott Brown lamented that "Postmodernism did change the views of architects, but not in the way that I had hoped. Architects lost their

social concern; the architect as macho revolutionary was succeeded by the architect as *dernier cri* of the art world; the cult of personality increased. This made things worse for women because, in architecture, the *dernier cri* is as male as the prima donna." Despite the contributions of other designers to the project, Viñoly is 432 Park's soft-spoken prima donna—a trained concert pianist turned architect with a boyish face under a mess of white hair and bushy gray eyebrows. With offices all over the world, he performs the role of international architect with unironic aplomb. He wears thickly rimmed glasses and keeps two (sometimes three) additional pairs either propped on his head or strung around his neck in what has become his sartorial signature—in a recent interview with the "How to Spend It" section of the *Financial Times*, Viñoly describes the multiple pairs of Lunor glasses as his "personal style signifier." A recent print advertisement for a forthcoming Viñoly project read simply, "Raphael Viñoly in Miami," alongside a black-and-white illustration of five pairs of glasses. The glasses are the brand. Le Corbusier wore custom Bonnets, Philip Johnson wore custom Cartiers, and Viñoly triples down on the trope of the bespectacled architect with a playful absurdity that would be funny (the visionary needs trifocals) if it weren't so arrogant.

—

Migraines generally manifest in four distinct phases—the prodrome, the attack proper, the resolution, and the postdrome. In *Migraine*, Oliver Sacks diagrams these phases as four quadrants of a circle over which the headache progresses, counterclockwise, like a system of weather orbiting the center of a circular map. The headache begins

in the upper left quadrant, the prodrome. This is the period leading up to the headache when the sufferer of a classic migraine would experience the visual aura, but aura is by no means the only prodromal symptom. Others may include intense drowsiness, rage or elation, stiffness, and a hypersensitivity to smell or noise. Not infrequently, people with migraine lose fundamental language skills just prior to or during an attack or experience a general sense of excitation of foreboding. George Eliot allegedly felt "dangerously well" the day before her attacks, while the pioneer of migraine research, Emil Heinrich du Bois-Reymond, described a symptom more consistent with Nina's experience—a "general feeling of disorder."

The beginning of a migraine is the only time medication will help. "Once an attack is under way," Didion explains, "no drug touches it." When a headache transitions from the prodrome into the "attack proper"—the unilateral, relentless headache that can last four to seventy-two hours—medication is more or less useless. In addition to the headache, the attack proper might include an excruciating oversensitivity to sensory stimuli, nausea, and vomiting. This phase is generally characterized not by excitation but by apathy, malaise, melancholy, or fatigue. In Sacks' circular diagram, the progression from prodrome to attack proper is marked by the passage from the upper hemisphere of "restless agitation" to the lower hemisphere of "lethargic stupor."

The "resolution," the bottom right quadrant, is the constellation of symptoms that occur once the acute headache has passed. In Nina's case, this is usually characterized by a morbidly deep sleep. The final phase of the headache, following this state of resolution, is the "rebound," defined by a feeling of alertness, renewed energy, and great physical

well-being. In his 1873 book *On Megrim*, the English physician Edward Liveing compared the rebound to a rebirth in which the patient "awakes a different being." When the pain recedes, Didion writes, "everything goes with it, all the hidden resentments, all the vain anxieties. The migraine has acted as a circuit breaker, and the fuses have emerged intact. There is a pleasant convalescent euphoria."

I had started going to neurologist appointments with Nina in the hope of understanding more about her headaches. The cause of a migraine is not so much a single catalyst as an accumulation of lesser triggers that combine to push the brain over a threshold. Self-help books on the subject, of which there are multitudes, like to use the metaphor of a boat trying to stay afloat. If you put one or two weights—a drop in blood sugar, a spike in blood sugar, stress, a hangover, fatigue, hormonal fluctuation, noise, heat, light, dehydration—in the boat, it stays afloat, but if you start adding additional weights at the same time, the cumulative burden sinks the ship. This is one of the reasons migraines are so difficult to treat. There is no single trigger, no single causal agent that leads to a headache, but rather a spectrum of stimuli and conditions that can combine in infinite permutations. A medical system such as ours, focused on linear causality, is frustratingly ill-equipped to address a condition of such complex origination. Too often, this institutional shortcoming leaves the migraine sufferer with the sense that their pain is not being taken seriously, a legitimacy deficit compounded by the fact that migraines affect nearly three times as many women as men and so fall within the broad continuum of medical phenomena under-recognized and underresearched by a male-dominated profession that has historically dismissed symptoms associated with the condition as psychosomatic or hysterical.

Nina's neurologist at the time was a migraine special-
ist at an uptown hospital, and most of our meetings were
spent huddled around his crowded desk talking in circles
about causation. "Nina gets a migraine every time there
is a dramatic change in barometric pressure," I would say.
"That's impossible, no correlation," he would respond. But
I knew that I was right (that Nina was right)—I had been
there a hundred times when the weather changed and
a headache followed. Those rainless, impossibly humid
summer evenings when the heat builds until sunset and
the low-hanging clouds glow magenta as if lit from below
by the smoldering asphalt. Those days are a headache
every time. I offered a further theory about a spike in head-
aches around full moons and he laughed in my face.

The exact physiological error that causes migraines has
confounded doctors for centuries and the science remains
inconclusive. Historical treatments for migraine include
the application of earthworms, bloodletting, trepanning,
and cranial surgery. When Didion wrote "In Bed," the most
common migraine treatment was methysergide—a deriv-
ative of LSD that was accidentally discovered by a young
chemist named Albert Hofmann after a psychedelic bicy-
cle trip through the streets of Basel in 1943. Today, the most
basic treatments are simple analgesics (anti-inflammatory
drugs like acetaminophen, ibuprofen, aspirin) and caffeine.
These have no effect on Nina's headaches—nor do alter-
native therapies like acupuncture, Botox, magnesium,
or marijuana. The most sophisticated pharmaceutical
approach is a class of drugs called triptans, derived from
methysergide, which treat both pain and nausea with fewer
side effects. When a triptan is combined with naproxen in
a time-release pill, it works better, but it can also increase
the frequency of headaches at an alarming rate.

One of the particular cruelties of migraine is the phenomenon known as the rebound headache. While triptans and analgesics can provide relief, they often carry the collateral risk of a future headache, so treatment can feel more like a deferral than a cure. The choice of when and whether to medicate is tied up in this double bind— if you wait too long to take medicine, it does not work, but if you take it too early, it can cause a more severe headache later. In other words, once the treatment cycle begins, the symptoms of withdrawal from the medicine become indistinguishable from the condition the medicine was intended to cure.

———

As Yamasaki continued to push back against the monoculture of late modernism, critics began to position his new work, along with that of contemporaries including Stone, Welton Becket, and Philip Johnson, under the category of New Formalism. It was a pejorative rubric, associated within certain typologies—airports, cultural centers, and embassies—the scale and financing of which were often connected to large government-sponsored projects that had to answer, at least superficially, to public opinion and were thus inclined toward a more populist vernacular. The best examples of the style are the large civic and cultural centers of the 1960s, such as Becket's Dorothy Chandler Pavilion in Los Angeles and Wallace Harrison's master plan for Lincoln Center in New York, both of which sit above street level on raised platforms with large public plazas and stretched slender colonnades that open onto opulent chandeliered lobbies. New Formalism was regarded, if never directly labeled by the architectural establishment,

as tacky and bourgeois, all glitz and no substance. Henry-Russell Hitchcock alluded to a strain of architecture that was "dainty and feminine." Reyner Banham called it the "Ballet School."

The most infamous example of New Formalism may be Edward Durell Stone's Kennedy Center in Washington, a design so reviled by Jacqueline Onassis that she called Yamasaki personally before it was built to ask if he would come on board to help improve the initial plans. When he declined, wary of interfering with a colleague's process, Jackie was furious, but the project proceeded without his intervention. When it was finished, Ada Louise Huxtable described it as "a national tragedy, a cross between a concrete candy box and a marble sarcophagus in which the art of architecture lies buried."

Like many of his fellow New Formalists, who found themselves marginalized in the American architectural world, Yamasaki's best commissions increasingly came from oversees. When he received the first of several major projects in Saudi Arabia, Dhahran was little more than a sand-swept desert outpost on the Persian Gulf, and the company headquartered there, Aramco (the joint venture between Standard Oil of California and the Saudi government), was still a relatively small operation. In hopes of maintaining a strategic Cold War outpost on the peninsula, the US government donated military training and an airport facility, to be designed by Yamasaki, to the Saudi government in exchange for the extended lease of adjacent land for a US Air Force base.

Yamasaki designed the airport with a clean white facade composed of a system of interlocking pointed arches reminiscent of another of his favorite buildings, the Jāmeh in Esfahān. The composition incorporated traditional Arabic

tracery and tentlike volumes that evoked the country's nomadic past, but it was defiantly modern—a combination of ornamental surface treatment and modernist form that would become a signature both of Yamasaki's future work and of the emerging style of the Saudi royal family, who were just embarking on an era of prolific nation-building. King Ibn Saud considered the finished structure "the only building in the country that looked like a Saudi building," and it became a symbol around which a nation that was struggling to define its international identity could build an architectural sense of self. The king's sons, King Faisal and King Khalid, sanctified that symbol by printing a rendering of its facade on Saudi one-riyal and five-riyal notes that remained in circulation for nearly twenty years. The airport was the first of many buildings Yamasaki would design for the Saudi government (a partnership that also lies at the foundation of a pernicious theory that Osama Bin Laden singled out Yamasaki's World Trade Center not only as a monument to Western capitalism, but also as an anathema and a false idol because of its attempt to synthesize modernism and Islamic influences).

The Dhahran Airport earned Yamasaki his fourth AIA honor award in eight years, outpacing rivals like Saarinen and SOM and bolstering the international profile of the firm. Minoru Yamasaki & Associates was a diverse group of about fifty employees working on the second floor of a nondescript brick building in suburban Detroit. Inside, the office was simple but pristine, with bare walls, a carpeted floor, and a line of white models arranged on a long table extending down the center of the room. Though he kept his own office, Yamasaki remained actively involved in all projects and insisted on signing off personally on every drawing that left the office. He called everyone who

worked for him by their first name and preferred that they call him Yama. He was by all accounts a tough boss, but a gentle and generous man. His former engineer Henry Guthard recalled the particular "style and grace" with which Yamasaki moved. "You could see when he was thinking or trying to come up with an answer that wouldn't hurt someone's feelings."

Despite the firm's successes, the work was taking a toll on Yamasaki's personal life. In June 1961 Minoru and Teri divorced. Less than a month later he married Peggy Watty, a young hospital administrator from California, whom the *Detroit Free Press* described as "a slim fine-featured blonde" in an article announcing the marriage. There is nothing in his papers to suggest a reason for the separation, though in a newspaper profile years later Teri told an interviewer that "a celebrated man must be superhuman to withstand the tremendous adulation." Balthazar Korab put it more bluntly: "now Yama is big enough that he could get everything he could not get before."

Yamasaki's marriage to Peggy Watty would last only two years. On a trip to Japan shortly after the divorce he met and married a Japanese woman about whom little is known. She returned to Detroit with him, but that relationship seems to have soon collapsed as well. It is at these moments of what must have been incredible emotional upheaval that the opacity of Yamasaki's archive, which offers nothing to suggest how his turbulent romantic life might have impacted him personally, is most frustrating.

———

I was at home in Los Angeles when a representative of the as-yet-unbuilt National September 11 Memorial & Museum contacted my gallery about using one of the photographs I had taken on the morning of September 11, 2001. I wondered where they had seen the images. I had only allowed them to be printed once, in a compilation of psychoanalytical essays about terrorism and war for which I had written an introduction and which, until that morning, I assumed only a handful of people had actually read. The persistence of whoever traced the photographs back to the gallery was admirable, but I still felt nervous about putting the images back into circulation. In the end I agreed because the honorarium would cover the cost of having the negatives scanned— a task I had put off for nearly a decade. The film had originally been developed at a Rite Aid because it was the only place open, and I had been meaning to transfer the negatives to a more archival platform ever since (it was only a matter of time before the cheap drugstore processing chemicals deteriorated). I had avoided these photographs for the same reason that I avoided most discussions of what Joseph O'Neil refers to in his novel *Netherland* as "the events synonymous with September 11, 2001"—I was unsure how to reconcile the public fact of what had happened that morning with the role it played in my own personal narrative. By avoiding the subject, I could avoid the absurdity of laying claim to the single most significant global event of the new century as something that also felt so intimate and so intensely my own. I did not get hurt and my ties to those who did were tenuous and remote enough that I felt a certain guilt about acknowledging the undeniable way in which my seemingly chance proximity to the towers that morning—at moments only an arm's length from the aluminum facade—fundamentally altered the trajectory of everything that followed.

79

The kid working at the Rite Aid told me I should sell the photographs to the *New York Post* as he handed them across the counter. I had not even seen them yet, but soon everyone I showed them to told me I should sell them to the *Post*. I decided I would only give the museum one photo. The honorarium for one would be more than enough to scan everything, so I signed the release and immediately regretted the decision.

I took exactly seventy-three photographs that morning and only the first two were particularly remarkable. I had a 35mm camera in my bag. I did not own a digital camera yet, and it would be another year or so before most cell phones, including my Nokia, would feature a built-in camera. I took the first photograph, the one that is now in the museum, as I stood on the stoop of my apartment building on Greenwich Street. It is a picture of a crumpled piece of paper burning on the street next to an unfolded cardboard compact disc case, some broken bits of acoustical ceiling panel, a piece of string, a few paper napkins, and a US passport.

I took the second photograph six minutes later and two blocks further north. From that vantage point, about a hundred feet south of the plaza, the view of the North Tower was completely obstructed by the South Tower, so that all I could see was a plume of smoke rising between the buildings. As I used the camera lens to zoom in on the southeast corner of the South Tower, the second plane hit the south facade just outside the camera's field of vision. I never saw the plane. The photograph shows the upper midsection of the building in sharp three-point perspective against a clear cobalt sky. The south facade, receding more acutely to the left, is in shadow, while the early morning sun lights the east facade. Three massive explosions project perpendicularly from the south, north, and east facades of the

tower—three distinct vectors of cadmium orange fire, gray smoke, and pulverized debris that look more like cinematic pyrotechnics than anything real.

I have no recollection of the impact making any sound, but I distinctly remember a wave of heat passing over my face followed by a compression in my stomach. I knelt behind a white van and put a new roll of film in the camera. The sky was full of sheets of white office paper suspended in the air like plastic flakes inside a snow globe. The event as we now know it was not yet a complete thought. I got a cup of coffee and started walking uptown. My shoes cut the back of my heel, so I took them off and walked barefoot on the cobblestones along Mercer Street. I turned my phone off and on again— on the screen, a pixelated hourglass spun in search of a signal. I was just below Houston Street when the North Tower collapsed on itself. I withdrew as much cash as the ATM would allow, bought a bottle of water, and continued walking north.

———

Our daughter Zoe was conceived on a spring afternoon before Nina left for a work trip to Oslo. Nina was worried about airport traffic, but I convinced her she had time to spare. We had had rushed, practical sex on the couch with the din of Chinatown outside the open windows and the late afternoon sun raking across the living room wall. Nina left and I fell asleep. When I woke up it was dark. I was still splitting my time between California and New York and this was the first time I had been alone in her apartment at night. My shirts were still hanging in the guest room closet and Nina's cat was asleep in my half-unpacked suitcase. Everything I owned, other than these clothes and a few books, was still in moving boxes at the studio.

Before I ever set foot in this apartment, I had assembled an image of it in my mind with fragments from months of phone conversations—the movement of a siren past a window, the direction of a door buzzer, or the number of footsteps from couch to kitchen, kitchen to bedroom. I got it all wrong. I had placed the door, the cardinal point of every New York apartment, in exactly the wrong place. It was a newer building with a clean, pine wood floor, not the yellowed prewar parquet I had imagined. There was art, leaning, not hung on the walls, some still wrapped in plastic. There were beautiful clothes and books, but there was a carelessness to it all—unopened mail, unwatered plants, little dishes full of crumpled euros and paperclips and keys. There was something about the disorder of the place that felt at odds with the poise Nina presented to the world. Everything about my relationship to this apartment was provisional. This did not seem like her space, much less our space, yet there was something about Nina that made me feel, whenever we were together and even when we were not, as though I was exactly where I was supposed to be, doing exactly what I was supposed to be doing.

———

In 1798 a yellow fever epidemic killed nearly two percent of New York City's population. No one knew the cause of the outbreak, but Aaron Burr, the former senator and future vice-president, took the opportunity to found the Manhattan Company with the ostensible aim of bringing fresh water from the Bronx River to Lower Manhattan through a network of primitive wooden pipes made of hollowed-out pine trunks. At the time, the formation of a bank required an act of the state legislature and Burr, in

an attempt to compete with his Federalist rival Alexander Hamilton's Bank of New York, surreptitiously inserted language into the charter for the water venture that would allow the company to "employ surplus capital" in "any monied transactions or operations." With the leeway afforded by the charter, Burr was able to turn the company into a bank (as he had always intended) and he soon abandoned the water utility entirely, leaving in place a dysfunctional monopoly that complicated the city's efforts to build its own system for decades.

A century and a half later the Manhattan Company merged with Chase National Bank, which had in turn merged with John D. Rockefeller Jr.'s Equitable Trust Company, to form what is now Chase Manhattan—the bank Robert Caro described in *The Power Broker* as "the principal twentieth-century repository and instrument of the wealth and power of the nineteenth century Standard Oil robber baron." The new bank's logo—the ubiquitous royal blue octagon with a square center designed by Chermayeff & Geismar—was based on the cross-section of the primitive wood water pipes used by Burr's original company. The octagon, widely considered to be one of the first abstract corporate logos, was in fact a direct reference to a failed bit of plumbing.

———

The island of Manhattan is built on three strata of course metamorphic bedrock—Manhattan schist, Inwood marble, and Fordham gneiss—that run north to south along the island's cetacean spine. The bedrock abruptly dips several hundred feet below ground just south of Washington Square before rising again near Chambers Street. These

geological contours account for the gap between the skyscrapers clustered in Midtown and Downtown, because tall buildings must be anchored on solid bedrock rather than on the glacial till that fills the valley between. In *A Practice for Everyday Life*, Michel de Certeau describes this wave of verticals as a sea in the middle of the sea, that "lifts up the skyscrapers over Wall Street, sinks down at Greenwich, then rises again to the crests of Midtown, quietly passes over Central Park, and finally undulates off into the distance beyond Harlem."

In 1955, David Rockefeller was Chase's executive vice president of planning and development. A gradual exodus of white-collar workers from Wall Street office buildings to Midtown landmarks like the Chrysler and Empire State buildings posed a problem for the Rockefeller family and the bank, which had significant real estate holdings in the financial district. On a February morning, real estate developer and family friend William Zeckendorf offered Rockefeller a ride to work, during which he proposed a plan to bolster the value of the bank's downtown properties with the construction of a spectacular new headquarters. Zeckendorf called his proposal—which involved an intricate sequence of sales, transfers, acquisitions, and demolitions within a tight tangle of downtown blocks—the "Wall Street Maneuver."

To execute the maneuver, Rockefeller needed the support of another family friend, Robert Moses, who, in his capacity as the New York City Planning Commissioner, was the only man who could grant permission to permanently remove one block of Cedar Street, above which David would ultimately build One Chase Manhattan Plaza, Gordon Bunshaft's sleek International Style tower. Moses promised his support (in exchange for Chase's support of

his proposed Lower Manhattan Expressway) but warned Rockefeller that the long-term viability of downtown real estate would require a project of even larger proportions. In 1956, on Moses' recommendation, Rockefeller founded the Downtown-Lower Manhattan Association—a consortium of executive stakeholders—to devise a plan to stop the "slow economic strangulation" of Lower Manhattan. The association asked Skidmore, Owings & Merrill to draw up a preliminary plan for a "World Trade and Financial Center" and hired the consulting firm McKinsey to do a feasibility study. When McKinsey concluded that the proposed project would almost certainly fail, Rockefeller ordered his aides to bury the report and pushed on, emboldened by his brother Nelson's election as governor.

At a small press conference in January 1960, David Rockefeller formally announced a revised SOM plan for a massive "World Trade Center" near the Fulton Fish Market on the East River, and the Downtown-Lower Manhattan Association recommended that the Port Authority do a feasibility study. With an uncharacteristic flourish, Rockefeller coined the term "catalytic bigness" to define the project's intended public purpose—to be deployed like an economic defibrillator with a shock of sufficient magnitude to alter the course of development in Lower Manhattan forever.

In the manuscript of a book that would be published the following year, Jane Jacobs dismissed the preliminary plans for the Trade Center as an act of "vandalism" against the authentic character—"the tumbled towers and jumbled jaggedness"—of Lower Manhattan. This is the only mention of the project in *The Death and Life of Great American Cities*, but there are inauspicious echoes of Rockefeller's catalytic bigness in Jacobs' admonition of the

dangers of cataclysmic money, which pours "into an area in concentrated form, producing drastic changes," but sends "relatively few trickles into localities not treated to cataclysm." Cataclysmic money, Jacobs warned, behaves "not like irrigation systems, bringing life-giving streams to feed steady, continual growth," but rather like "manifestations of malevolent climates beyond the control of man—affording either searing droughts or torrential, eroding floods."

———

Just weeks after Rockefeller's press conference, Jean Tinguely's self-destroying sculpture *Homage to New York* gave its first and only performance to a live audience in the MoMA sculpture garden. Nelson Rockefeller, then both governor of the state and president of the museum, held court in the garden named for his mother as the unwieldy, twenty-seven-foot-tall assemblage of scrap metal, deconstructed musical instruments, and bicycle parts spun into a maelstrom of smoke, paint, and broken glass. A crudely automated saw attempted to cut a radio in half, a meteorological balloon inflated and burst, radios broadcast static, automated arms hammered notes on a dismembered piano, and a mechanized brush scratched out paintings like an erratic electrocardiogram. In the middle of it all, Tinguely, fire extinguisher in hand, crouched beneath his *méta-mécanique* like a mischievous lionkeeper.

Only a few singed fragments of *Homage* remain—among them a small cart fitted with a motor and a klaxon horn and a spring-and-gunpowder-loaded *Money Thrower* contributed by Robert Rauschenberg—but pieces of film footage captured by D. A. Pennebaker and an NBC camera crew show the machine heaving and lurching and

bursting into flames in front of an adoring audience, until the fire marshal intervenes and ends the performance after twenty-seven minutes.

—

Like Moses' Triborough Bridge Authority, the Port Authority of New York and New Jersey was a quasi-governmental "public benefit corporation" that presided over nearly every piece of trade-related infrastructure that fell under its jurisdiction, which was poetically, if arbitrarily, defined by a circle drawn on a map with a twenty-five-mile radius around the Statue of Liberty. In addition to its influence and expertise, Rockefeller needed the Port Authority for two key reasons. First, the authority had access to far more capital than the city because it was able to issue its own revenue bonds, guaranteed with income from tolls and fees rather than from taxes. Second, it possessed, thanks to Title I of the Housing Act, the power to circumvent city building codes and public review processes and to seize property by eminent domain for any project that could be justified as serving a "public purpose."

The Port Authority was run by Austin Tobin, a savvy former real estate lawyer with a reputation for ruthless, often autocratic efficiency, who had recently outmaneuvered Moses for control of New York City's airports. Tobin lacked Moses' charisma, but he was no less ambitious, and although he was initially suspicious of what appeared to be a speculative real estate venture, he needed a new high-profile project to put the authority's extra capital to work before state legislatures could redirect it to mass transit as they had long hoped to do. If Tobin could justify it as trade-related, the Port Authority would build it.

The authority partnered with a "genius committee" comprised of Edward Durell Stone, Gordon Bunshaft, and Wallace Harrison to produce a revised plan that was presented to the mayor and the governors of New York and New Jersey in the spring of 1961, the same year David Rockefeller became president of Chase. Nelson's endorsement was a fait accompli (he had already begun stacking the Port Authority board with friends and political allies in Albany), but New Jersey Governor Robert Meyner rejected the proposal on the grounds that it had little to offer his constituents.

The project lay dormant for six months until the Port Authority secured the support of New Jersey's newly elected governor Richard Hughes by agreeing to take over the failing Hudson & Manhattan Railroad and moving the project to the West Side to serve as a transit hub for New Jersey commuters. When the plan was approved in early 1962, Tobin created a World Trade Department within the Port Authority and named Guy Tozzoli, a brusque military engineer and construction expert who had worked for both Moses and Tobin, as its head. For reasons that are not entirely clear, but suggest a desire to move away from architects known for their loyalty to the Rockefeller family, the Port Authority decided not to proceed with the genius committee, and the task of selecting an architect was entrusted to a newly formed search committee.

The candidates included I. M. Pei, Philip Johnson, Welton Becket, The Architects Collaborative/Walter Gropius, Carson, Lundin & Shaw, Kelly & Gruzen, Ely Kahn & Robert Jacobs, and Minoru Yamasaki. It is an odd list, a jumble of established masters and younger firms that suggests the conflicting desires of the various parties involved. It was also a list in which Mies was conspicuous

by his absence. He was excluded because of his advanced age—the Port Authority feared that he would not live long enough to see the project through, and they were right.

Yamasaki was working on the Science Pavilion at the 1962 Seattle World's Fair, less than two miles north of the tenement where he was born, when he received the letter formally inviting him to participate in the competition. In his autobiography, he remembers mocking the Port Authority for adding a seventh zero to the $280,000,000 projected budget before being informed over the phone that it was not a typo. He knew that the project was too big for his office and that undertaking it was a gamble, but, as he would tell *Time* magazine a year later, he recognized a "once-in-two-lifetimes" opportunity to prove himself on the world's biggest stage.

As the proposal process moved forward, I. M. Pei withdrew for unknown reasons and Philip Johnson was dismissed for a lack of experience with large-scale projects. Gropius, by many accounts an early frontrunner, fell out of contention because his office appeared to be overcommitted. Among the remaining (and considerably lower-profile) firms, he had a favorite. While he was working for Moses, Tozzoli had been sent to visit the Seattle World's Fair, where he was singularly impressed by the way Yamasaki's Science Pavilion conveyed a sense of "warmth and human scale so rarely found in modern architecture."

While Yamasaki may have seemed an unlikely choice in a field of better-known architects, Tobin and Tozzoli were looking for something specific. They did not want a masterpiece, they wanted a pragmatic, popular building designed by an architect with whom they could work. Tobin and Tozzoli saw in Yamasaki an appetite for grand achievement balanced with accessible appeal and a reputation for

working well with clients. In the context of the World Trade Center competition, the fact that Yamasaki was perceived as existing on the margins of the architectural establishment likely worked in his favor. While Yamasaki had been maligned by his peers for the populism of his recent work, it was precisely that ability to resonate with a public that positioned him perfectly to get the most important commission of his career. As his former employer and genius committee member Wallace Harrison would later tell a reporter, Yamasaki "understood what people need in architecture."

Minoru Yamasaki & Associates was officially offered the job in September 1962, and the firm expanded to eighty people to manage the workload. As associate architect, the Port Authority chose Emery Roth & Sons, a firm known for churning out prolific amounts of cheap, practical New York office space. Not intending to be a passive client, the authority also added its own team of architects and engineers under the supervision of Tozzoli's chief aide, Mal Levy. The structural engineering job went to Worthington, Skilling, Helle & Jackson—an innovative young engineering firm that had worked closely with Yamasaki on his IBM Building in Seattle—despite the fact that they had never designed a building over twenty-two stories.

———

In the weeks following September 11, everything below Canal Street was cordoned off. Residents were allowed to return to the restricted area only long enough to retrieve essential items—passports, prescription medicine, glasses, pets. A member of the National Guard was ordered to accompany each resident at all times. No exceptions. Proof of address

was required to cross the cordon sanitaire. Two months earlier, my roommates and I had found a cheap apartment a block and a half south of the World Trade Center above a lunchtime topless bar called the Pussycat Lounge. The apartment had two large windows that looked out onto a gray wall of HVAC units servicing the building across the street. During their lunch break on Fridays, a group of analysts from Deutsche Bank in slacks and running shoes would barricade the block at both ends with traffic cones and bet on which of their colleagues could beat the other in a footrace. At night the streets were empty for blocks in every direction. It was a miserable apartment, but we were thrilled by the immediacy of living in Manhattan. I had not been in residence long enough to have a utility bill in my name, but I managed to talk my way through the cordon with a paycheck that had been forwarded to the new address.

My roommate and his boyfriend had been to the apartment the day before and reported that the procedure was relatively straightforward. A large National Guardsman had escorted them in and waited patiently while they collected their things. The power was out, but they offered him a warm beer from the refrigerator, and he responded flatly, "Thanks, but if I have one, I'll want to drink six." Then he escorted them out. The whole process took about an hour.

When I entered, everything in the apartment was covered in a thick layer of powdery ash. My National Guardsman's name was Harris. He was from Buffalo and at least four inches taller than me, bearded and broad-shouldered. He was holding an M16 with the butt held tight to his right shoulder and the nozzle pointed groundward on his left hip. His fatigues were the old standard-issue woodland camouflage pattern (the pixelated, Gulf War-era version had not been put into circulation yet).

The ash nearer to the front of the apartment was rough, full of torn bits of paper—faxes, interoffice memos, expense reports—blown in through the two windows we had left open that morning. Harris stood quietly as I looked for my passport. Deeper inside the apartment the dust was finer. There were a few fingerprints and the perfect rectangular outlines of books removed by my roommates the day before. I offered Harris a warm beer and he replied, "If I have one, I'll want to drink six."

The acrid air that hung over the neighborhood smelled both natural and industrial, organic and synthetic—the smoldering remains of fax machines, gold ingots, floor wax, teeth, ashtrays, water coolers, suitcases, umbrellas, fire extinguishers, doorknobs, hair, subway cars, asbestos, glass, mops, elevators, running shoes, paperclips, smoke detectors, landing gear, filing cabinets, seatbelts, newspapers, jet fuel, extension cords, fingernails, steel.

Harris had not had a break in seven days, he told me, seven back-to-back twelve-hour shifts. Tonight, he had a night off. He had never been to the city. What are you going to do, I asked? I was rifling through another drawer looking for my passport when Harris asked haltingly if I could recommend a gay bar. I could tell from his tone he was anxious about the question and he waited nervously for my reply. I removed a subway map from a kitchen drawer and circled a broad swath of Chelsea and the West Village, figuring that anything more specific might not be what he was looking for. I marked a few more places on the East Side. I knew whatever I came up with would be better than anything he was going to get from the guys milling around the roadblock. I found my passport and we headed back down to the street.

—

Zoe was born on a cold clear February morning. The streets were pebbled with salt laid down in anticipation of a snow that never came. At home Zoe was a restless sleeper, but down on the street, strapped to my chest with a long loop of fabric, she would sleep for as long as I could walk. We covered miles together like this, on the empty early morning streets of Lower Manhattan. Our block was among the densest in the world when Nina's ancestors first arrived here from Lithuania. When she told her grandfather that this was where she planned to live, he laughed. "We spent so many years trying to get out of the Lower East Side and now you are moving back in."

As it got warmer, our walks got longer, stretching up into the park that lines the embankment of the East River. As we passed the power plant at the bend in the river, we could see the concrete column of 432 Park rising over Midtown, squares of orange safety netting filling the unglazed windows. The pace of its construction became a marker against which I measured the passage of time. Elsewhere in the city, I watched from street corners and car windows as it climbed from floor to floor. I scrolled through the social media accounts of the steel workers and electricians who posted photographs on the job. I liked to imagine the narrow tower as a gnomon, its shadow tracing time across an island-sized sundial throughout the course of the day. By the end of the year, it would be the tallest building in the city. At its full height 432 Park is conspicuous from any direction. From an Amtrak car heading north out of the city, the concrete gridwork on the service floors, backlit by the sun setting over the Hudson River, had disappeared entirely. From the MoMA courtyard it soared over the bonnet top of Philip Johnson's AT&T Building. In traffic in Queens, it looked like a square spike driven into the center of the city.

The tower's profile so fundamentally alters the Midtown skyline that the New York Mets and the New York Fire Department are said to have held special meetings to discuss modifying the skylines on their respective logos. That both declined to make the change is a reflection of the city's reluctance to embrace a building entirely devoid of any discernable civic, cultural, or commercial content. It exists only for private consumption, yet it is there whether you like it or not—an unavoidable monument to an economic reality most New Yorkers are not eager to celebrate.

The history of the tallest buildings in Manhattan tells a story of the shifting geography of power in the city. In the 1600s, temporary Lenape hunting shelters were replaced by the homes of Dutch settlers who built the pentagonal Fort Amsterdam at the island's southern tip. By the 1800s, churches, like Collegiate and Trinity, where Melville and Whitman both worshiped (though allegedly never met), were the highest structures on the island. At the turn of the next century manufacturing was driving a skyscraper boom and the tallest buildings—Singer and Woolworth—were flagships of major American brands. In 1930, as the Great Depression began to rattle the national economy, the Bank of Manhattan and Chrysler buildings competed in a highly publicized race to be the tallest in the world. Both held the title briefly, only to be surpassed the following year when, with the help of legions of laborers desperate for work, the Empire State Building completed its ascent from street to spire in only four hundred and ten days. The Empire State remained the tallest for over forty years until the consolidation of public and private money used to finance the World Trade Center ushered in an era of the quasi-governmental power wielded by organizations like the Port Authority. Today a private residential

94

tower is the tallest structure in Manhattan. As power is increasingly concentrated in the hands of a small group of extremely wealthy individuals, a new structural paradigm has emerged for the new New York.

By the time I returned to a regular routine at the studio after Zoe was born, the landlord had painted over the sign for Sepulvedas Custom Cabnets and Furnture with a matte gray paint that did not quite match the matte gray paint of the door. A mouse had eaten a bag of almonds and tiny mountains of dust had collected below the holes in the floorboards of the carpentry shop upstairs. I called Alamo and asked if he needed a job. He arrived several days later in basketball shorts and a long apricot button-down and I set him to work sweeping while I filled the dumpster with unfinished sculptures.

Alamo was perpetually in motion—always swinging a long pendular arm or tapping a foot even when the rest of his body was stone still. There was something about the way he outfitted himself for the task of sweeping—dust mask, safety goggles—that felt almost comically overcautious. I was just getting to know him, but his attention to workplace safety felt inconsistent with his general nonchalance about everything else in his life. The morning we first met I had been immediately taken by his intellectual recklessness, testing new thoughts and theories the moment they appeared in his mind, hurling them, loose ends and all, like little grenades into a conversation. I appreciated how often he said things out loud that I would have kept to myself. He seemed socially promiscuous too, in the best sort of way, but all of this felt somehow incompatible with these impeccable safety habits. I considered the possibility that this was a millennial trait. No one who taught me how to make things ever wore safety glasses or respirators. The

creative process as it had been modeled for me required a little self-destruction, a natural drive to explore the generative energy of personal risk, physical peril, aberrant behavior. I was intrigued by the way that Alamo could be so careless in so many ways—emotionally, financially—but take such care with his own body.

I had assumed he was from Texas, but Alamo's mother later told me he was named after the sculpture in Astor Place where she had met his father in the 1980s when she was working as a photographer's assistant in the East Village. They had moved up to the Hudson Valley before Alamo was born. Perhaps it was Alamo or just a new father's oversensitivity, but over the course of the next few months, I became increasingly preoccupied with the toxicity of the studio—Krylon, Rust-Oleum, Smoothcast. I wondered why I had treated my own body so carelessly—the accumulated toll of years spent in studios filled with wood dust and paint fumes, the aerosol in my sinuses or the chemical chill of acetone on my skin, my nonchalance with table saws or the lunacy of welding in running shoes. I thought of Zoe crawling over an expanse of nylon carpet soaked with fire retardant and glue—formaldehyde and styrene passing through her skin and lungs and into her bloodstream. The short walk from the studio to the subway began to feel like a gauntlet of respiratory assaults—marble dust and automotive paint, the sweet heavy smell of the asphalt plant across the canal and the exhaust invisibly cascading down from the elevated highway. Concrete barriers on the corner collected broken husks of air conditioners disemboweled of their copper coils and plastic bottles filled with piss. I began to notice the air-sampling devices, primitive goose-like robots chained to lockboxes in the corners of subway platforms, and wondered how long they had been there.

In the late 1980s, a NASA scientist named Bill Wolverton conducted extensive research on common houseplants that could be used to naturally remove volatile organic compounds like formaldehyde, benzene, and xylene from the air on a hermetically sealed international space station. Wolverton's NASA Clean Air Study lists dozens of common plants—elephant ear philodendron and wax begonias, butterfly palm, flamingo lily, Boston ferns and purple waffle plants, weeping fig and Caribbean tree cactus, devil's ivy—each promising demonstrable levels of space-age air filtration. I sent Alamo to the nursery to buy two of everything he could find on the list and as many pots as he could fit in the car.

—

At the end of December, I found a hardcover copy of Donald Barthelme's penultimate novel, *Paradise*, at the Strand bookstore. The protagonist, Simon, was a reasonably successful architect from Philadelphia who may or may not have been killed by a car bomb tied neatly to the tailpipe of his Volvo by a disgruntled contractor. Simon had either narrowly escaped death or been transplanted directly, as the title implies, to a sort of otherworldly postmodern purgatory (paradise itself is a place farther afield, awash in shades of rose and terra-cotta, which seems to Simon to have been "designed by Edward Durell Stone"). Either way, as the novel opens, Simon finds himself living in an empty apartment in the East Village with three lingerie models from Colorado named Veronica, Anne, and Dore. The apartment is unfurnished but for four mattresses, a couch, Veronica's trampoline, and gold-flecked aucuba. Simon is divorced, distant from his college-age daughter,

and he passes his days bemused, cooking elaborate meals, drinking white wine, listening to Horace Silver, and reflecting on his architectural achievements with a mixture of nostalgia and regret. When he is not with the women, Simon talks with his doctor (listed only as Q to Simon's A) about his domestic arrangement. There is a lot of sex. The whole situation, Simon acknowledges, has the structure of a male fantasy (like the Taj Mahal or the Chrysler Building), but he is more beleaguered than ecstatic.

I had read most of it before I left the store, terrified that I had stumbled upon some dark prognostication of my own future. Would this be me in twenty years—toilworn, unsure of what to do next, amazed by what I don't care about, tender as a sea lion?

———

Neither the Port Authority nor Yamasaki began with the intention of designing the tallest building in the world. The World Trade Center program called for ten million square feet of office space. That was more office space than existed in the entire city of Detroit at the time and Yamasaki had to figure out where to put it. After working through over a hundred massing models of variations ranging from a complex of six or eight towers to a single monolithic block, he arrived at a scheme of two ninety-floor towers in a staggered configuration reminiscent of (though in crucial ways not identical to) Mies' Lake Shore Drive apartments in Chicago. It was an elegant solution, but it only held eighty percent of the program.

Exactly what happened next is unclear. There are almost no remaining records of the design development stage of the project, no correspondence or meeting minutes,

no drawings or memos, because the entire Port Authority archive, which at one point included over 75,000 volumes of blueprints and details of buildings and bridges and tunnels across the region, was incinerated in a subbasement storage cage when the World Trade Center collapsed in 2001. It was, in aggregate, a staggering loss of information that included records not only of the World Trade Center but also every other project in the vast Port Authority portfolio.

There seems to be some agreement that Lee Jaffe, the Port Authority's director of public affairs, had actually been the first to raise the possibility of the tallest building in the world in a memo several years earlier, though at the time her suggestion was largely ignored. By his own account, it was Tozzoli who flew to Detroit and told Yamasaki, "President Kennedy is going to put a man on the moon and I want you to build me the tallest buildings in the world." Either way, what is clear is that at some point during a regular Friday afternoon meeting at Yamasaki's office in Michigan, the project shifted in a fundamental way—the program that had begun as a large complex of bureaucratic office towers now called for the two tallest buildings in the world. The brief had changed, and Yamasaki could go along with it or walk away. According to one former employee Yamasaki was visibly shaken by the turn of events, but by the time he returned to work on Monday morning he had made a decision. He gathered the office together and announced that they were going to design two buildings taller than had ever been built before. In the following weeks, Yamasaki pushed the two-tower scheme from ninety floors to an unprecedented one hundred and ten floors—two high-rises with a combined square footage greater than the Pentagon and a footprint slightly larger than an acre each. Yamasaki's model makers

had to remove the ceiling panels in his office to stand the final scale model upright. Tobin and Tozzoli were thrilled.

Shortly after Yamasaki won the commission, Ada Louise Huxtable, writing in *Art in America*, quoted an excerpt from a lecture he had given on the Voice of America the previous year. Huxtable often seemed to comprehend the narrative of Yamasaki's work in a way he never could, and the excerpt was a public reminder of how difficult it was going to be for Yamasaki to frame this audaciously large commission in a way that would sound consistent with his own philosophy of design. In the broadcast, he warned his audience that only the abhorrent "dogmas of totalitarianism demand buildings be powerful and brutal—to impress the masses with the absolute power of the state," and that an overpowering "monument to the ego of a particular owner or architect is contradictory to the principle that each man who uses the building should be able, through his environment, to have the sense of dignity and individual strength."

Yamasaki had proposed a World Trade Center that would become "a living representation of man's belief in humanity and his need for individual dignity." In a personal letter to Tobin, he described the importance of building at a scale that would be "inviting, friendly, and humane." Adjusting to the new demands of the Port Authority would require Yamasaki to reconcile this vision with the new mandate to build taller than anyone ever had before.

By using two extremely tall towers, Yamasaki felt he could open the space surrounding the building to create a generous public plaza—it was the logic of the tower in the park stretched to an unprecedented scale. Despite the staggering height of the two towers, Yamasaki imagined the plaza, like the open areas of the Piazza San Marco and

Rockefeller Center, as a "great open space with sufficient containment and variety to permit its users to observe and relate the overall scale of the towers to the detail of their parts, making them comprehensible and accessible, not overwhelming and forbidding." It would be, in Yamasaki's words, "a Mecca, a great relief from the experience of the narrow streets and sidewalks of the surrounding Wall Street area." He imagined a plaza encircled by arcades and broad water features, with pedestrian bridges and dense stands of trees, but by the time it was built, all that remained was five acres of empty windswept space and three monumental sculptures—Masayuki Nagare's black granite *Cloud Fortress*, James Rosati's stainless steel *Ideogram*, and Fritz Koenig's bronze *Caryatid Ball* (commonly known as the *Sphere*), rising from a central fountain.

In retrospect, Yamasaki's soaring descriptions of the whole scheme are filled with ambitions so hyperbolic that they seem either entirely delusional or impossibly naive. He ignores the scale of his primary references, overlooking the fact that his plaza is three times the size of the Piazza San Marco and his towers are four times taller than Mies' Lake Shore Drive apartments. As the project moves forward, the scale of the Port Authority's program seems to exert a distorting force on Yamasaki's logic. He never manages to entirely resolve this language and the growing schism between his humanitarian vision and the pragmatic priorities of the Port Authority. The stress of the job was taking a physical toll on his weakened stomach and by year's end he was back in the hospital in debilitating pain (it is not clear if Yamasaki knew exactly how ill he was at this point, though as a man of Japanese ancestry with a history of severe ulcers and alcohol abuse, he would have been at extremely high risk of contracting stomach cancer). After

several major operations in a matter of months he had lost forty pounds and was addicted to synthetic morphine. He struggled to wean himself by gradually tapering off medication so he could return to work.

———

In a long lightless stretch of January a year after Zoe was born, Nina had fallen into a sequence of headaches from which she could not break free. She had cycled off of all the medications she relied on to get through the day, replacing them with weaker substitutes that were largely ineffective, because the ones that worked were considered unsafe for women who are nursing. Without a reliable medication, the recesses between headaches were gradually shortening. As the wave function finally collapsed in the last week, the headaches had blurred into a single monolithic event. She had not *not* had a headache for eight consecutive days now and her body was at a breaking point. She could not keep water down and her eyes had faded from blue to a dull empty gray. After the third sleepless night we went to the hospital. I dropped Nina off at the emergency room and took Zoe to a friend's apartment. When I got back an hour later Nina was still waiting, head folded into her lap, exactly where I had left her. Another hour later, a nurse moved her into a room and drained four bags of intravenous fluid into her arm. A doctor began working through an excruciatingly slow protocol of ineffective medications until some combination finally broke the pain. Her neurologist was not answering the phone, but as the fluids moved through her body, the color gradually came back into her face. A room opened up where she could sleep. I rolled her through the fluorescent corridor and watched

a constellation of freckles on her back between the open folds of her green hospital gown.

I sat on a folding chair outside Nina's room while she slept. The long hallway was quiet and the same ad for Viagra kept playing on the television mounted to the wall of the nurses' station. A silver-haired man is sailing alone along a wooded coastline. The shackle connecting the mainsheet block to the boom breaks and rather than panicking, he turns calmly upwind, pulls a nylon strap from a lifejacket, lashes the block back to the boom, and replaces the shackle, while a deep, confident voiceover says, "this is the age of knowing what needs to be done." I thought of Simon in the empty apartment with Anne and Dore and Veronica.

I went downstairs to get a coffee. When the barista asked for my name, I said Simon. The coffee shop was full of nurses and a few bleary-eyed families I recognized from the waiting room. I took Simon's coffee and bought a copy of the *New York Post*. The Knicks had lost fifteen games in a row and there was an outbreak of Legionnaires disease in the cooling tower of a housing project in the South Bronx. As I rode back upstairs, the crowded elevator seemed to open on every floor, revealing quick glimpses of oncology and intensive care units, rehabilitation wards, and administrative offices. I was in awe of Nina's ease in hospitals. She had grown up among doctors, following her father on his rounds or doing homework in his lab after school. She found comfort in these spaces that left me claustrophobic and paranoid. I went in to check on Nina, but before I could open the door, the nurse signaled that she needed to rest. I got back on the elevator and went downtown to get Zoe.

103

The word hospital comes from the Latin *hospes*, meaning a stranger or foreigner. The same word is the root of *hostage* and *hostile*. Until the late nineteenth century hospitals were sites of disorder—buildings for people to die in, designed with religious salvation in mind, not medical treatment. The concept of a hospital as a healthy space is a relatively new one. When Florence Nightingale published *Notes on Nursing: What It Is, and What It Is Not* in 1859 she wrote that "the very first requirement in a hospital is that it should do the sick no harm." A century later Michel Foucault described the principal factor in the transformation of medical architecture as "not the search for a positive action of the hospital on the patient or the illness, but simply the annulment of the negative effects of the hospital." The building, like the doctor, should do no harm.

In Robert Musil's unfinished novel *A Man without Qualities* (written between 1930 and 1945, but set between 1913 and 1914), Ulrich, tasked with restoring an old house in Vienna but indifferent to how it might look, considers the advice of a leading architect (presumably Otto Wagner) and is told, "modern man is born in a hospital and dies in a hospital, so he should make his home like a hospital." Ulrich wandered the streets of Vienna in a moment when changing attitudes toward medicine made the hospital the central metaphor of the emerging modernist movement. While modernism may have shifted the humanist emphasis away from the body as the central model of architecture, it reinforced the idea of disease as the enemy. Just as Vitruvius had taught his students to study anatomy, the early modernists drew

inspiration from contemporary healthcare. One disease in particular became a foundational metaphor for the rhetoric of early modernism.

Tuberculosis is caused by an airborne mycobacterium believed to have caused nearly a quarter of all deaths in Europe between 1850 and 1900. The prevailing pathology at the time, miasma theory, held that diseases like cholera, typhoid, and tuberculosis were the direct result of contaminated water, bad air, and poor hygienic conditions associated with the overcrowded, underventilated living conditions of the workers who flocked to cities to find jobs during the Industrial Revolution. Tuberculosis was an architectural problem—a disease directly connected to the perils of unregulated urban density—and early cures were based primarily on exposure to fresh clean air. When bacteriologists discovered that sunlight could kill contagious tuberculosis bacilli, light became the second pillar of what came to be known as the light and air cure.

The central medical instrument of climate therapy was the sanatorium—an explicitly architectural solution that instrumentalized buildings in the treatment process. The translation of medical prescriptions for tuberculosis therapy (cleanliness, fresh air, sunlight, rest) to physical form (white walls, roof decks, long horizontal windows, reclining chairs) was first manifest in these early sanatoriums. Musil's protagonist Ulrich would have known the white walls, tiled surfaces, and geometric ornament of one of the first sanatoriums, Purkersdorf, designed in 1905 by Josef Hoffmann and the Wiener Werkstätte on the site of a natural spring outside Vienna. Purkersdorf, with a minimal interior designed to calm the nerves as well as heal the body, quickly became a social nexus of Vienna's upper class. The model was subsequently refined in sanatoriums such as

Zonnestraal ("sunbeam" in Dutch), which was completed in 1925 in Hilversum, Holland. Zonnestraal was designed by Jan Duiker and Bernard Bijvoet with treatment wings radiating from a central core to maximize the sun exposure that was the primary prescription of heliotherapy.

The most iconic example of the form was Aino and Alvar Aalto's Paimio Sanatorium in Finland, built in 1933. In the second edition of *Space, Time and Architecture*, the architectural historian Sigfried Giedion called Paimio "one of the three institutional buildings inseparably linked to the rise of contemporary architecture" (the other two were Walter Gropius' Bauhaus Building in Dessau and Le Corbusier's design for the League of Nations Palace in Geneva, which was never built). Paimio unfolds horizontally in the Finnish countryside, with its largest wing facing south-southeast with sun terraces on the roof, recumbent areas positioned to maximize sun exposure, and long ribbons of simple metal casement windows to distribute light evenly across the building. Alvar and Aino Aalto collaborated on every detail of the interior of the sanatorium, including customized splashless washbasins and conical glass spittoons for the bathrooms to minimize the spread of infectious droplets. Having recently been hospitalized himself, Aalto knew that a reclining patient would be most comfortable with no overhead lights, so he designed their rooms without them. Together with master joiner Otto Korhonen, the Aaltos designed the bent-plywood recliners—with backs angled to open the patient's chest and make breathing easier—that would become one of the signature pieces of mid-century modernism. Every surface in Paimio is devoid of unnecessary ornament, sanitary, easy to clean, and engineered to mitigate the spread of a highly contagious respiratory disease. Aalto's design, which he described as a "medical

instrument," was initially rejected by the building committee before being endorsed, not by architects, but by three doctors assigned to review the proposal.

In Thomas Mann's novel *The Magic Mountain*, a young engineer, Hans Castorp, travels to Davos in the Swiss Alps to visit his tubercular cousin at the fictional International Sanatorium Berghof. Here he becomes enamored both with the disease (which he gradually convinces himself he has) and with one of his fellow patients, Clavdia Chauchat (whom he gradually convinces himself shares his affection). Castorp stays on the mountain for seven years. Berghof is immaculate and sterile, but bristling with sexual energy and febrile creativity. It is a site of both illness and intrigue, of physical languor and intellectual vigor, and Castorp soon finds himself consumed by its aesthetic and intellectual thrills. In addition to its distinctly pallid glamour, tuberculosis was also closely associated with literary fecundity—Camus, Barthes, Baudelaire, and Thoreau all spent time at sanatoriums, as did Adolf Loos and Richard Neutra. Tuberculosis killed Kafka, Chekhov, Orwell, Anne and Emily Brontë, Balzac, and Novalis. It was a disease, Shelley wrote to Keats on his deathbed, "particularly fond of people who write such good verses as you have done."

A compelling case has been made by a number of architectural historians that every distinctive feature of modern architecture—the white walls, the ample windows, the sterile unupholstered surfaces, the lack of ornament, the open well-ventilated interiors and the sun-soaked roof gardens, the serving areas and the areas to be served—can be traced back to the tuberculosis sanatorium and medical prescriptions for the treatment of the disease. Gropius built terraces for plein-air calisthenics and Loos

designed accommodations for quarantining sick children. Respiratory health was a particular preoccupation of Le Corbusier, who wrote incessantly about clean air and whose exposed cylindrical columns or *pilotis* were specifically designed to pull the building up above the "damp, tubercular ground."

———

When I arrived back at the hospital, Nina had been moved upstairs. The hallway outside the room was decorated with images of African landscapes that an internist had taken on vacation in Kenya—huge glossy photographs mounted on Plexiglas of zebras standing in tall grass. Inside I found Nina in bed, scrolling aimlessly through her phone. I could see she was still weak, but she looked clear-eyed and radiant, not like someone who had emerged from a bout of pain, but rather like someone who had just awoken from a long and rejuvenating sleep. She asked how Zoe was and I played her a video of our friends giving her a bath in the kitchen sink. She smiled and returned to her phone, and I lay back on the empty bed next to her and looked up at the infinite porous surface of each spongey panel of acoustic ceiling tile. Several minutes later, the doctor returned and said we were free to go.

———

The sanatorium was an idea built around two fundamental contradictions. First, it was an expensive and often inaccessible solution to a disproportionally working-class problem. In 1926 the tuberculosis mortality rate in the poor and overcrowded thirteenth arrondissement of Paris was more

than quadruple the rate in the affluent eighth. Maps of tuberculosis deaths in Paris and London in the early 1900s read like maps of income distribution and urban density. In New York, the disease ran rampant through crowded downtown tenements. Tuberculosis was an affliction associated with the overcrowded and unsanitary living conditions of the workers of the Industrial Revolution, but early treatments, predicated on the idea of moving the patient from the crowded contaminated streets of the city to clean mountain air, were accessible only to those with the means to afford them. With a few exceptions (notably Zonnestraal which was funded by a progressive General Dutch Union of Diamond Workers), sanatoriums were unavailable to the populations most impacted by the disease.

The second contradiction was that the so-called light and air cure for which sanatoriums had been designed did not work. At its foundation, the sanatorium movement was based on a false premise. Sanatoriums provided temporary relief for those who could afford to spend idle months in mountain resorts, but light and air alone cannot cure tuberculosis. As many as eighty-five percent of patients released from sanatoriums eventually died of the disease. At best, time spent at a sanatorium could arrest the progress of the disease, but it could not rid the lungs of tubercular bacilli entirely.

By the mid-1940s, the development of the antibiotic streptomycin made effective treatment of tuberculosis a reality. Antibiotics gradually replaced sanatoriums, and by the 1950s tuberculosis was no longer considered a major public health threat (though it still kills more than a million people a year). Davos, home at one point to dozens of tuberculosis sanatoriums, returned to its former life as a resort town, and Paimio was converted into a general

hospital. Other iconic European exemplars were demolished or rebranded as spas with a simple shift of vowels—sanatoriums became sanitariums. The tuberculosis sanatorium became a medical and cultural relic, but the form had already changed the course of modern architecture. Shortly after the Chicago doctor Edith Farnsworth commissioned the first Mies van der Rohe house in the United States, she began to hear rumors that she was building a sanatorium. The influence of tuberculosis on modernism has been well established, but less consideration has been given to the irony that the most significant architectural movement of the last hundred years was predicated on a model that did not work and was available only to those few who could afford it.

———

On January 18, 1963 the World Trade Center commission earned Yamasaki a place on the front cover of *Time* magazine. This was a rare honor for any architect and one only bestowed upon designers of broad popular appeal (other covers pictured Frank Lloyd Wright, Eero Saarinen, Edward Durell Stone, Wallace Harrison, and Buckminster Fuller). The accompanying article, "The Road to Xanadu," opens with an image not of Yamasaki's work but of the Taj Mahal. This odd conflation of Shah Jahan and Kublai Khan sets an unmistakably Orientalist tone for the profile, which also includes a photograph of Yamasaki's second wife, Peggy Watty, wearing a kimono and filling a traditional Japanese soaking tub. Teri is pictured as well, looking on while Yamasaki plays chess with their children. The article comes as close to a biography of Yamasaki as existed at the time, and its uncredited author presents a comprehensive

assessment of a career approaching its apex—Yamasaki had just turned fifty and the World Trade Center was the highest-profile job in the world. Although the details about the commission remained shrouded in secrecy, the article draws to a close with an auspicious assessment of the challenge ahead: "If Yamasaki can keep a firm control of the job, it will be one of the greatest opportunities ever presented to an architect."

A year later, on a mild winter morning at the New York Hilton, Yamasaki and Nelson Rockefeller posed together for a photograph next to an intricate eight-foot model of the World Trade Center as the two-tower scheme was unveiled to the public for the first time. The buildings were sleek and shiny with minimal corduroy facades that eschewed the decorative flair of Yamasaki's midcareer work. It was only at plaza level, where the vertical lines of the facade converged into tall lancet arches—Gothic for Gotham— that the buildings were recognizably Yamasaki's. But those details were largely overlooked as the public ogled at their monumental scale.

The Port Authority issued a press release comparing the buildings to the high growths of iron in Walt Whitman's "Mannahatta," a poem written when Trinity Church was still the tallest structure on the island. The proposed towers were promptly nicknamed "David and Nelson" for the brothers whose ambition they had come to embody, and as reviews went to press in the coming days the praise was unanimous. *Washington Post* architecture critic Wolf von Eckardt called Yamasaki's proposal "a magnificent work of architecture and urban design" that "promises much of the elegance of the Piazza San Marco in Venice combined with the grandeur of Rockefeller Center." Huxtable, now well established as the critical conscience of New York

City architecture, celebrated the design as a bellwether of a "second great period of the skyscraper." In a review titled "A New Era Heralded: Architectural Virtue of Trade Center Expected to Enhance City's Skyline," she praised Yamasaki for skillfully restoring the human scale of the skyscraper with a "a level of taste and thought that has been distressingly rare in the city's mass of non-descript post-war commercial construction." In her estimation, the World Trade Center promised to be "the best new building project that New York has seen in a long time."

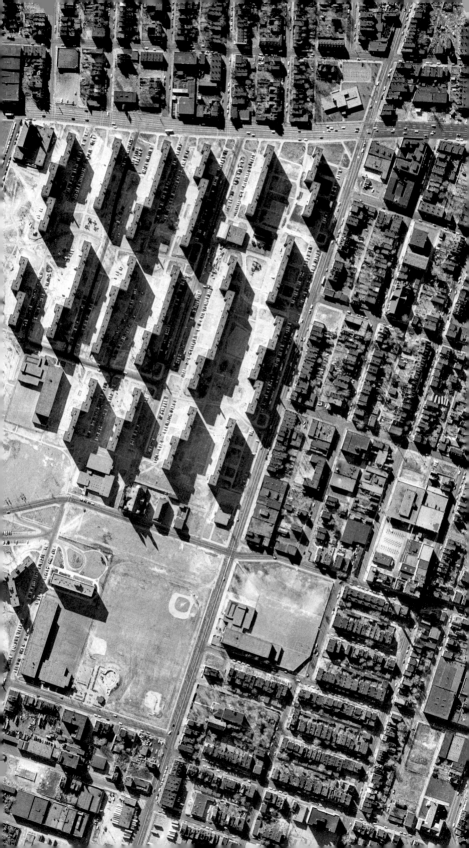

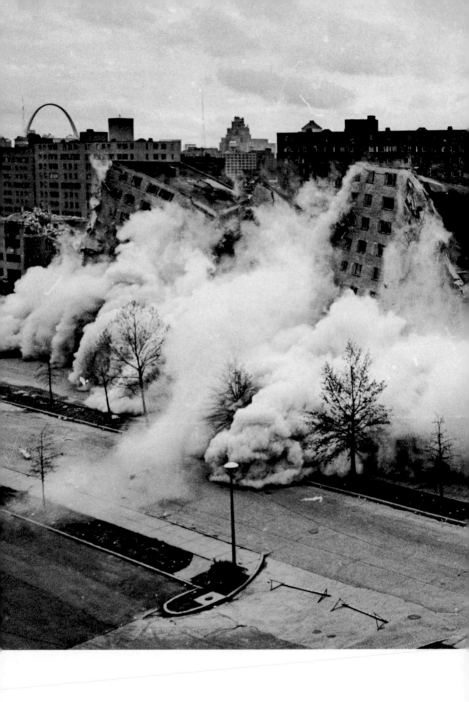

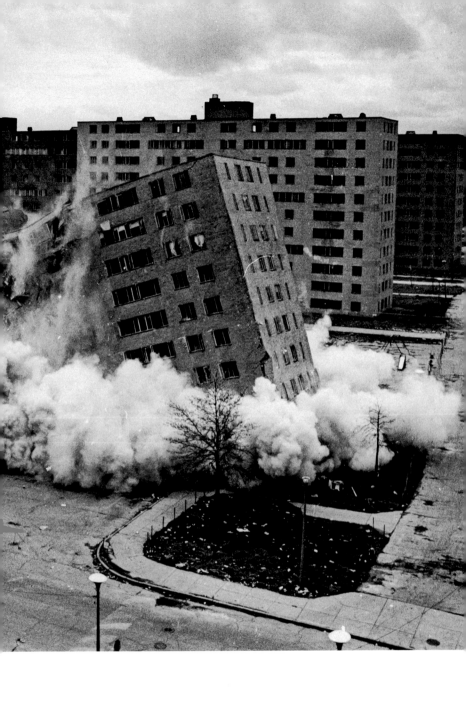

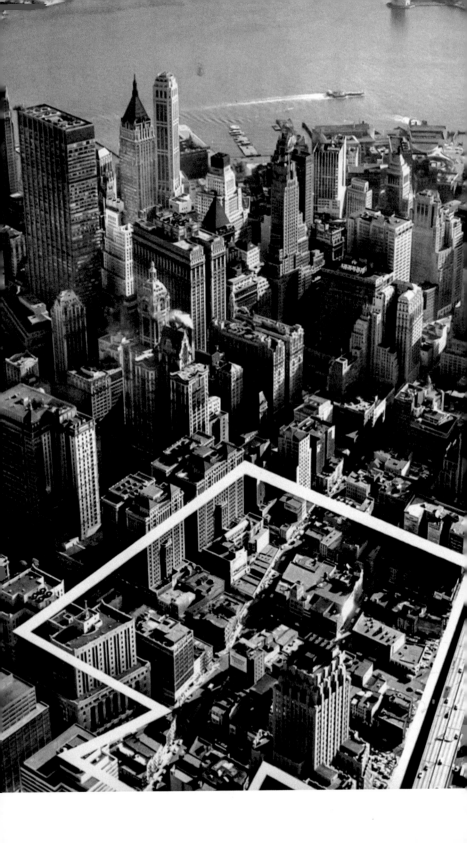

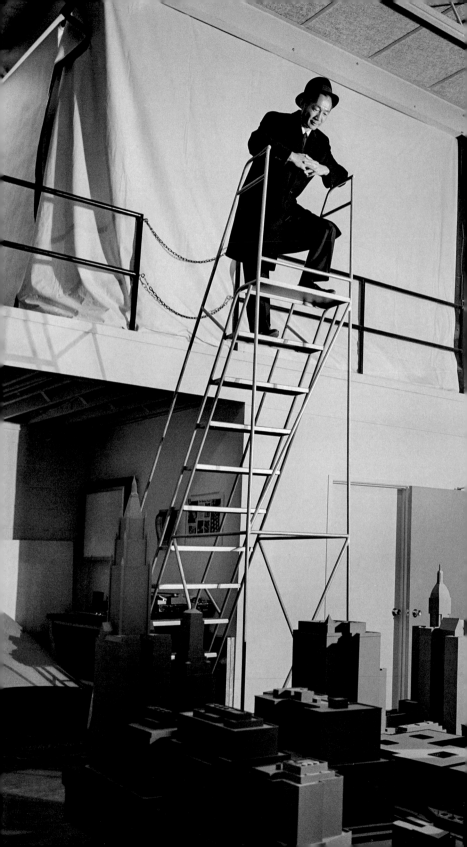

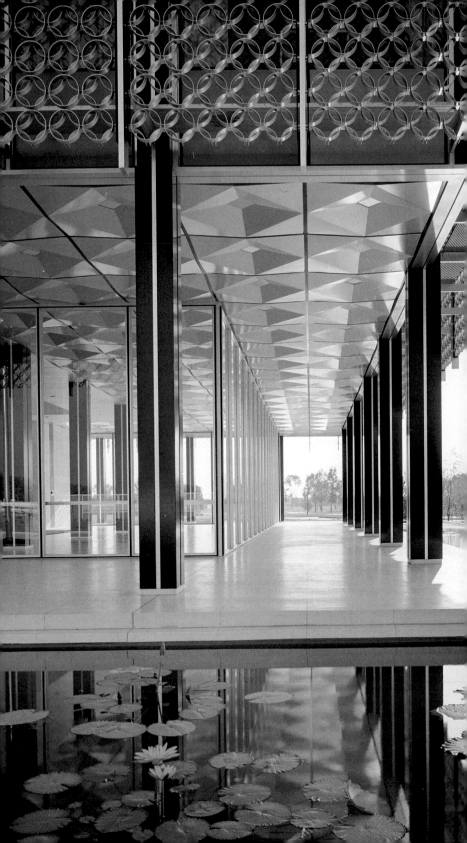

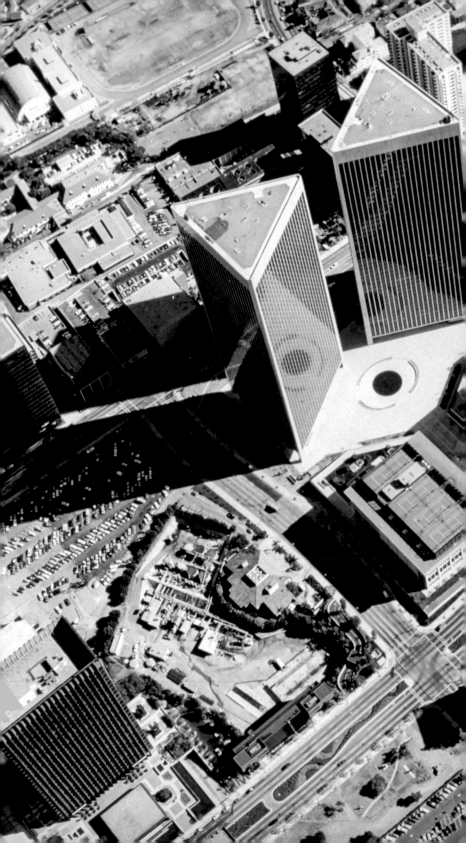

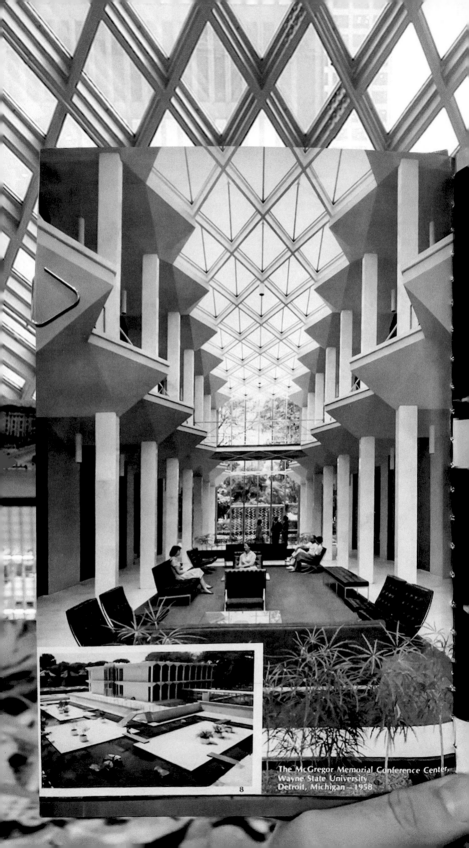

The McGregor Memorial Conference Center
Wayne State University
Detroit, Michigan — 1958

8

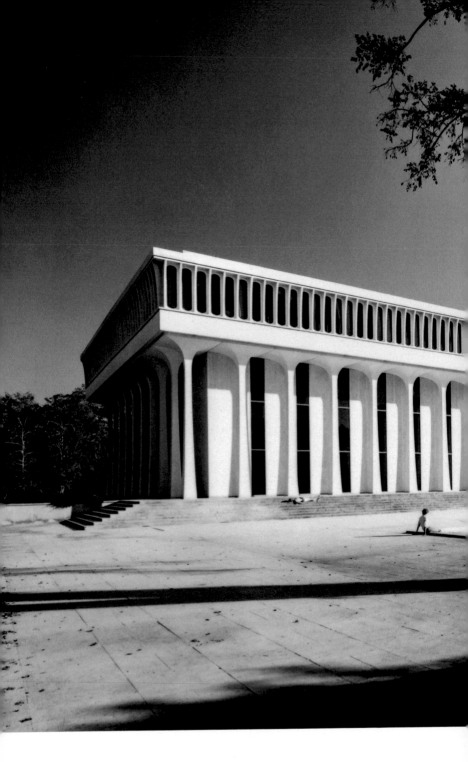

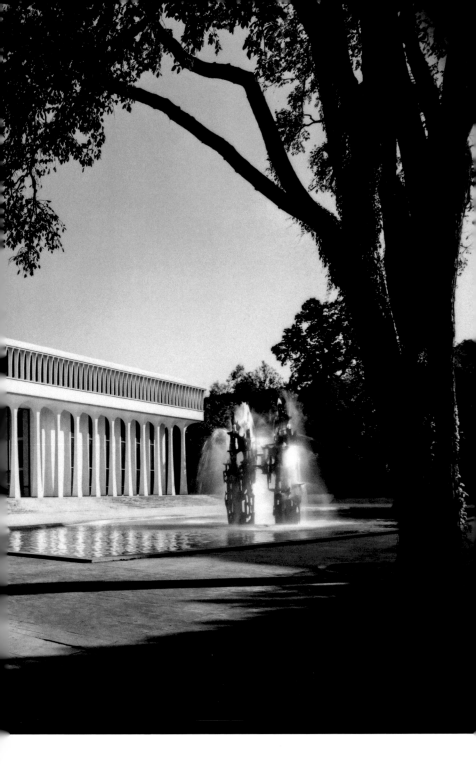

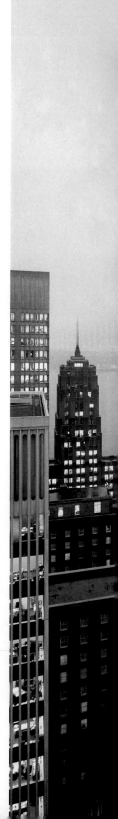

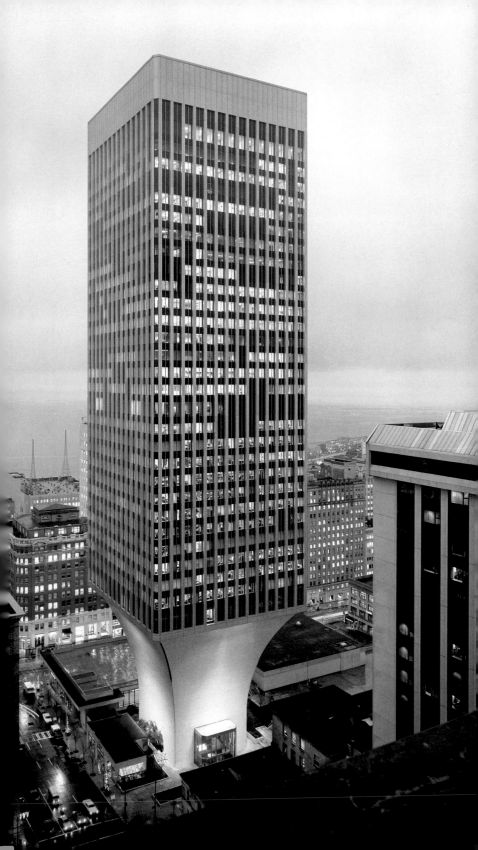

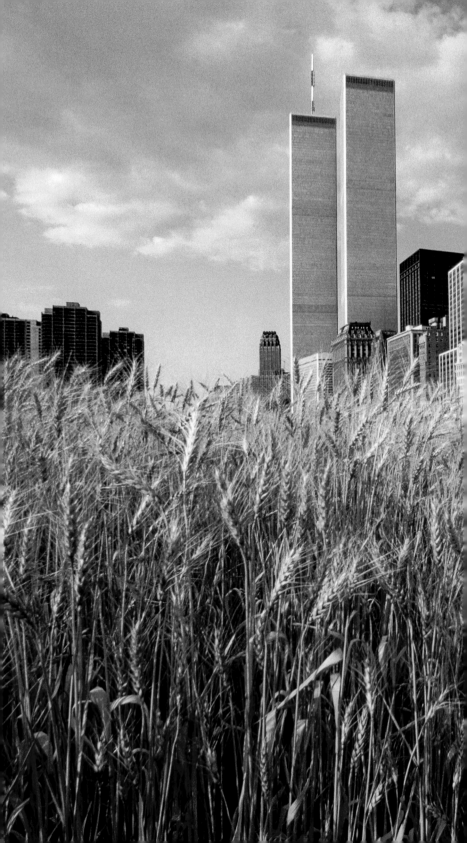

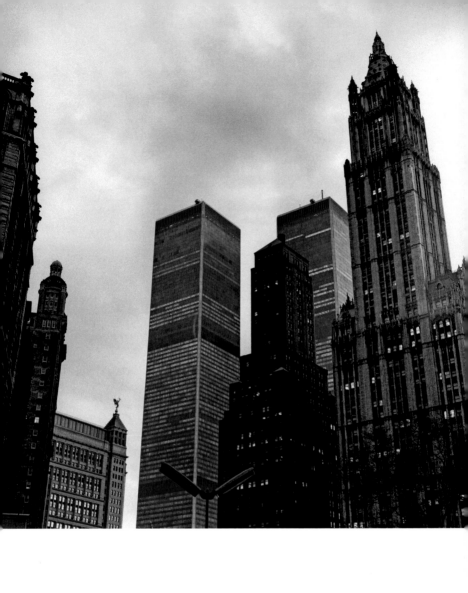

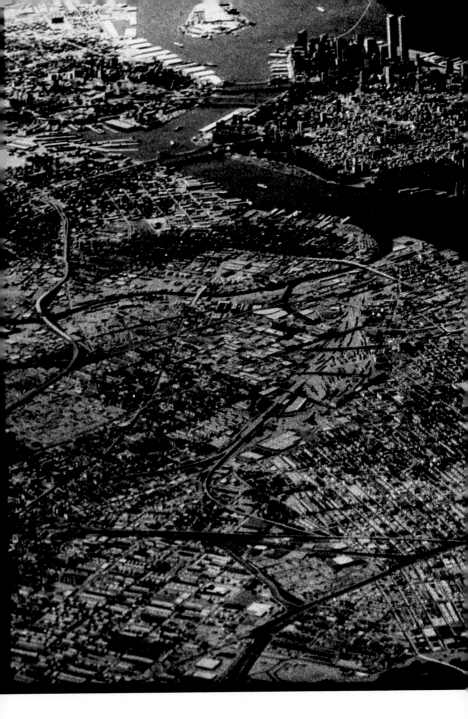

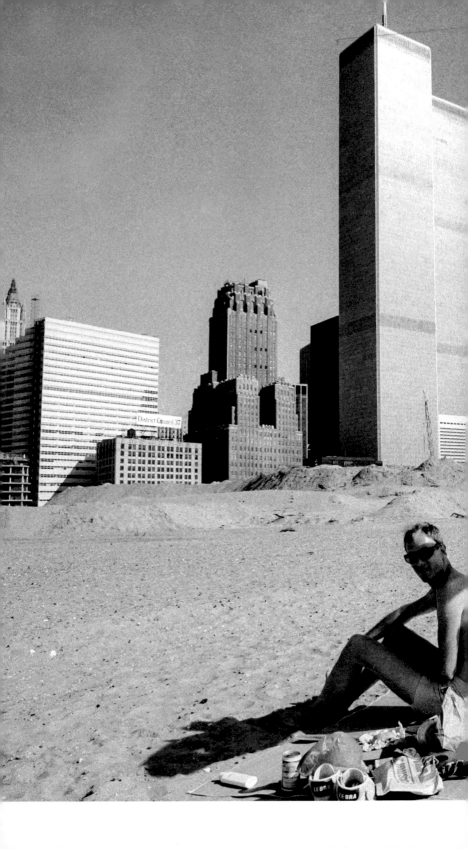

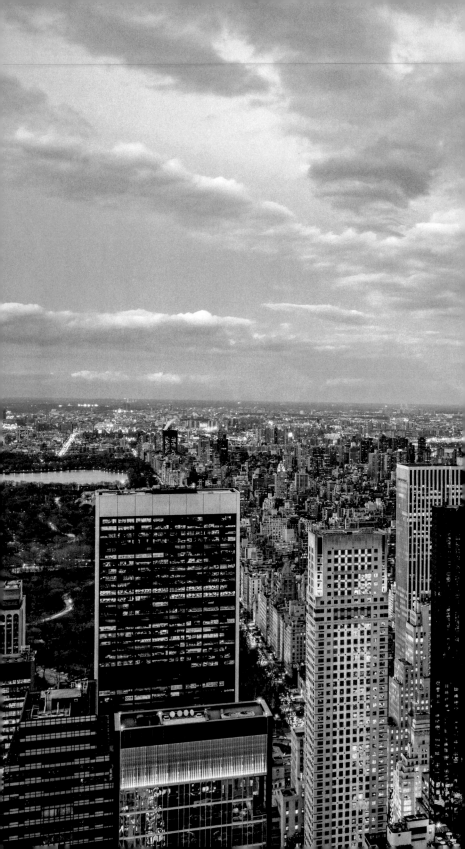

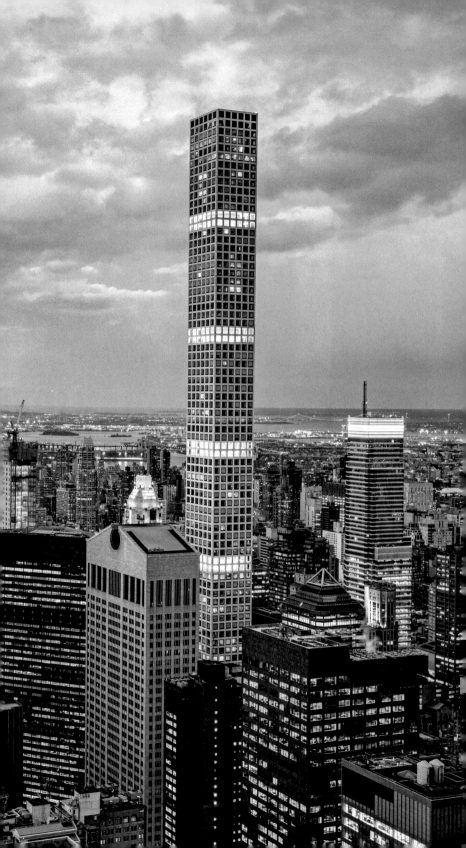

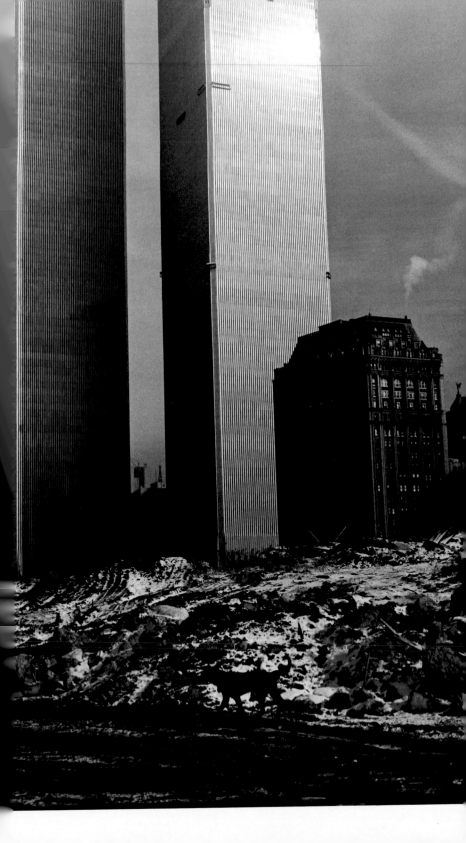

What Nina wants least when she has a headache is to be touched. As much as I understand the mechanics of migraine, I find this simple limitation enormously complicated. To spend so much time with a partner who is simultaneously in such clear distress and so completely unavailable, hidden behind an unspoken boundary prohibiting the exchange not only of communication but of physical contact itself, is deeply disconcerting. Troubling as it may be, I am not the one in pain. I know that I fall away from Nina's field of view simply because everything falls away from Nina's field of view as the waves of pain begin to radiate outward to every nerve in her body. The urgency of this suffering requires a kind of tunnel vision, which in the case of migraine is both literal and figurative. The headache commands focus on nothing other than the headache.

Didion refers to her migraines as a companion and a friend—a stranger with whom she shares long hours spent in the fog of pain. Nina seems, instead, to see her headaches as a spatial condition, a phenomenon presiding over its own solitary domain, a dimly lit, acoustically softer parallel space, adjacent to but entirely separate from the life we share. She can slide between realms—the present (outward, vertical) and the migraine (inward, horizontal) —but in the latter she is always alone. When she has a headache, possessive pronouns become singular—she lies down in *her* bed, in *her* room, in *her* apartment. The space she inhabits changes. I disappear.

———

Once the decision had been made to build the two tallest buildings in the world, the question of how to build them was another matter entirely. The design presented to the

145

public was over a hundred stories tall, and the conventional wisdom was that it was not economically feasible to build over eighty stories. Yamasaki's former employer, William F. Lamb, described the form of the skyscraper as "a pyramid of non-rentable space surrounded by a pyramid of rentable space"—wider at the bottom to accommodate steel and elevators and gradually tapering toward the top as less structure and circulation were required on the upper floors. Lamb's Empire State Building, with exactly twenty-eight feet of rentable space on each side of a central core that narrows as it rises, is a physical diagram of the double pyramid scheme that remained standard for over forty years.

The value of a building is essentially the price per square foot, multiplied by the usable square feet per floor, multiplied by the number of floors. As the number of stories increases, the rentable square footage on each floor decreases to accommodate additional structural steel and elevators. The result is a very logical set of constraints that govern what is financially viable. The equation plots a curve with a clear tipping point where continuing to go up ceases to make sense because the ratio of rentable square footage to total square footage starts to decrease. Developers call this ratio net to gross. When Yamasaki was designing the World Trade Center, the industry standard was a net to gross of about sixty-two percent, and that was nearly impossible to achieve at eighty floors, much less a hundred. To fit ten million square feet of office space into the two towers, Yamasaki's team would have to somehow change the paradigm of vertical construction.

Yamasaki's solution to the problem was predicated on two novel ideas, though neither of them was entirely his own. Instead of filling the core of the building with a traditional system of elevators running its full height, Yamasaki

created a "sky lobby" system in which three separate but interconnected elevator systems served different segments of the building. The scheme was based on Port Authority engineer Herb Tessler's suggestion that the elevators could run in a manner analogous to the local and express trains in the New York subway, though the logic also echoes the simple economy of Pruitt-Igoe's skip-stop system. Oversize fifty-occupant express elevators ran from the plaza level to two double-height sky lobbies on the forty-fourth and seventy-eighth floors where riders could transfer via escalators to local elevators to reach their desired destination. Because the triple-stacked local elevators shuttling between sky lobbies could share a single shaft, the scheme increased rentable square footage by nearly twenty percent without compromising efficiency.

The second innovation came from the Seattle-based engineering team. Previous high-rises had relied on a grid of supporting columns on each floor for their structural integrity. These columns were typically spaced about thirty feet apart throughout the interior. The exteriors of such buildings were merely curtain walls, letting light in and keeping weather out but providing little structural support. At the World Trade Center, a different model was developed. Yamasaki's structural engineer John Skilling put the project in the hands of a brilliant young associate named Leslie Robertson who had a reputation for pushing back against the more conservative tendencies of the profession. Robertson was just thirty-four, with no formal degree in engineering, and the World Trade Center was his first high-rise. He designed the towers with a relatively new method of construction called a framed tube structure in which load-bearing perimeter walls provide support for virtually all lateral loads (primarily wind) and share

the gravity loads (the dead weight) with the internal core structure. The perimeter columns, fourteen inches square in section, were connected by horizontal steel spandrels which would transmit shear stress between columns and allow the exterior structure to act as a sturdy rectangular truss. To improve efficiency, the high-strength steel varied in thickness from three inches at the bottom of the tower to a quarter inch at the top, so that the entire design required forty percent less steel than a conventional building.

At the center of each tower, a rectangular core of forty-seven columns housed the elevators, utility shafts, restrooms, and three stairwells. The large, column-free space between the perimeter tube structure and the core was spanned by prefabricated floor trusses that supported four-inch-thick lightweight concrete floor slabs. All told, the scheme allowed for sixty feet of unobstructed rentable space on two sides of the core and thirty-five feet on the other two—an acre of column-free space on every floor, perfectly suited to the open-plan office systems that managerial consultants and efficiency experts had prescribed for the postwar information economy. The thin floorplates allowed the Port Authority to fit a maximum number of stories into each tower, yielding a total of ten million rentable square feet at an unprecedented ratio of seventy-five percent net to gross. It was an extraordinary engineering accomplishment—a structure over twenty stories taller than the Empire State Building with a net to gross almost twelve percent higher than previously thought possible.

The efficiency of this approach meant that the frame of the World Trade Center was much lighter than that of a traditional tall building, but this in turn meant it was difficult to anticipate how much the towers would move in high winds. By reconfiguring the floor plans so that the stiffer

central core ran east-west in one tower and north-south in the other, the engineers were able to mitigate the risk of catastrophic mechanical resonance caused by vortex shedding between the two structures, but they would still move considerably in the steady onshore winds. To test the maximum sway occupants could tolerate without feeling uncomfortable, Robertson constructed a fake optometrist's office in Eugene, Oregon with an examination room suspended on massive hydraulic arms. He then invited the public in for free eye exams while engineers gradually increased the movement of the room until the patients sensed a disturbance. By the time the test was complete, they had determined that occupants could tolerate a sway of about twelve inches (the Port Authority repeated the experiment by suspending a room from ropes in the ventilation shaft of the Lincoln Tunnel with similar results). To meet this standard, Robertson designed ten thousand thin viscoelastic dampers to be installed at either end of each floor truss throughout both buildings to absorb shock and help reduce sway.

———

As planning proceeded on the World Trade Center, conditions were deteriorating at Pruitt-Igoe. After the Second World War, the demographics of St. Louis, as of so many other American cities, changed in ways that the Housing Authority had not anticipated. The Great Migration had drawn a steady stream of black southerners to the city in search of work, but as the industrial economy retracted after the war and white residents began to move out of the city, growth stagnated. The total population of St. Louis, once forecast by city planners to increase steadily, plummeted by

nearly a third between 1950 and 1970. The white population dropped by nearly two-thirds. The Housing Act, which had originally made projects like Pruitt-Igoe possible, had also subsidized the highways and mortgages that lured much of the city's middle class to the suburbs, while restrictive covenants and discriminatory lending ensured that only white families had access to the new suburban developments. White flight and black sequestration radically altered the makeup of the city. Following the precedent set by *Brown v. Board of Education,* a circuit court decision just months after the first white residents moved into Igoe outlawed segregated public housing, but Pruitt-Igoe was never really integrated. Within a matter of months, nearly all the white residents left, and within a year of its opening Pruitt-Igoe was essentially black-only—segregated not by law but by a lack of opportunity mandated by policy.

The St. Louis Housing Authority had taken population growth as a given, and their financial model provided no contingency for low occupancy. Federally sponsored projects were expected to fund their own operations out of rents collected from tenants and, at partial capacity, Pruitt-Igoe could not generate enough revenue to pay for basic maintenance. Infrastructure rapidly deteriorated—broken windows were left unrepaired, elevators stopped working, and trash piled up in front of incinerators. The overwhelmed maintenance crew could not keep pace with repairs and, as crime grew, outside contractors refused to work on site without security escorts. As those who could afford to gradually left, Pruitt-Igoe became what civil rights activist Joyce Ladner later called "a residence of last resort"—a refuge for the poorest segment of the population, primarily single mothers with larger families who relied on the support of public assistance (occupancy rates

were always highest in the buildings' largest apartments). The Housing Authority's moralistic policies—including bylaws that prohibited residents from owning televisions or telephones and banned any unemployed able-bodied man from living with any family collecting welfare—further infringed on tenants' autonomy. Incrementally, occupancy fell and physical conditions deteriorated. The project's empty towers developed a reputation as a haven for criminals, and the St. Louis police began patrolling the grounds with German shepherds. As residents began to feel increasingly unsafe in their own homes, hostility toward the Housing Authority grew.

In 1965, *Architectural Forum* published an article on Pruitt-Igoe titled "The Case History of a Failure" in which the author, James Bailey, cataloged the infrastructural damage since the project's completion and argued that many of the features praised by the magazine fourteen years earlier had proven to be dangerously flawed. In particular, the skip-stop elevators and anchor floors Yamasaki had designed to foster a sense of community within the massive buildings had instead become sites of fear and intimidation. Because the elevators only stopped on every third floor, the concourses and staircases they serviced offered convenient settings for vandalism and assault. "The galleries are anything but cheerful social enclaves," Bailey wrote. "The tenants call them *gauntlets* through which they must pass in order to reach their doors." The single human accommodation Yamasaki had been able to fit within the meager budget had gone horribly wrong. Bailey reiterated Yamasaki's original objections to many of the Housing Authority's cost-cutting decisions and quoted his subsequent confession, "I suppose we should have quit the job. It's a job I wish I hadn't done."

"Demapping" is a term used by urban planners to describe the removal of existing streets from an urban grid. Like the literal *tabula rasa*, demapping requires the physical erasure of the text of the city. Before the Port Authority could begin construction on the World Trade Center, sixteen densely populated acres of Lower Manhattan had to be cleared to accommodate the site. Thirteen city blocks would be removed from official municipal maps forever, and the only remaining underdeveloped quarter of downtown would be exploited to its full potential. An image printed in a Port Authority publication at the time shows an aerial photograph of Lower Manhattan with the site traced in a thick white outline. The collage seems to reduce the incalculable complexities of urban redevelopment to a simple application of scissor to paper (a gesture that would be ingeniously reversed by Ellsworth Kelly in his 2003 collage *Ground Zero*). The brutal clarity of the Port Authority graphic belies the aerial perspective of the urban planners—like Moses or Tobin or Bartholomew—who believed that a city must be approached as a network of infrastructure rather than an ecosystem of individuals. Twenty years earlier Moses had decimated the neighborhood of Little Syria when his Triborough Bridge Authority appropriated land to build the Manhattan approach to the Brooklyn-Battery Tunnel. At the heart of the land to be razed for the World Trade Center site, immediately north of where Little Syria had once stood, was Radio Row—a thriving commercial district of electronics stores overflowing onto Cortland Street.

When the Port Authority announced plans to clear space for the proposed "superblock," the merchants and repairmen of Radio Row paraded a coffin through the

streets declaring the death of the small businessman. Then they filed a lawsuit to stop the construction on the grounds that the project was outside of the Port Authority's jurisdiction. Writing in support of Radio Row in the *Nation*, Desmond Smith called the proposed World Trade Center "Manhattan's Tower of Babel" and accused the Port Authority of abusing its power and seizing land on behalf of a vast, for-profit real estate development under the guise of public benefit.

There were, at least theoretically, some limits to what land the Port Authority could take by eminent domain. From the beginning, the authority's involvement was contingent upon the project's essential connection to ports and transportation infrastructure, but the specific language of the charter—which granted "full power and authority to purchase, construct, lease, and operate terminal, transportation, and other facilities of commerce"—left the limits of its jurisdiction ambiguous. The merchants of Radio Row were the first constituency to challenge Tobin's claim that the World Trade Center served any essential "public purpose" at all, arguing instead that it was simply a speculative real estate venture. In April 1963, the New York State Court of Appeals dismissed a case filed by the Radio Row merchants and allowed the Port Authority to take all sixteen acres of the proposed site by eminent domain, judging that the project would positively impact the ports of New York and New Jersey by dedicating space to the "facilitation and development of world trade." Ultimately, legislation would require that seventy-five percent of the World Trade Center tenants had to be either directly involved in international business or serving it, but what exactly that meant was unclear.

The Port Authority encountered another logistical challenge when John Lindsay won a mayoral campaign

based in part on promises to take down unelected power brokers like Moses and Tobin. When the project was first introduced, Lindsay's predecessor, Robert F. Wagner, had made a handshake deal which allowed the Port Authority to pay the city a set annual fee in lieu of taxes. That fee amounted to less than seven percent of what a private developer would have paid in taxes on a comparable development. Lindsay vowed to correct this disparity, and—given the broad powers already granted to the Port Authority—used the only remaining piece of leverage available to him. While the authority controlled the land on which the towers would be built, the site was surrounded on all sides by land controlled by the city. Without municipal street closure permits, no material could be delivered to the building site, so Lindsay threatened to withhold permits until the Port Authority agreed to pay the city more. Negotiations dragged on for weeks, and by the summer of 1966 the two sides were deadlocked. Then one morning Tozzoli came up with an idea. The Port Authority could use the rubble excavated from the foundations of the towers to create over twenty acres of new landfill immediately west of the site on the Hudson River and gift the reclaimed land to the city. Lindsay accepted Tozzoli's offer and within days the Port Authority broke ground.

———

While 432 Park was still under construction, details of a four-minute, $1 million promotional video were printed in the *New York Times*. The short film, available only to prospective buyers, was loosely plotted around a young woman's return home from a country estate in England, via Rolls-Royce and private jet, to an apartment in one

of the building's upper floors. Her trip is spliced together with dreamlike sequences of the aerialist Philippe Petit simulating a skywalk from the spire of the Empire State Building to the flat roof of 432 Park while ballerinas dance in oversized square windows. The video strives to situate the building within the cultural history of New York, but the connection feels strained because its true market is global, not local. This is not a building for New Yorkers (few people who have spent any significant amount of time in New York, given unlimited resources, would *choose* to live in Midtown). Like so much of the postmillennial luxury construction in the city, the majority of its units are owned by investors who will rarely use them. The apartments are held, often empty, by absentee owners, who see Manhattan real estate as a secure harbor for money. The building's location only matters in that its address carries with it the precarious promise that the New York housing market will never do anything but hold its value, regardless of political or financial instability elsewhere in the world.

Rather than comparing 432 Park to the buildings that preceded it, critics inevitably arrive at financial metaphors to describe the structure—"a three-dimensional balance sheet" or "safe-deposit boxes in the sky" (images reinforced by the flatness of the facade's blank geometry). Each unit is not so much a space to be inhabited as a landing pad for international capital flight, a container for wealth, or a financial envelope for a shell company. In this sense, the building is a conceptual empty vessel—an assemblage of apartments, the metaphorical vacancy of which is made literal by the conspicuous lack of regular residents. It is, as J. G. Ballard wrote of the city surrounding the high-rise in his eponymous novel, "an environment built, not for man, but for man's absence."

Like Ballard's fictional architect, Anthony Royal, Viñoly has a residence in his own high-rise, though instead of the penthouse, Viñoly had to settle for one of the smaller apartments closest to the ground (even the most successful architects can be priced out of their own buildings). If Ballard's *High-Rise* forecast a bleak future of unsustainable class stratification in 1970s London, 432 Park tells the story of the growing extremes of wealth inequality that are changing the landscape of this particular concrete island. As Viñoly told a reporter while the tower was under construction, New York has increasingly become a city where "there are only two markets, ultraluxury and subsidized housing."

———

By the second half of the 1960s, the political climate in the United States had shifted. Growing frustration with military policy in the Vietnam War led to widespread distrust of government projects of any sort, including the World Trade Center, which was increasingly seen by its critics as a monument to bureaucracy—a pair of "glass and metal filing cabinets" or "two shiny new sticks of Arrow staples" —a mundane harbinger of an uncertain future. In *Harpers*, Wolf von Eckardt, who had praised the design as "a stunning tour de force" when it was first unveiled, now called it "utterly inhuman," the "world's tallest fiasco," and a "fearful instrument of urbanicide." A sidebar piece in *Architectural Forum* referred to the project as Gargantua-by-the-Sea, comparing the buildings to Rabelais' grotesque cannibalistic colossus.

European critics similarly saw the project as a symbol of a particularly reckless strain of American capitalism —something made visual by Hans Hollein's brutally

effective photomontage *Rolls-Royce Grill on Wall Street*, which pasted the iconic radiator onto an image of downtown Manhattan, as if it were its own towering edifice. Writing in *Architecture d'Aujourd'hui*, Manfredo Tafuri described this species of American development as malevolent growth, what he termed the "bastard excrescence of the architecture of bureaucracy." Later, the English *Architectural Review* printed a full-page photograph of the nearly completed World Trade Center menacing over the steeple of St. Paul's Chapel with the headline "Death of the Heart." The image ran alongside an article condemning the latest and most terrifying example of the "ultimate sterility towards which monumental development is heading" and decrying American developers as "gamblers on the giant scale, whose only interest is in the next fall of the dice."

As metaphors of violence emerged in nearly every review of the project, David Rockefeller's concept of "catalytic bigness" began to acquire a sinister undertone. As Jane Jacobs had predicted when the design was in its early stages, a project of such catalytic ambition could just as easily be cataclysmic. Even Huxtable, who had always understood both the complexity and the stakes of the project better than any of her fellow critics, started to express reservations. In a 1966 *New York Times* article titled "Who's Afraid of the Big, Bad Buildings?," her confidence in Yamasaki began to waver for the first time. Yamasaki's use of "delicate detail on massive construction as a means of reconciling modern structural scale to the human scale of the viewer" had, she felt, begun to feel "more disturbing than reassuring." What Huxtable was tracking was not so much a change in her own opinion as an evolution of the larger cultural context in which Yamasaki's design had

become increasingly "disquieting." Acknowledging the lack of information available to the public, Huxtable conceded that the World Trade Center's "potential is greater than its threat," before warning that "there are so many things about gigantism that we just don't know. The gamble of triumph or tragedy at this scale—and ultimately it is a gamble—demands an extraordinary payoff. The trade center towers could be the start of a new skyscraper age or the biggest tombstones in the world."

———

Zoe slept in my arms as our train glided through the Swiss countryside. Nina and Danielle had been coming to the smaller independent art fair in Basel every June for the last decade. Now, after years of politics, they had been accepted into Art Basel, the annual event at the gravitational center of the increasingly itinerant art world. It was important that things go smoothly. I was there to help, to unpack crates, hang photographs, change money, run errands, and watch Zoe while Nina worked.

Nina and Danielle always rented the same small apartment from a graphic designer who lived a short walk from the convention center. Every year their assistant hid a pack of cigarettes behind the Ikea dresser in the living room. She had been fired around Christmas for extravagant misuse of the gallery's FedEx account, but the American Spirits were still there, secured to the back of the dresser with a long strip of blue tape. Inside the pack, as I had hoped, I found two joints, tucked neatly among the cigarettes. Nina had gone straight to bed and Zoe was curled up beside her in the dark bedroom. I sat in the morning sun on a reclining chair on the balcony, smoked half a joint, and

downloaded a virtual tour of the Basel headquarters of the Swiss pharmaceutical company Novartis—a sprawling corporate compound with buildings designed by Yoshio Taniguchi, David Chipperfield, and Pritzker Prize winners Frank Gehry, Tadao Ando, Rafael Moneo, Fumihiko Maki, Álvaro Siza, Eduardo Souto de Moura, SANAA, and Herzog & de Meuron.

When the buffering wheel eventually stopped, a camera hovered between buildings. It tilted slightly forward, moved smoothly down a canyon of glass facades, and sailed upward over a rooftop. The camera's view, its lens fixed perpendicular to the surface of the earth, flattened the buildings into a map. A narrator spoke in a neutral Continental accent over a soft instrumental soundtrack. *Welcome to the Novartis campus in Basel. The headquarters of Novartis is a place of knowledge, innovation, and encounter. More than 2,500 scientists and over 7,500 employees from more than a hundred countries are working here on the vision of a long and healthy life.* What is it about drones that always make the real look rendered? Something to do with frame rate, probably. Or maybe this whole video is rendered, and the buildings aren't real at all. There are several pieces of duct tape on the edge of a roof panel on the Gehry building. The tape could be proof that it is real, or could it be a decoy—a rendered piece of duct tape added for enhanced authenticity? *A complex development process is required to successfully launch a medication, including key success factors such as innovation and interdisciplinary collaboration. The architecture of the campus reflects the global diversity of Novartis and creates ideal conditions. We are working with future-oriented laboratory models and multi-space concepts and are applying state-of-the-art technologies.*

What was the music? I held my phone over the computer's internal microphone, another wheel spun, then it vibrated. The phone heard Visage's "Fade to Grey," but if it was there, its original synthpop structure was so deconstructed, so lost in this electronic instrumental cover, that I could barely make it out. The drone stared down like a raptor at workers filing between buildings with rolling suitcases and bicycles. The gaze of a drone never feels nonviolent. The camera glided up through another courtyard where a single awning window was left slightly ajar, glass pitched just enough to momentarily reflect the passing drone. *Associates can choose between a wide variety of areas for productive wellbeing, including parks and cafes. Innovation research shows that new ideas come from unexpected impulses. That's why works of art form an important part of the campus. They are intended to inspire and awaken a feeling for connections and new perspectives.* The camera flew backward now, out over a stand of trees. Another building came into view. *Exceptional performance needs an exceptional environment.*

The next morning, I walked for hours with Zoe on my shoulders. Basel is where the mathematician Leonhard Euler was born and these bridges would have been among the first he crossed, years before he laid the foundations of topology and graph theory with his negative resolution to the Seven Bridges of Königsberg problem. Zoe and I followed our own Eulerian circuits back and forth across Basel's six bridges, crossing occasionally, on the outermost arcs of those loops, into Germany or France before returning to the massive complex of exhibition halls that contain the fair. I bought an espresso and a bottle of water from a kiosk in the plaza, pulled my exhibitor's lanyard from under my shirt, and walked tentatively into the warren of gallery booths.

Artists should not be at art fairs. To be present is to implicate yourself in the financial engine that drives the art market, and one of the fundamental social contracts that sustains the art world is that artists agree to act, through a very rehearsed kind of denial, as though they are wholly ignorant of the mechanics of the market that supports them. Nina and Danielle hated doing this, but they were good at it. They would stand here in this windowless hall (or one that looked exactly like it in London, Miami, Paris, New York) for days, warm and unpretentious, jetlagged and hungover, somehow remaining authentically them-selves in an environment often crackling with insincerity. We found Nina. She read to Zoe in the exhibitor's lounge while I waited in line to buy her some lunch.

———

Art Basel was founded in 1970 by Swiss art dealers Trudi Bruckner, Balz Hilt, and Ernst Beyeler, in an effort to balance the growing influence of auction houses on the primary mar-ket. It was not the first art fair (Art Cologne opened three years earlier), but it eventually became the most important and the foundation of the sales model that has fundamen-tally altered the landscape of the contemporary art mar-ket. As galleries have increasingly grown to rely on fairs for profits, the art world has shifted from a network of loosely connected local economies to a single, increasingly homo-geneous global marketplace. It is an economic model that puts small galleries at a distinct disadvantage—to say no to the fair is to not exist, but to say yes is often to commit to sell work that could not possibly cover the costs of participation.

The growth of the postmillennial art market has largely been fueled by the growing concentration of wealth at

the very top. In May 2015 Picasso's *Les Femmes d'Alger* (*Version O*) broke auction records when it sold for almost $180 million at auction. Writing about the sale in the *New York Times*, Neil Irwin tried to make sense of the price by posing a hypothetical limitation that no buyer would reasonably spend more than one percent of their net worth on a single painting. The last time *Version O* had been sent to auction, in 1997, it had sold for about $32 million. At that time, Irwin notes, there were only a dozen people in the world for whom that price would have been below the one percent threshold. When the piece went to auction again in 2015, there were fifty potential buyers for whom $180 million would only be a single percent of their worth, so in that sense, the second sale was a relative bargain. In 2017, when *Salvator Mundi*, which may or may not have been painted by Leonardo da Vinci, was sold for $450 million, Irwin's logic held. Auction results garner headlines, but the extremely small niche market for ultraexpensive paintings is not so much a reflection of a growing interest in art itself as it is an illustration of how art can be exploited as a financial tool and a largely unregulated instrument for the international transfer of money.

The art market and the real estate market are not always in lockstep, but Irwin's point lays bare a fundamental change in postmillennial wealth distribution. The buyer of *Version O* was eventually revealed to be the former Qatari prime minister Hamad bin Jassim bin Jaber Al Thani, who was also a financial backer of the retail space at 432 Park, which is now the New York headquarters of the auction house Phillips.

I woke up early, walked upstream, and jumped into the Rhine. I had my phone, wallet, shoes, and shirt strapped to my side in a little orange float bag, as is the custom in Basel, and let the current propel me downriver. When I returned to the apartment, Zoe was eating blueberries off of the kitchen floor. She was one and a half now, with deep dimples and hair just long enough to pull into a ponytail on the top of her head. Zoe and I walked Nina to the convention center and took the number 3 tram to the Novartis Campus stop on the far side of the Dreirosenbrücke. The main entrance of the campus is a glass pavilion, described in official company literature as "a reception device" designed to "resolve the contradiction between the desired transparency and the security required." The pavilion—essentially just a safety-glass box with a cantilevered fiberglass roof, knowingly furnished with several Franz West chairs and a leather reception desk—embodies the anxiety of a company seeking both corporate opacity and public-facing transparency.

I first learned about the Novartis campus when I was in Basel several years earlier installing a pair of sculptures at the fair. At the end of that trip, I found a book at the Kunsthalle bookstore about a Novartis laboratory building designed by the Portuguese architect Álvaro Siza. I remember being struck at the time by a sense that the building, or at least the version of it pictured in that book, was doing something I wanted my work to do. The labs had been photographed empty in the weeks before they were put into use and the vacant spaces seemed to pulse with latent energy. This was architecture designed to contain all the things in the world least like architecture—bacteria, virus, liquid, odor, error, chance, whimsy. The spaces were antiseptic and cold, still an incomplete thought without the addition of the soft matter, the bodies and microorganisms, that would soon

render them less orthogonal, less perfect. Certain details—mirrored ceilings, rubber floors—felt almost willfully erotic, an understated provocation of the Swiss repression that seems to hold every surface on the campus in tension. I wanted to see something spill on the pristine countertops, drip down through the drawer slides and casters out onto the floor. I wanted to push my body against the expanses of Estremoz marble or jerk off on the immaculate glass walls. There was so much precision and so much restraint, you could not think of anything other than defacing it. I spent years trying to capture that same material tension, pouring water-clear urethane over glass or casting rubber in rough aluminum molds—a process which, in addition to drawing the studio into increasingly toxic material territory, never quite yielded the desired result.

———

The pharmaceutical industry in Basel has its roots in chemical production that began in the city with the manufacture of synthetic aniline dyes in the late 1800s. In nineteenth-century England the textile industry was booming but entirely dependent on natural pigments like indigo and carmine, which were slow and painstaking to use. A breakthrough came in 1856 when William Henry Perkin accidentally discovered a rich, saturated purple dye while experimenting with aromatic hydrocarbons derived from coal tar. Aniline mauve (or mauveine) became a sensation and its chemistry became a model for new synthetic pigments that would revolutionize the textile industry.

The invention of these chemical processes created an opportunity for countries like Germany, which had robust industrial economies but controlled no colonies

from which dyewoods could be extracted. Frankfurt quickly became the center of European dye production, but two hundred miles south in Basel, a small city known for the manufacture of silk ribbons, two rival dye makers, Alexander Clavel and Johann Rudolf Geigy-Merian, were capitalizing on a strategic advantage of lenient Swiss patent enforcement. Switzerland, known to its northern neighbors as *der Räuber-staat*, would not recognize chemical processes as intellectual property for another fifty years, allowing manufacturers to reproduce legally protected dyes with impunity.

By 1860 Clavel and Geigy were prospering, manufacturing aniline dyes—including mauvine and fuchsine (a brilliant magenta)—in factories on the eastern side of the Rhine. Basel was quickly becoming a center of artificial dye production, but not without consequence. In 1864 arsenic-laced water from the Geigy factory poisoned a nearby well and made seven neighbors sick. The incident was among history's first recorded toxic waste spills, but the industry continued to grow and the fast-moving Rhine continued to wash the toxic byproducts away. In 1886, the Kern & Sandoz chemistry firm began manufacturing alizarin blue and auramine (a bright goldenrod yellow) dyes in a factory on land that is now the Novartis headquarters.

We crossed back over the Dreirosenbrücke on foot and I could see the campus stretch out like a sterile fortress along the western bank of the Rhine. Zoe kicked the shoe off her left foot and watched with delight as it flew through the air and vanished into the roiling water below.

Over time, the search for dyes and solvents led to a spectrum of new chemicals—phenols, alcohols, bromides, alkaloids—molecules unlike anything encountered in the natural world. These new compounds became the building

blocks of the synthetic chemistry industry. In 1878 when the German physician Paul Ehrlich realized that one of the dyes he had been using for staining microscope slides killed bacteria, he developed a theory of "specific affinity" which would become a core principle of modern pharmacology. Ehrlich isolated a compound that could effectively treat the parasite *Trypanosoma brucei* (the cause of sleeping sickness), and he named the new medication *trypan red* because of its ruby color, a vestige of its original application as a dye.

We continued walking east, past the decommissioned brewery that held the smaller independent art fair and along the bend in the Rhine toward the riverside park that the Tinguely Museum shares with another corporate pharmaceutical campus where, in 1896, Fritz Hoffmann-La Roche opened a company concentrated on the medical applications of synthetic chemistry (today, Roche and Novartis both consistently rank among the world's five largest pharmaceutical companies). The Roche campus is defined by a white wedge-shaped tower—the tallest in Switzerland—designed by another Basel-based institution, Herzog & de Meuron. We sat at the small cafe outside the museum and I bought Zoe a croissant while she played with her one remaining shoe in the grass.

Public opinion of the pharmaceutical industry, which until the 1960s had largely maintained a reputation for innovation and progress, was slowly shifting. In 1961, birth defects in thousands of newborn children were linked to the widely prescribed morning sickness medication thalidomide, rattling confidence in the safety of prescription medications. The following year, Rachel Carson's book *Silent Spring* warned of the risks associated with the introduction of foreign chemicals into our internal environment.

By 1970, the industry had become a symbol of technological arrogance and contempt for nature, and Ciba-Geigy (the merged successor of Clavel's and Geigy's companies) was soon entangled in a decades-long scandal surrounding carcinogenic groundwater contamination linked to waste from its dye factory in Toms River, New Jersey.

Public opinion in Basel reached a new low in 1986, shortly after the meltdown at Chernobyl, when a massive fire at a Sandoz chemical storehouse spilled enough red dye, toxic agrochemicals, and insecticides into the Rhine to turn the water bright red, leaving a visible trace of the pollution and another vibrant reminder of the intertwined histories of dye, chemical, and pharmaceutical production. Protesters took to the streets with banners that read *Chernobâle* (a portmanteau of Chernobyl and the French spelling of Basel, *Bâle*).

Novartis was created by the merger of Ciba-Geigy and Sandoz ten years later. The union provided the company with an opportunity to replace the tarnished brands with something clean, conflict-free, new. The name Novartis is one of thousands of pharmaceutical neologisms, empty words synthesized from familiar sounds and syllables. It evokes another alias, Novalis, the nom de plume of the German romantic poet who wrote among his many fragments that the ideal of perfect health is little more than a scientific curiosity because only sickness "belongs to individualization." Novartis (which, like Novalis, is meant to sound Latin) combines *novus*, meaning new, and *artis*, the genitive form of *ars*, which is literally defined as skill, but carries a connotation of artistry—as in Horace's "ars longa, vita brevis" or Metro Goldwyn Mayer's "Ars Gratia Artis." Together, *novus* and *ars* merge into a simultaneous title-cum-motto contained within a single trademarked hybrid

intended to mean something like *new arts*. While Zoe shared her croissant with a starling, I wrote the words out on a napkin—N O V [A R S G R A T I A] A R T I S.

———

Oliver Sacks describes migraines with distinctly spatial language—fields, maps, horizons, points, broad regions, boundaries and limits, clearly defined centers, and huge changes of scale. One of the illustrations in *Migraine* maps a variety of comparable maladies—epilepsy, vagal attacks, migraine, narcolepsy—on a graph according to duration on the horizontal axis and intensity on the vertical axis. The result looks strikingly like a floor plan with "migraine" in the middle, an irregular doorless room, like the hidden spaces that reveal themselves under staircases or behind familiar walls in dreams.

Part of the challenge of living with headaches like this is, or so I imagine, the constant emotional and logistical trauma of normal days interrupted, of crossing in and out of the narrative of your own life as it proceeds without you and trying to make sense of the redacted passages as you go. If there is any benefit of this affliction, perhaps it is focus—the clarity of action that comes from knowing at an instinctual level how to eliminate all frivolous expenditures of energy, how to concentrate on one thing at a time.

I wonder sometimes if the root of migraine lies in the conservation of resources. If a migraine-afflicted brain simply shuts one of its hemispheres down so the other can keep running, like an electric company taking part of the power grid offline to keep the whole system from going dark. Certain species of birds—peregrine falcons, frigate-birds, white-crowned sparrows, blackbirds, mallards—have

developed the ability to put one hemisphere of their brain to sleep and continue to fly with one eye open, so they can pass over unfamiliar territory without rest during long migratory flights. Some marine mammals—pilot whales, bottlenose dolphins, fur seals—evolved a similar adaptation in order to continue surfacing for air while sleeping underwater. Biologists call this behavior, in which one hemisphere (and its corresponding eye) remains awake and vigilant while the other rests, "unihemispheric slow-wave sleep." Perhaps migraine is the vestige of a similar evolved behavior that went amiss—an incomplete asymmetric response to stress and overstimulation gone haywire.

———

Each time a new building is erected, Novartis produces a white, canvas-bound monograph meticulously documenting every aspect of the design, with detailed plans and elevations rendered in exquisitely thin line weights, deliberately overexposed photographs, and commissioned essays by chemists, architects, and executives. As I tracked each volume down from various online booksellers they slowly began appearing in my mailbox from Frankfurt, Boston, and Geneva until I had the complete inventory—identical in style and format, just as the buildings on the campus are regulated by a uniform zoning envelope—arrayed neatly on my bookshelf.

At the center of the fifty-acre Novartis campus is Fabrikstraße 10, a milky-white glass box that appears to hover above the campus' main thoroughfare. The building's recessed first story, the space that fills the void between the street and the upper core, is occupied by a four-hundred-square-meter ground-floor gallery, clad in ultratransparent

low-iron glass engineered to appear as though it were not there. This is the campus "exhibition laboratory."

The laboratory's floor, a seamless polyurethane stage raised just slightly off the ground, is bisected into two symmetrical labs with anodized-aluminum workbenches and glass projection screens (the benches suggest minimalist sculpture, the robotic arms sitting on top of them suggest biotech). Two equipment lifts inside glass columns allow experiments to be shuttled from the ultraclear exhibition space up into the labs in the building's core where thousands of silk-screened white dots transform the glass facade into a frosty-white illegible translucence. The exhibition lab provides a simulated glimpse inside a pharmaceutical research process that would never actually be allowed to leave the hypersecure confines of the "real" laboratories, locked away in the opaque mainframe that hovers above the ground, just out of reach. It is a space designed for the express purpose of *staging* research—a pharmaceutical anatomical theater.

Here, presumably, curious visitors can gather outside the glass walls like the eager surgeons huddled around Doctor Nicolaes Tulp, though in the only publicly available photograph of the space in use, the three researchers inside—the exhibitionists—appear to be alone, working diligently beneath a pair of translucent images of a bisected brain projected on glass screens.

Fabrikstraße 10 was designed by Yoshio Taniguchi, an architect so meticulous he professes only to work on one project at a time. When MoMA hired Taniguchi to design a 2004 extension to their home in Manhattan, he is said to have told the board: "If you raise a lot of money, I will give you great, great architecture. But if you raise really a lot of money, I will make the architecture disappear." Whether

or not such material sleight of hand was the right approach for an institution devoted to a movement so invested in structure and materiality is debatable, but either way, it did not work. The result, in the words of one reviewer, was "immaculate, rectilinear, capacious, and chaste"—architecture that was "breathless with un-spared expense," but very much still there. It was still there in part because, like so many architects before him, Taniguchi had underestimated the low standard of quality in New York construction, and the soaring north face of the museum's central atrium, with sheetrock seams bulging beneath an expanse of white wall, never looked as pristine as he had intended. MoMA did not disappear, though ultimately much of Taniguchi's work did when, barely a decade after its completion, the museum initiated another renovation and commissioned new, expanded public galleries.

⸻

One of the few illustrations in Paul Preciado's book *Testo Junkie: Sex, Drugs, and Biopolitics in the Pharmacopornographic Era* juxtaposes the plan of Jeremy Bentham's late eighteenth-century panopticon prison against an illustration of David P. Wagner's DialPak birth control dispenser designed for Ortho Pharmaceutical in the 1960s. The striking graphic similarity between the two clocklike emblems deftly illustrates one of the book's central concerns—the evolution of the structural metaphor of disciplinary control from a model of architectural organization to one of chemical regulation. Here, of course, Preciado is building on Foucault's historical analysis of how power maintains social control through the manipulation and regulation of bodies. These techniques evolve from sovereign

society (power enforced with the threat of death) and disciplinary society (power maintained through the protection of life) into a biopolitical system in which medical technologies allow disciplinary power structures to manage entire populations through the regulation of factors such as reproduction, immunity, and public health. In his book, Preciado lays out an argument for another mode of disciplinary control—a regime of what he calls "pharmacopornographic biocapitalism" in which the sphere of authoritarian control has been reduced from macro to micro and the systems of power that have traditionally exerted control *on* bodies have achieved a means of exerting that control *in* bodies at a molecular level. "If architecture and orthopedics in the disciplinary society served as models for understanding the relationship of body to power," Preciado writes, then the new "models for body control are microprosthetic." This new mode of disciplinary power assumes the material form of antibodies and hormones, vaccines and medications (as well as the biopolitical systems that determine who can and cannot access them). "The body no longer inhabits disciplinary spaces but is inhabited by them."

———

The economic principle at the center of the pharmaceutical industry today is the idea that the consumer pays not only for the manufacturing of the drug, but for the intellectual labor of its research and development. The product is not the medication, it is the intellectual property. As a former chairman of the Novartis Foundation wrote in one of the white canvas-bound books, "we sell knowledge that has been accumulated over generations and in which billions of dollars have been invested." Not new things, but new ideas.

This intellectual property, and its legal enforcement, resides at the center of the industry's identity and its profit model. The consumer must be constantly reminded of the sanctity of the research and development process because it is presumed to be the primary driver of exorbitant brand-name drug prices (particularly in the United States, where Novartis does a third of its business and drug prices are generally much higher than in the rest of the world). Like the medical patent itself—a legal means of withholding information by disclosing information—Taniguchi's exhibition laboratory is designed to show everything and reveal nothing, to be both opaque and transparent, and to give physical form to a proprietary product produced at a microscopic scale. In this sense, his building represents a perfect emblem for the industry as a whole. But as such, it may also serve as decoy—a luxurious piece of artifice engineered to distract from the reality that the industry's motivations are more often aligned with maximizing profit than democratizing health.

———

In a passage of Victor Hugo's *Notre-Dame de Paris* particularly beloved among architecture's more literary practitioners, the cathedral's archdeacon describes the moment in the fifteenth century when the printed word eclipsed architecture as the principal register of human civilization. "The human mind discovered a means of perpetuating itself, which was not only more lasting and resistant than architecture but also simpler and easier." The book killed the building. "In the days of architecture," the archdeacon explained, "thought had turned into a mountain and taken powerful hold of a century and of a place. Now it turned

173

into a flock of birds and was scattered on the four winds occupying every point of air and space simultaneously."

When a fire tore through the attic of Notre-Dame in 2019 Preciado stood on the Pont de l'Archevêque, phone in hand, watching "1,001 images proliferate across the screens" like Hugo's flock of birds scattering on the wind. In that "fusion of lead and wood," Preciado saw both a "medieval version of the Twin Towers" and "an astronomical technology"—a spaceship with a limestone buttress gantry preparing for takeoff beneath "a boiling rain of tweets."

———

Ibsen's master builder, Halvard Solness, was not the first literary architect (others, such as Seth Pecksniff in Dickens' picaresque novel *Martin Chuzzlewit,* would have better claims to the title), but his character resides at the center of the archetype. He may also be the hardest of all literary architects to like. In a recent *New Yorker* review of a production of *The Master Builder,* Hilton Als described Solness' joyless megalomania as "emotional vampirism"— a visceral metaphor for a man whose insatiable ambition seems to deplete everyone around him. Solness treats his employees with contempt and his wife with indifference. He is successful, but spiteful of his own advancing age and haunted by the possibility that his professional ascent was inextricably tied to the tragic death of his two children in a fire he imagines he might have prevented. When Solness is visited by Hilde, a young woman he met ten years earlier at a topping-out ceremony for a church, he recalls being struck as he ascended the steeple by a vertigo so powerful that he has never left the ground since. In the play's climax, driven by Hilde's encouragement, Solness attempts to

climb to the top of a newly completed church, and before a crowd of onlookers falls to his death.

Solness is not entirely Ibsen's invention. According to his biographer Michael Meyer, Ibsen was on vacation in the Italian Alps when he first heard the legend of St. Michael's Church in Munich from an acquaintance of the young Viennese student Emilie Bardach, with whom he was having an affair. The story holds that the architect threw himself from the belfry when the church was completed. Variations of the same legend, with moral undertones of hubristic overreach or Faustian quid pro quos, can be found throughout northern Europe. In Copenhagen, for example, the architect of the Church of Our Savior is said to have cast himself off the roof when he realized that he had mistakenly wrapped the spiral stair around the spire counterclockwise.

These stories belong to a larger tradition of superstitions about human sacrifice in the service of architecture. In a 1909 essay titled "Foundations Laid in Human Sacrifice," the theologian and philosopher Paul Carus described the ubiquity of immurement in folklore: "Perhaps the most persistent among religious superstitions from the beginning of mankind down into so-called civilized ages has been the custom of offering human sacrifices and burying them in the foundation stones of important buildings." There is a Balkan folk belief, one of several derived from the traditional ballad of "The Walled-In Wife," that a building can only be completed if an offering has been made during construction. In order to make such a sacrifice, superstitious workers would entice a passerby to cast a shadow over the incomplete foundation and then measure the length and breadth of the shadow with string, which they would bury in a box within the foundation walls—symbolically

entombing the body through the proxy of its dimensions. It was believed that the passerby would die in forty days and the shadow would be turned into a guardian spirit that would protect the building forever.

In Germany there are numerous variations on a myth about entombing infants in the foundations of castles and fortresses as a sacrifice to protect against storms and war (most stories include the detail that the child can still be heard crying or talking from within the walls). In Japanese the term *hitobashira* or "human pillar" refers to an ancient immurement rite in which a person was buried alive under the cornerstone of a large building as a plea to the gods that the building not be destroyed by natural disasters or enemy attacks.

———

Like Halvard Solness, Yamasaki was afraid of heights. "Man is a ground animal," he wrote in notes for an undated speech, and "nearness to the trees, the flowers, and the earth itself offers security that cannot be found from a ten or twelve story window." In his first high-rise, the Michigan Consolidated Gas building in Detroit, Yamasaki tested a theory that an exterior wall with a thirty percent glass area was "enough to completely eliminate feelings of claustrophobia and still give the secure sense of being in a building." Satisfied with these results in Detroit, Yamasaki implemented a similar scheme of slender floor-to-ceiling openings in his design for the World Trade Center, with narrow bays running uninterrupted the entire height of the building. At the foot of the tower, trios of vertical lines converged into the tall lancet arches that greeted visitors at the plaza level. Yamasaki based the exact width of each

window, twenty-two inches (and by extension the governing forty-inch module of the fenestration), on the span of his own shoulders, inscribing his slight frame on the facade and embedding his own dimensions within the walls of the two buildings.

When he presented the scheme to the Port Authority, Yamasaki insisted that the narrow windows, set back a foot from the exterior wall, would greatly increase the efficiency of the cooling system by reducing heat from the sun. Furthermore, the strong lines of the structural members, running vertically like flutes on a column, would have the effect of making the building seem even taller than it was. But Tozzoli hated the narrow windows, and when he refused to sign off on such limited views in the public (and potentially highly profitable) spaces at the top of each tower, Yamasaki threatened to quit. Knowing it was a job Yamasaki would never walk away from, Tozzoli took a car to the Plaza Hotel where he was packing his bags and persuaded him to stay on. Yamasaki reworked the facade to provide for wider windows on the upper floors that eventually became the observation deck and the spectacularly successful restaurant Windows on the World.

These constant conflicts with Tozzoli, and the greater demands of the project, continued to affect Yamasaki's health. Even as he projected a calm confidence, his body was in revolt. He was suffering from debilitating stomach pain despite the operation he had undergone at the outset of the commission, and it was clear to those close to him that his health was in decline. One of the few personal items among Yamasaki's papers is a handwritten letter from his friend Manfredi Nicoletti, who had seen Yamasaki recently in Rome. Struck by how frail he had seemed, Nicoletti implored Yamasaki to take better care of himself.

My dear Yama, Please excuse me if in this letter I am going to take the liberty to intrude in your private life. But you know that I love you like you were my father (the kind of father I never had)—I am very worried about your health—you must take very good care of yourself for two good reasons which are responsibilities on your part: for those who love you—for what you can give to architecture—you cannot believe yourself that the Trade Center will be the culmination of your career. You must give a lot more to architecture—people expect to learn from you a lot more... I beg you not to travel too much, not to drink at all.

Despite doctors' admonitions, Yamasaki slept little and continued to push his body beyond its limits. Employees at the time recount long drunken lunches despite immense pressure to finish work at the office. On his way home from one trip Yamasaki had a seizure and was rushed to the hospital where he continued to work, with employees shuttling plans to and from his bed. He remained hospitalized for weeks, and before he was released he fell in love with one of his nurses and ended up living with her briefly before that relationship also collapsed.

———

Glossaries of carpentry and construction are replete with anthropomorphic terms—oculus, dentil, header and footer, cheek cut, hip rafter, eyebrow lintel, cripple stud, weep hole. Chimneys have throats. Vaults have ribs. Windows sweat. Hinges have knuckles and buildings have bowels. There are elbow joints and finger joints, collar beams and haunch beams. A facade is a face. A male fixture fits a female socket. A tongue fits a groove. Contemporary architectural parlance extends this metaphorical connection with corporeal terms

like skin, membrane, exoskeleton, follicle, and capillary. In French, a moldering stone facade is called *lépreuse* (leprous). In English, a contaminated building is said to be "sick."

For as long as there have been buildings, buildings have been compared to bodies. The body is codified within architectural language and projected onto buildings through units of measurement—digits, palms, feet, cubits, fistmeles, spans, shaftments—many of which originate in the writings of Vitruvius that are generally presumed to be the oldest surviving architectural text. Vitruvius was a humanist—he believed in architecture in the image of man and he made his students study anatomy, insisting that "healthfulness was their chief object." Vitruvius mapped Pythagorean geometry onto bodies with a system of proportion interpreted and illustrated by Cesare Cesariano, Fra Giovanni Giocondo, Leonardo da Vinci, and others as a series of male figures stretched uncomfortably within circles and squares. Albrecht Dürer's *Four Books on Human Proportions* expanded the Vitruvian model to include other body types—a healthy young woman, a sturdy infant, an infirm old man—but, by and large, the central conceptual metaphor of western architecture has remained the body of an idealized young man overlaid with a circle. The circumference of that circle is defined on the bottom by the base of the man's feet and near the top by the middle fingers of his outstretched hands in such a way that its center falls exactly at the navel. The distance from the fingertips of the man's upstretched arms to the ground is exactly twice the distance from his belly button to the ground (the circle's radius). The navel is the focal point of the proportional system—a bullseye at the center of each diagram. This logic carries through to twentieth-century studies like Ernst Neufert's *Man as Measure and Goal* and Henry Dreyfuss'

The Measure of Man, which are the basis of the indexes of architectural standards on the shelf of every design office today, codifying the universal rules of human proportion.

Even as modernism began to imagine a mechanical, rather than an anthropomorphic, architectural ideal, the Vitruvian diagram endured. Le Corbusier's Modulor—an attempt to recalibrate human proportion according to the more rational metric system—liberates the representative figure from its geometric constraints, but retains its omphalic focal point, rendered as a conspicuous white dot in the midsection of the distended, faceless, black figure. One photograph of Le Corbusier with a wire mesh sculpture of his ideal man shows the architect gazing at a navel represented, with almost comical emphasis, by a formidable section of steel pipe. The circle and the square fall away. The navel remains.

The strongest diagrammatic counterargument to the Modulor may be Louise Bourgeois' Femme Maison, the recurrent female figure with a house for a head that appears in eponymous paintings, prints, and sculptures, as well as, quite fittingly, on the iconic cover of Lucy Lippard's 1976 anthology of feminist art writing, *From the Center.* Unconstrained by circle or square and (with the exception of one edition modified years after it was first printed) conspicuously without navel, Bourgeois' Femme Maison belongs to a different realm altogether, a psychological space unconcerned with the physical constraints of geometry or proportion.

Considered in relationship to other modernist belly buttons—Jean Arp's *Die Nabelflasche,* Paul Klee's *Omphalo-Centric Lecture,* Freud's "dream navel," or Joyce's "footnote of the flesh"—the Modulor's center might be read as a blind spot or lacuna, implicated in too many inextricable meanings to be reducible to simple

logic. Nevertheless, this center of gravity, the space of intuition and digestion and gestation, resides at the geometric if not physiological heart of nearly all architectural diagrams designed to deal with measurable extremities (arms, hands, legs, feet) and rational organs (eyes, ears, brain), but not bellies. The stomach is the one territory architectural logic seems incapable of colonizing.

The architect wants to control everything, but the center resists. Even his own stomach—plagued with anxiety, indigestion, and uncertainty—defies rational order. Frederick Kiesler saw the house as a body with a digestive system that can "suffer from constipation." Frank Lloyd Wright was particularly preoccupied with nausea (his own and that of his buildings, which he often anthropomorphized), frequently describing his distaste for one thing or another in terms of gastric distress. In a 1930 lecture titled "The Cardboard House" Wright argued:

> Any house is a far too complicated, clumsy, fussy, mechanical counterfeit of the human body. Electric wiring for nervous system, plumbing for bowels, heating system and fireplaces for arteries and heart, and windows for eyes, nose, and lungs generally. The structure of the house, too, is a kind of cellular tissue stuck full of bones, complex now, as the confusion of bedlam and all beside. The whole interior is a kind of stomach that attempts to digest objects—objects, "objects d'art" maybe, but objects always. There the affected affliction sits, ever hungry—for ever more objects—or plethoric with over plenty. The whole life of the average house, it seems, is a sort of indigestion. A body in ill repair, suffering indisposition— constant tinkering and doctoring to keep it alive. It is a marvel we its infesters do not go insane in it and with it. Perhaps it is a form of insanity we have to put into it. Lucky we are able to get something else out of it, though we do seldom get out of it alive.

In these ten sentences, the afflicted building—a counterfeit body, but a sick body nonetheless—spins into something monstrous, devouring its hapless infesters while its creator, half-lunatic, half-surgeon, tries to keep it alive. Wright stops short of comparing himself to a doctor directly, but the implication is there. He revisits the comparison in a 1931 lecture titled "To a Young Man in Architecture," warning students that "the physician can bury his mistakes, but the architect can only advise his client to plant vines."

———

There are either two or three Yamasaki buildings in Los Angeles depending how you categorize the Century Plaza Towers—a pair of identical forty-four-story office buildings, each equilaterally triangular in plan, that dominate the skyline of Century City, the city within a city built in the 1960s by Alcoa and William Zeckendorf on the former backlot of Fox Studios in West Los Angeles.

Yamasaki's Century Plaza Hotel—a large gently curving parenthesis-shaped building—was part of the original development. The two Century Plaza Towers, directly downhill and east of the hotel, were completed a decade later, shortly after Yamasaki had partnered with Alcoa to develop the custom aluminum alloy for the World Trade Center. The towers are situated on an open plaza, vertex to vertex, so that in plan the two footprints describe a shape like the close-door icon on an elevator control panel. They are connected by an underground concourse, but above ground they do not quite touch. This gap—a sliver of sky between aluminum monoliths—gives the entire scheme the feel of a pagan monument. As you walk between these towers and look back uphill toward the hotel directly

west, it is tempting to imagine how one evening a year the sun might set perfectly between the two silver menhirs. Yamasaki claims to have come up with the double-triangle scheme during a night of fitful sleep, though in section the plan of the two towers is nearly identical to Alcoa's iconic postwar hourglass logo. I have never been inside the Century Plaza Towers, but I have occasionally pulled over to stand between them in search of the same material energy that the World Trade Center had. It is not there, though they appear to work better as buildings.

———

Nearly all the work I had made in the previous decade relied on entropy in one way or another—plastic stretched to its breaking point, glass balanced precariously on rotting fruit, cast rubber that would deform and discolor in the sun. I sought out instability, tension, and inherent vice as a strategy for animating the inanimate. This undoing presented a litany of conservation issues. A gallery visitor bit into a cucumber in New York. Flies infested a sculpture in London. A crate got seized en route home from Mexico City because oranges were listed as a material on the customs paperwork. Days before a benefit auction in Dallas an unwitting preparator sliced through the surface of a wrapped work, mistaking the taut urethane skin for packing material. Individually, these events were bumps in the road—amusing anecdotes, easily resolved with insurance companies, that would become part of the narrative surrounding the work—but now something more troubling was happening. Five or ten years later, much of the work was finding its way back to me accompanied by concerned calls from collectors or emails from registrars who had

noticed the extremities of white rubber sculptures gradually yellowing or who had opened a crate to find the brittle surface of enamel painted on polyethylene splintering at the edges. Slowly, the most unstable pieces returned to the studio—one piece from a museum in a crate of astonishing complexity, another wrapped only in a towel in the back seat of a black Mercedes. I was not surprised, given the instability of the work in the first place, but I also understood their grievance. I had promised them something simultaneously provisional and archival and I should have anticipated that that was impossible.

———

Early in Peter Greenaway's film *The Belly of an Architect*, the fictional American architect Stourley Kracklite, who has come to Rome to curate an exhibition about the French Enlightenment architect Étienne-Louis Boullée, is the guest of honor at a lunch on the high colonnade of the Altare della Patria with his young wife, Louisa. They are joined by Caspasian (an Italian architect responsible for financing the exhibition, who does little to conceal his interest in Louisa) and Caspasian's sister Flavia. The table is set with a lurid red tablecloth. A model of the Colosseum, piled with green figs, sits at its center. Kracklite, played with lumbering pathos by Brian Dennehy, looks withered in the heat. He has had terrible stomach pains since he arrived in Rome. As they eat, Caspasian reminds Kracklite that Boullée was Albert Speer's favorite architect and recounts an ancient rumor that Augustus' wife Livia killed the emperor with a poisoned fig. Kracklite returns to his apartment and lays a postcard of a bronze statue of Augustus on the bed of a large Xerox machine. Flashes of acid green fill the room.

Hunched over the machine, Kracklite grips his own stomach in pain while incrementally enlarged copies of the sculpture's naked abdomen slide into the outfeed tray.

The Belly of an Architect is at times relentless in its singular focus on the conflict between the endurance of architecture and the impermanence of the body—what Greenaway calls "the relationship between the soft body and the hard core." Kracklite is obsessed with the fragility of his own body. He is impotent with pain and ridiculed by Louisa—looking less like the emotional vampire than like his pallid, depleted victim. He has dreams of falling down stairs. As planning for the exhibition continues, monuments of Roman Fascism begin to assert their inescapable presence in the city as Kracklite discovers that his underwriters are siphoning funds to restore Mussolini's Foro Italico.

Later, as a despondent Kracklite visits the apartment of Caspasian's sister Flavia south of Rome, the Palazzo della Civiltà Italiana—the austere centerpiece of Mussolini's unrealized Esposizione Universale Roma—looms on the horizon. The palazzo, designed in 1937 by rationalist architects Giovanni Guerrini, Ernesto Bruno La Padula, and Mario Romano, has four identical flat facades composed of six rows of nine arched openings designed to evoke the loggias of the Roman Colosseum. Its core is set back from the facade so that the open colonnades appear to contain nothing but darkness. The Palazzo's sobriquet, "the square Colosseum," is a testament to the fundamental tendency of Fascist architecture to repackage the old as new, to disguise nostalgia as progress. It is a uniquely sinister building, and it performs the role of Mussolini's architectural metonym for Greenaway as it did for Roberto Rossellini in *Rome, Open City*, Michelangelo Antonioni in *L'Eclisse*, and Bernardo Bertolucci in *The Conformist*.

When Kracklite visits a doctor, he is seen waiting anxiously in the examination room, deliberately counting out the length of his own intestine with surgical tubing measured between his nose and his outstretched arm. He learns that he has stomach cancer and several hours later, collapsed in a drunken heap beneath the fountain in the Piazza della Rotonda, he is arrested for disturbing the peace. He is taken to a police station where he is questioned by an officer sitting behind a long wooden table. Mounted to the wall above the table are fragments of a massive marble sculpture—head, elbow, hand, and stomach.

Greenaway shot the interrogation scene in the courtyard of the Capitoline Museum and the marble body parts belong to the *Colossus of Constantine*, an acrolithic statue of the late Roman emperor, with exaggerated bulging eyes and an aquiline nose. An acrolith is a form of composite sculpture, common in classical statuary, in which a figure's body is made of a wooden armature draped with fabric or (as historians believe was the case here) a brick-and-mud infill covered in gilded bronze, while the exposed flesh of head, hands, and feet is rendered in carefully sculpted marble. It is a shortcut—an economic use of material and a means of upscaling. Such a sculpture would never have had a marble belly. I paused the film, pulled an image of the Capitoline Museum up on my phone and held it in front of the screen. The head, elbow, and hands belong to the original, the belly does not. The fragment of stomach over Kracklite's shoulder was a plaster prop.

———

As 432 Park was nearing completion, the Italian fashion house Fendi announced that it would celebrate its ninetieth anniversary by moving its headquarters into the Palazzo della Civiltà Italiana, which had stood empty since Mussolini commissioned it shortly before his fall from power. It seemed impossible to me that this building could be absorbed so seamlessly into the syntax of luxury, but the announcement came and went without much attention. One of the few objections ran in the *Architectural Review*, where Owen Hatherley suggested that Fendi's engagement with the building "propounds a notion of 'good taste' that is deeply similar to that of the fashion industry—shamelessly elitist, willfully sinister, hierarchical, classical, its apparent minimalism belied by an obsession with the finest possible material and the severest cut." As compelling as the architecture of the era may have been, Hatherley concludes, "its values were deeply sick." Asked to comment on the matter, Fendi's creative director Karl Lagerfeld evaded any associations with the past by comparing the building to "a spaceship being transported into the future," while chairman Pietro Beccari simply maintained that such a "masterpiece of architecture" is "beyond a discussion of politics. It is aesthetics."

It was difficult for me to look at the empty colonnades of 432 Park's mechanical floors and not think of the palazzo rising above the south of Rome. 432 Park is the product of global capitalism, not authoritarian rule. As important as that distinction is, there is something about the austerity of its form that shares a sensibility with the most conservative strains of modern architecture. Just as the palazzo's visual power resides in the redeployment of the classical form of Rome's Colosseum in a rationalist mode, the stark geometry of 432 Park feels uncomfortably like the fundamental program of the skyscraper reduced to its most minimal form.

I went inside the World Trade Center for the first time in 1999. I was working for a sculptor for the summer, a job I had found posted on an art department bulletin board. Every evening, the sculptor, Donald, would fill a blue Rubbermaid pitcher with coffee and put it in the freezer. In the morning, he would carry the sweating jug to the studio and drink it as it slowly melted through the morning, so that the first cup ran thick and coarse and the last looked like water from a rusty pipe. Each cup seemed to make him more tired. Around midday he would leave to pick up his son and I would spend the afternoon alone with no clear sense of what he wanted me to do. Every object in the studio— boxes of dull tools, half-finished sculptures, decade-old magazines—felt burdened by Donald's sense of resignation. There was nothing about the job that would recommend the profession to anyone, but I convinced myself that when I became an artist it would be nothing like this.

At the end of the summer, Donald invited me to a workshop at the World Trade Center. I was put off by the vagueness of his description, but he pressed hard and I agreed only because I had always wanted to go inside the building. The workshop was on a Saturday morning. I came up the escalator from the subway into an empty lobby—acoustics hardened by acres of marble. This was the same expanse of "tyrannic grandeur" Pam crossed in Don DeLillo's novel *Players*, when she mistook one tower for the other on her way back to work at her grief management firm after lunch and found herself on the wrong eighty-third floor. Two guards sat behind a marble desk flanked by geraniums in oversized chrome planters. They asked me for identification, took my photograph, and produced a plastic visitor

badge on a lanyard—standard operating procedure ever since Ramzi Yousef had driven a massive urea nitrate hydrogen bomb in a Ford Econoline van into the parking garage three levels below when I was in high school. The elevator doors closed and opened again on an interior corridor that was as drab as the soaring lobby was ornate—shaky fluorescent light, perfunctory fittings, and worn colorless wall-to-wall carpeting. In those hallways I could as easily have been five hundred feet below ground in a windowless bureaucratic bunker as halfway up what had once been, if only briefly, the tallest building in the world.

The smell of cigarettes, long since banned inside New York office buildings, still lingered in the carpeting, and the ceiling tiles were yellowed on the corners like stained teeth. Inside the room listed on my badge, a foam core sign on an easel read, "if you leave for any reason, you may get the result but you have no right to expect it." I felt immediately that coming here was a mistake, but I continued. I made up an address and phone number and wrote my name on a nametag with a Sharpie. Inside the workshop space the ceilings were uncomfortably low, a condition exaggerated by the wide expanses of open floor. From a distance, the narrow windows sliced the view into pieces too disjointed to be reassembled by the eye without tremendous effort. Unlike the Michigan Consolidated Gas building, where the vertical windows run from floor to ceiling and are separated only by narrow structural members, the World Trade Center windows were set back between thick exterior supports and stopped short of the floor to accommodate a cumbersome baseboard radiator cabinet, as if there were nothing particularly spectacular to see on the other side of the glass.

Donald was seated in the front row. I nodded hello and found a folding chair near the door. A speaker who seemed

familiar to Donald rolled up his sleeves and made two circles on a dry-erase board. In one circle he wrote "this is what happened." In the other he wrote "this is the story you tell yourself about what happened." I liked that. He tapped the white board emphatically with the butt of his marker and I copied the diagram into a notebook. From there, the rhetoric spiraled into incoherent self-help blather. "If life feels empty and meaningless, then the idea that life is empty and meaningless is empty and meaningless." My skepticism began to assume physical dimensions—a cold sweat and a claustrophobic shudder. I no longer cared what Donald thought. It had been a mistake to come. I rose from my folding chair and everyone in the room turned. The voice at the front of the room paused. "Your resistance is proof that you need to stay," the speaker offered, but I had already reached the door.

Back in the lobby I changed elevators and took the express to the hundred-seventh floor. Like the lobby, this floor was airy and extravagant, with high ceilings and sweeping panoramic views, a world apart from the ninety-four stories of generic office space that comprise the building's midsection. It is common enough for large commercial construction projects to spend lavishly on public spaces and economize elsewhere, but the discrepancy here felt extreme—like Constantine's acrolith, all marble at the head and foot and nothing more than sticks and plaster sandwiched in between.

The bar had just opened for the day and the bartender was slicing lemons and stacking coasters in neat cylinders on the bar. I ordered a beer, figuring it would be the least expensive way to avoid being asked to leave. On these upper floors the exterior columns narrowed and converged, allowing for lighter fenestration and much taller

and wider views than elsewhere in the building. From this height, you do not feel in the city so much as above it. "To be lifted to the summit of the World Trade Center is to be lifted out of the city's grasp," Michel de Certeau wrote in *The Practice of Everyday Life*. The perspective "transforms the bewitching world by which one was *possessed* into a text that lies before one's eyes."

This view was Yamasaki's concession to Tozzoli, and it was breathtaking. It was a view not only of New York, but of the vast confluence of rivers and estuaries on which the city was built. At this altitude, you can see the full twenty-five-mile radius of the Port Authority's domain—Port Elizabeth, the Red Hook Container Terminal, the Bayonne Marine Terminal, six airports, and every crossing between New York and New Jersey. It is easy to imagine Tozzoli and Tobin willing the towers into existence solely for the simple pleasure of eating lunch here on a clear day and looking out over every acre of their vast circle of influence.

———

Zoe pressed her face against the glass balustrade and watched a miniature airplane suspended on two wires disappear into a hole in the tarmac, then emerge a moment later from the other end of the runway to shakily take off again. The plane is the only remaining moving piece of the Panorama of the City of New York, a 9,365-square-foot replica of the city, conceived, like so much of the infrastructure it depicts, by Robert Moses. The panorama was built as a celebration of New York City infrastructure for the 1964 World's Fair in what is now the Queens Museum. The bridges so beloved by Moses (the great builder of roads who did not drive) are etched in brass. When it opened,

small "helicopters" conveyed visitors over the map and a voiceover described the "lines of force, paths of energy," and "bold and eloquent poems in concrete, glass, steel" laid out on the floor below. The city's parks and playgrounds were painted phosphorescent green and thousands of tiny lights flickered on and off to indicate municipal services— red for libraries, white for hospitals, blue for elementary schools. Every building in the city's public housing network is painted red, a detail that emphasizes both how expansive the system is—by even the most conservative estimates, these buildings house a population larger than New Orleans—and how much of it is built on the city's most vulnerable low-lying coastal plains—broad swaths of Rockaway, Coney Island, Red Hook, and Alphabet City.

The panorama had its last significant overhaul when the Queens Museum was renovated in 1994. New buildings were added to the model and the "helicopters" were replaced by a sloping glass walkway (designed by Rafael Viñoly) that follows the circumference of the room toward a high point above the northern boundary of the Bronx. In the subsequent decades, the panorama has suffered a bit of a lag—a few buildings have been updated by developers willing to pay for the miniaturization of their projects, but the city shown here is largely the New York of the 1990s. The World Trade Center towers are still the tallest structures on the map. There is no High Line, no Hudson Yards, no 432 Park Avenue.

From a certain angle—such as the one Zoe Leonard captured in her photograph *Model of New York No. 2*— the panorama looks exactly as the city does as you approach by air. In *When the Cathedrals Were White*, Le Corbusier describes seeing New York for the first time from this vantage point—the rational, organized city in

the moments before it reveals all of its hidden terrestrial hostilities. "A hundred times have I thought New York is a catastrophe," Le Corbusier wrote, "and fifty times: it is a beautiful catastrophe." In *Delirious New York*, a sequel of a sort to *Cathedrals*, Rem Koolhaas refines Le Corbusier's beautiful catastrophe—"Manhattan is an accumulation of possible disasters that never happen." The delirium begins with an "anticlimax as denouement"—the moment Elisha Otis, standing on an elevated platform high above an audience at the New York Exposition in 1854, slices the cable that is holding him aloft and nothing happens. The safety break, not the elevator, is the essential technology of urban density. "Like the elevator, each technological invention is pregnant with a double image: contained in its success is the specter of its possible failure," Koolhaas writes. "The means of averting that phantom disaster are almost as important as the original invention itself."

Koolhaas' logic is reflected (albeit less optimistically) in the philosopher Paul Virilio's concept of the integral accident, the notion that every new technology contains within itself the germ of its own destruction. "When you invent the ship," Virilio writes, "you also invent the shipwreck; when you invent the plane you also invent the plane crash." Electricity and electrocution are not independent phenomena, but two inextricably attached parts of a whole. The anxiety of the accident, improbable as it may be, is part of any tall building's disposition. The technology of the skyscraper cannot be decoupled from the specter of its own failure.

In July 1945, during Yamasaki's final summer in New York, a B-25 Mitchell bomber crashed into the seventy-eighth floor of the Empire State Building, killing fourteen people. Three years later, in his essay "Here Is New York," E. B. White marveled at this new fragility.

The city, for the first time in its long history, is destructible. A single flight of planes no bigger than a wedge of geese can quickly end this island fantasy, burn the towers, crumble the bridges, turn the underground passages into lethal chambers, cremate the millions. The intimation of mortality is part of New York now: in the sound of jets overhead, in the black headlines of the latest edition.

This anxiety conjured by such a tall building's vulnerability was not lost on the opponents of the World Trade Center. Just weeks before the first steel grillages were set in place to anchor the foundations of the towers, a consortium of Midtown real estate owners, concerned that the glut of tax-free government-sponsored office space would flood the commercial rental market, ran a full-page ad in the *New York Times*—a grainy image of the towers as they might appear from the ground, with an airplane flying from the right margin toward the North Tower. The accompanying text warned of a "staggering hazard" and an "unjustified risk" to aviation, despite the fact that Skilling and Robertson had already presented evidence that a direct impact from a Boeing 707 traveling six hundred miles per hour would only cause local damage. The image tapped into a fundamental anxiety about tall buildings, but it came too late to incite any meaningful resistance to the project.

———

Nina hated Brooklyn. We had barely moved a mile, but the retreat into the more suburban brownstone landscape had left her feeling disconnected from the city where she had lived for fifteen years. I felt responsible. We had both agreed we wanted to live closer to our friends, where we could have more room, but it was her apartment we had left

behind. As time wore on, the dynamic began to turn. Nina grew accustomed to the shift in pace, the relative quiet of returning home after work, and I found myself missing the energy on the other side of the river on days when I would do little more than trace the short loop between home, Zoe's school, and studio.

The neurologist called while we were making dinner. Three pharmaceutical companies, including Novartis, had won FDA approval to bring a new class of preventative migraine medication to market in the United States in the spring. Nina had been waiting for years as the drugs moved through the protracted approval processes, monitoring developments in fragments of medical journal articles forwarded by her father (Nina had hoped to be part of the preliminary study, but she was ineligible when the trial began because she was still pregnant with Zoe). The trial had "demonstrated robust efficacy across the spectrum of migraine," and prescriptions would soon be made available to patients with chronic headaches. It was, astonishingly, the first class of drugs specifically designed for the preventative treatment of migraine—despite huge unmet need, every other previously approved migraine medication had originally been engineered to treat something else before being discovered to have off-label efficacy on headaches. The new drugs used monoclonal antibodies to disrupt the activity of a protein that transmits pain signals along the trigeminal nerve and into the brain. Furthermore, unlike triptans on which Nina had become increasingly dependent and which have to be taken at the onset of a headache, this drug would come in the form of a shot that could be self-administered once a month, a far more appealing option in part because it took the precarious guesswork out of assessing when to self-medicate.

Robert Smithson described his 1967 essay "The Monuments of Passaic" as an appendix to *Paterson*, the epic New Jersey poem written by his boyhood pediatrician, William Carlos Williams. As the essay opens, Smithson walks into the Port Authority bus station and buys a paperback copy of Brian Aldiss' novel *Earthworks* and a one-way ticket to Passaic. What follows, a primary document in the history of sculpture in the expanded field, is a catalog of the unfinished infrastructure of the town where he was born—the excavated landscape of "artificial craters" and "monumental vacancies that define, without trying, the memory traces of an abandoned set of futures." In text and photographs, Smithson describes the "zero panorama" of a suburb with a future but no past, where the culverts and foundations of unbuilt projects lie idle in the sun like "ruins in reverse." No ideas but in things.

In the hundreds of years since Henry Hudson first sailed up the river then known by the Mahican word Muheconnetuk, the downtown waterline of the Hudson River's east bank has moved nearly seven hundred feet west of its natural boundary. The waterfront's densely packed wharves, which Melville, in the opening pages of *Moby Dick*, compared to the coral reefs belting Indian isles, had been gradually absorbed by the Manhattoes' expanding circumference. More than half of the land beneath the World Trade Center's trapezoidal superblock—everything west of Greenwich Street—had once been riverbed. Above the bedrock on which the towers were meant to stand lay over sixty feet of sediment, jetsam, and a beguilingly unstable quicksand-like silt known as bull's liver. To keep the Hudson at bay, the Port Authority had to build a massive watertight

foundation, over three thousand feet in circumference and about sixty feet deep, in which each tower would be anchored, as Glenn Collins wrote in the *New York Times,* "like a tooth in a bed of spongy landfill." The only way to pour the foundation without undermining neighboring buildings was to dig a series of narrow trenches (three feet wide, twenty-two feet long, and as deep as bedrock) and backfill them with a bentonite slurry that was thick enough to keep the trench from collapsing, but light enough to be displaced by concrete when it was ready to pour. As digging commenced, construction workers began to unearth remnants of a maritime past—British halfpennies, cannon balls, a two-hundred-year-old anchor, and a Portuguese fishing gaff.

When the perimeter wall of the foundation was completed in the spring of 1968, a slow caravan of yellow Euclid dump trucks began hauling the earth away until all that remained was a dry eleven-acre void bound by Greenwich, West, Liberty, and Vesey streets. It is tempting to think of how this artificial crater might have exerted its influence on the artists living and working nearby as they began to lay plans for some of the first Earthworks—the *Sun Tunnels* and *Displacement Drawings*—realized in the American West but first imagined in Lower Manhattan. All told, the Port Authority displaced 1.2 million cubic yards of earth—fifty percent more than Michael Heizer would carve out of the Nevada desert to create *Double Negative* the following summer. The entire basalt fiddlehead of Smithson's *Spiral Jetty,* still a year away from construction, could have fit easily inside the monumental vacancy of the World Trade Center's foundation.

———

The decision to close the gallery took nearly everyone by surprise. Nina and Danielle appeared to be doing well. Curators respected their program and museums bought regularly from their shows. With a combination of intellectual rigor and personal warmth, they had cultivated a loyal cadre of collectors and a good reputation among artists— accomplishing one was relatively simple, accomplishing both nearly impossible. They were beloved by critics, and several of the artists they had supported early in their careers had gone on to great success at larger galleries and institutions. Nina and Danielle had managed to stay open for over a decade. They had weathered a flood. The gallery did not make a lot of money, but it brought in enough to stay open. By any standards that might reasonably apply to a gallery of this size, it was a success.

What might have been harder to see from a distance was how the dynamics were shifting in the art world in a way that made forward progress, at least on the terms to which Nina and Danielle were committed, impossible. Their unwillingness to bend under the influence of the basest commercial impulses endeared them to colleagues and artists, but eventually made the business unsustainable. They had exhausted every possible option and lost months of sleep worrying about how the decision to close would impact the artists they worked with, but there were no viable paths forward. There were no models to look to, because the galleries of the previous generation were operating under entirely different circumstances. Rental rates in Chelsea, as in many other parts of Manhattan, were now defined less by what the space might generate in a return than by the prestige a flagship store might bring to a parent company whose overhead need not be offset by local income. A similar phenomenon was occurring within the

art business. The two decades on either side of the millennium saw a paradigm shift in the economic strategy of commercial art galleries away from a local retail model to a global culture industry organized around the art fairs on which many galleries now depended for as much as half of their annual sales. Power in its various forms—money, influence, access—was gradually consolidating in a small echelon of large galleries, conglomerated enterprises with venues in multiple cities and markets.

The endlessly rising value of blue-chip art at the top and the constant proliferation of young artists at the bottom had begun to distort the art market into something like a hyperboloid or an hourglass on its way to becoming a dumbbell—an unwieldy shape, top- and bottom-heavy, whose opposing extremes left the middle of the market in a constant state of strain. The economic downturn in 2008 enhanced this distortion, adding mass to the extremes and stretching the already anemic middle in such a way that the spattering of galleries that still devoted themselves to the artists who fell between the classifications of "emergent" and "established" could barely stay open.

Nina and Danielle announced that the gallery was closing via a press release on a quiet June afternoon. They had told the artists privately and in person weeks earlier, but the public announcement still seemed to catch some of them off guard. A gallery, in the best of circumstances, can be a source of emotional as well as material support, and the loss of that support can be profound. Nina and Danielle were a part of these artists' lives, just as the artists had been part of theirs. Good wishes piled up in gallery inboxes, champagne and flowers arrived by messenger. A collector who still owed them $100,000 called to ask if there was anything he could do to help. Owners of galleries

in similar positions came in search of advice. Invariably, the dealers who had been working the longest sent congratulations rather than condolences. A reporter from *Bloomberg News* called to ask how such a celebrated small gallery could close despite "the unprecedented avalanche of money blanketing the contemporary art world." The metaphor answered the question.

It took Nina and Danielle the better part of a year to wind down all the gallery business. The work that had not been damaged in the flood was being held in various storage facilities and the final details of the insurance settlement took months to resolve. As time passed, it became clear that Nina and Danielle were slightly ahead of a sharply steepening curve as one after another of their colleagues also began to close, first in Chelsea and on the Lower East Side, then in London, Los Angeles, and Berlin.

———

It had always been assumed that the construction of the World Trade Center would require the manufacturing might of both pillars of the American steel industry— US Steel and Bethlehem Steel—and so when Tobin accused the duopoly of price fixing and pledged in a fit of pique to get his steel elsewhere, many assumed he had committed his final act of autocratic hubris. Instead, he had the engineers divide the steel into dozens of separate orders to be fulfilled by a complex network of smaller companies all over the world and steel began to arrive on site from as far afield as Seattle, St. Louis, Canada, and Japan. Numerous historians have evoked Colonel William Starrett's dictum, "building skyscrapers is the nearest peacetime equivalent of war," to describe this triumph of logistical complexity

that could only have been undertaken by an entity with the Port Authority's infrastructural control and expertise. To streamline construction, steel for the perimeter structure was delivered in prefabricated modular sections, ten feet wide and up to thirty-six feet tall. Each piece was identified with a unique sequence of numbers recorded on an IBM punch card and coordinated to arrive on site at the exact moment it was needed. The final connections still had to be secured by hand, as they had always been, by generations of German, Norwegian, Irish, and Kahnawake ironworkers, but the delivery system ensured that work could proceed without interruption. When construction was under way, the Port Authority produced a film of the large modular pieces being carefully craned into place accompanied by a lively Strauss waltz.

As the buildings began to take shape, Yamasaki's romantic life took a final strange turn. Minoru and Teri had been seeing more of each other. A family trip to Hawaii had gone well and after eight years of divorce they decided to get remarried in June 1969. The reunion was widely covered by the press in Detroit, including an article in the *Detroit News Magazine* with two bold half-page pull quotes— Teri: "I will try to be a more Japanese wife," Yama: "I'm just going to be nicer to her." Before Minoru and Teri left for a trip to Europe, Tozzoli hosted a dinner party in their honor, at which Yamasaki, again, had too much to drink. Tozzoli had to step in and calm Teri, who grew angry as the night wore on. "You know very well he is a great, eccentric artist," Tozzoli said reassuringly to Teri, "he's an architect after all."

While the Yamasakis honeymooned in Europe, the political unrest that had been gradually building since the beginning of the Vietnam War was reaching a climax. It was the summer of Stonewall and Woodstock. As the rusty steel

cage of the North Tower began to rise from the foundation, it became harder to reconcile the material reality of what was being built with the humanist philosophy Yamasaki espoused throughout his career. As Huxtable had warned, nothing had ever been built on this scale before so there was no way to truly anticipate the haptic experience of an object of this size—it had been modeled, but the physical effect of a project so large was literally unknowable until the design slowly began to take material form. Construction on the South Tower soon followed, and within the fraught political context of that summer, the presence of the rising towers became an inescapable symbol of authoritarian power at a moment when corporate and government institutions were looked upon with increasing suspicion.

It was also the summer of NASA's first manned mission to the moon, an undertaking that was seen by many critics as an epitome of the profligate spending of the military-industrial complex. Lewis Mumford was writing *The Pentagon of Power*, the second volume of *The Myth of the Machine*, at the time and he drew a direct comparison between the Port Authority's ambition and NASA's "extravagant feat of technological exhibitionism." Mumford saw both the Apollo mission and the World Trade Center towers as products of the "megamachine"—the large hierarchical social and bureaucratic structure that enabled a ruling power to coordinate a huge workforce to undertake vast, unnecessary projects ostensibly in the interest of "human progress."

The fifty-two graphic plates in *The Pentagon of Power* present captioned juxtapositions of various representations of megatechnic power. The priapic figure of William Pereira's Transamerica Pyramid in San Francisco appears alongside a Saturn V rocket on the launch pad in Cape Canaveral. A drawing of Buckminster Fuller and Shoji

Sadao's unbuilt Tetrahedron City is compared to the archetypal megamachine, the Great Pyramids of Giza, which, like the NASA shuttles, were in Mumford's estimation nothing more than "a device for securing, at an extravagant cost, a passage to heaven for a favored few." Above the caption "Homage to Giantism," a picture of Yamasaki's model of the World Trade Center appears alongside a photograph of another Rockefeller-sponsored machine, *Homage to New York*. Here, Tinguely's self-destructing sculpture is pictured mid-performance—its weather balloon rising skyward as bicycle wheels spin furiously and smoke billows from various small fires—a still image of the "formalized expression of megatechnic chaos" beside a maquette of a project that threatened to "eviscerate the living tissue" of the great city to which it paid homage. Where David Rockefeller had reached for "catalytic bigness," Mumford saw only "purposeless gigantism."

———

I lay on the floor with Zoe and tried to imagine what the house would look like if it were upside down—if the entire structure stood on its head and we could walk on the ceiling. The stair became useless for climbing (though its underside could be used as a slide). A ladder would be necessary to go upstairs, which she reminded me was now downstairs. Most door casings were close enough to the ceiling that she figured she could climb over them, so doors could still be used as doors, perhaps with the help of a chair. Lights and especially ceiling fans would present a new hazard to ankles and shins. Furniture would tumble onto the ceiling (now the floor) and would need to be rearranged, but fixtures would stay put. The sink would be

a big problem, she noted, pointing a fat finger toward the kitchen. When that thought led us to the possibility of the house filling with water, Zoe pointed out where she might be able to swim—the shallow pools left in ceiling recesses and the waterfall coming down the stairs.

———

By October of 1970, Yamasaki's North Tower was the tallest building in the world. A grainy Port Authority film of the topping-out ceremony, shot two days before Christmas, shows workers hoisting the final steel column and a large fir tree skyward through a thick fog. The first government tenants moved in days later, though construction on both buildings would continue for several more years. After the second tower topped out, Leslie Robertson snapped a slightly irresolute photograph from a helicopter of the sun rising behind the twin structures. The buildings had reached their full height, but the interiors were largely unfinished, so the open steel framework allowed the morning light to pass directly through the building like an x-ray, with the solid elevator cores rising through the North Tower like a clearly articulated spine. Where the sun is the brightest, below an opaque band of sky lobby on the seventy-eighth floor, the thin steel lattice disappears completely in the dawn light. Robertson's image—reminiscent of Mies' iconic "skin and bones" proposal for the glass Friedrichstraße skyscraper fifty years earlier—perfectly illustrates the skeletal lightness of the building's engineering.

As construction on the World Trade Center progressed, the project began to appear in the work of artists living in Lower Manhattan. Paul Thek painted the unfinished towers—*Sodom and Gomorrah*—from the window of

his East Village apartment. Pierre de Fenöyl captured the silhouette of a black dog crossing a field of snow-covered rubble south of the towers with Cass Gilbert's West Street Building, the only vestige of the former riverfront, standing grandly at their feet. André Kertész's photograph (taken the same year, from the opposite direction) of a single bird soaring between the fog-shrouded Trade Center and the bell tower of Judson Church later became the cover of Don DeLillo's 1989 novel *Underworld.*

Gordon Matta-Clark, himself a twin, scribbled captions in the margins of his notebooks in his distinctly fragmented, concrete language—"the World Trade Center as Astrolabe" or "the towers surround me are too close too rigid too solid & important learn to relax." Matta-Clark's production nearly always involved subtraction, and he included a tightly cropped photograph of the negative space between the two towers in his collaborative 1974 exhibition *Anarchitecture.* Then he mailed himself an aerogram with a sketch of two towers crossed out with the caption, "erase all the buildings on a clear horizon."

Trisha Brown's equipment dances, *Walking Down the Side of a Building* and *Roof Piece,* while not explicitly created in reaction to the World Trade Center, suggest the anxiety of its influence and presage Philippe Petit's balletic crossing that would come to define the towers in the public imagination. The towers appear in works by Keith Haring, Jean-Michel Basquiat, Hiroshi Sugimoto, Baldwin Lee, Dan Graham, Tehching Hsieh, and Robert Irwin. Thomas Struth photographed Dey Street looking west from a perspective that made the North Tower look less like a building than a rectangle of corrugated sky. Peter Hujar, so often a photographer of solitary figures in repose—Susan Sontag or Candy Darling—took

a particularly stirring pair of portraits, *The World Trade Center at Dusk* and *The World Trade Center at Night*.

The towers had become an unavoidable feature of the cinematic landscape as well—still under construction in *The French Connection*, rising above a cemetery in *Dog Day Afternoon*, standing on the horizon in *Serpico* and *Mean Streets*, and standing in as the CIA headquarters in *Three Days of the Condor*. Jonas Mekas' 2010 film *WTC Haikus* compiles found footage from Mekas' personal inventory in which the World Trade Center just happened to appear—clips of a family picnic on the derelict Westway or Philip Johnson pontificating from the deck of a boat in the East River while the towers loom mountainlike on the horizon (Mekas compared the film to Hokusai's *Thirty-Six Views of Mount Fuji*). Shortly after it was first shown, Mekas told an interviewer that he liked to look at the towers from a distance, but every time he entered them, he felt a kind of terror and was happy to leave. "I never felt good inside them," he explained, "I did everything to avoid them."

———

I took an early train to New Jersey to see Yamasaki's Robertson Hall, home of the Woodrow Wilson School of Public and International Affairs and the most prominent of three buildings Yamasaki designed on the Princeton University campus. Robertson Hall, referred to affectionately on campus as the Woody-Woo, is the best example of Yamasaki's work remaining in the Northeast. A defiantly modern outlier on the conservative collegiate campus, Robertson sits temple-like on a raised pedestal overlooking a reflecting pool. The awkwardly proportioned top

floor looks as though it has been pulled skyward, stretching the white concrete columns below like rubber and creating a narrow colonnade that wraps the circumference of the building. Inside, Robertson's bifurcated plan and wood-paneled skylit corridor improve upon the scheme used in McGregor. Like so many of Yamasaki's buildings, it feels more postmodern than late modern in its relationship to history and form. Its Gothic allusions assume a cunning, if unintentional, humor within the context of the otherwise uniformly faux-Gothic campus. When it was first designed, Huxtable praised the synthesis of "Greco-Roman and Far Eastern influences" and the way in which "undertones of the past emerge subtly in a quite advanced and experimental construction." A decade later, however, Huxtable singled Robertson out as an exemplar of the "acrobatic novelties and vacuous vulgarities" of postwar American campus design—a critical reversal that anticipated her evolving opinion of the World Trade Center.

Now Robertson was back in the news. Several weeks earlier, student activists had sent a letter to the university administration demanding that it acknowledge the racist legacy of Woodrow Wilson, who denied admission to black students during his tenure as president of Princeton University and implemented segregationist policies as president of the United States. The week before my visit, students held a thirty-two-hour sit-in in the university president's office to pressure the board of trustees to remove Wilson's name from the school, though no one at the time seemed confident that the board would authorize the change. It has since been renamed the Princeton School of Public and International Affairs.

Cass Gilbert, the architect of the Woolworth Building—the so-called Cathedral of Commerce—explained the logic of vertical construction with the simple maxim: "A skyscraper is a machine that makes the land pay." The fact that a structure as slender as 432 Park had never been built before has as much to do with economics as engineering. The technology required to construct such an attenuated tower has existed for decades, but the financing never made sense. The tallest buildings have always been commercial because they command the highest rents. Because commercial buildings have a lot of occupants, they are particularly beholden to the restraints of circulation. There are two basic metrics that determine the number of elevators in a building—handling capacity and interval. Elevator experts say a building should have the capacity to move approximately thirteen percent of its occupants in five minutes. The target interval (the average round trip time divided by the number of elevators) should be under thirty seconds. Those two factors, combined with the net to gross ratio, essentially dictate the scale of most tall commercial buildings.

In the last decade, a steadily expanding global economy, growing wealth disparity, and an influx of foreign investment have pushed the value of residential space in Manhattan past a threshold where developments of previously unimaginable proportions are now starting to make sense. A residential building can go higher on a smaller footprint than a commercial building ever could because it requires far fewer elevators. The result is taller and slimmer structures than have ever been considered economically feasible.

The primary obstacle for 432 Park's developer, Harry Macklowe, was not financing or engineering but zoning.

New York's 1916 Zoning Resolution was America's first comprehensive zoning law, and it is best known for the introduction of the "wedding cake" setback regulations designed to limit the bulk of buildings and allow more light to reach the street. The result was a zoning envelope that required the facade of a building to pull back from the street as it grew taller (as it does in the ziggurat shape of buildings like Ely Jacques Kahn's 120 Wall Street, which sits on the East River like a tiered limestone cake). Influenced by the success of the Woolworth and Singer buildings, the 1916 resolution also included an exception allowing a slender tower to rise above the bulkier mass of a building to an unlimited height provided the tower's footprint occupied no more than a quarter of the lot.

The resolution was overhauled in 1961 to include the concept of floor area ratio (FAR) as a tool to control density based on location and use. A lot with a FAR of two, for example, might be developed into a two-story building that uses the entire buildable footprint of the lot or a four-story building that uses only half. The 1961 amendment also introduced incentive zoning, under which a building would be granted additional FAR in exchange for improvements to infrastructure, support of the arts, and, based on the success of the Seagram and Lever buildings, publicly accessible (privately owned) plazas. It also allowed for the exchange of air rights between properties. Any building that conformed to this code, even with sophisticated air rights transfers and zoning lot mergers, could be built "as of right" with no additional approval from the city. Macklowe's plan for 432 Park was a cunning assemblage of air rights transfers, lot mergers, and floor area bonuses that made it possible to build the tallest building in New York on the small Midtown lot where the twenty-one-floor Drake Hotel once

stood, without ever having to present the plans to the City Planning Commission's Board of Standards and Appeals.

The existing site, by right, had enough FAR to be built up to about thirty stories. Air rights transfers added at least twenty-five additional floors. The "plaza bonus" (granted in exchange for the addition of a small public park at street level) added four more. By limiting the footprint of the tower to only a quarter of the lot, the developers used the 1916 tower exemption to avoid being subject to any setbacks or height restrictions. Floors dedicated to building mechanicals do not count toward the total habitable square footage and there is no regulatory limit to the amount of space allotted to such services, so the building's nineteen floors of mechanical systems and structural voids, which include two six-hundred-ton tuned mass dampers at the top, do not technically count as "floors." Then, because FAR laws make no provision for floor-to-floor height, an unusually tall slab-to-slab dimension allowed the building to stretch vertically. Finally, the signature element of the design, the open facade on the mechanical floors, earned an additional "wind shear reduction" bonus. In total these exceptions, all legal under current zoning resolutions at the time of construction, added over three hundred linear feet to the tower's height without subjecting the design to public approvals or environmental reviews.

If you imagine 432 Park as a yardstick, only fifteen inches would be comprised of square footage normally allowed on the site. Eleven inches would come from air rights transfers, eight inches from structural and mechanical "voids," and two inches from a plaza bonus. Because the building has a floor-to-floor height about fifty percent taller than average, you might also imagine the entire yardstick stretching to four and a half feet.

For a certain generation of American artists—Gordon Matta-Clark, Paul Thek, Peter Hujar, and their contemporaries—the towers could never be separated from the political moment in which they were created. It is no surprise then that one of the few artists to embrace them entirely, if not entirely uncritically, came to New York for the first time when she was twenty-one and the World Trade Center was still under construction. From that visit forward, the two towers have been a recurring touchstone in sculptor Isa Genzken's work—the material contradictions of the soaring marble lobbies and the tacky souvenir shops that lined the lower concourse below; the mediated realness of a building that cannot be fully experienced without looking at it through a camera; the politics of power; the vast expanses of aluminum; the friction between the extravagant and the mundane. By her 2008 show, *Ground Zero*, the World Trade Center had become a cynical emblem of the troubling arc of modernist disenchantment and American excess, but earlier in her career the buildings asserted themselves in a way that was less abstract, more anthropomorphic. The towers are undeniably present, for example, in the series of column-shaped sculptures, often named for friends, that Genzken began making in the late 1990s. These totems, like modernist caryatids, are architectural embodiments of their namesakes in much the same way that Yamasaki's two towers had become monolithic surrogates for the brothers who conspired them into existence.

A tower with four identical facades that rise straight up from a square footprint is actually a rather uncommon form for a building. It is a shape that lacks a clearly articulated top or bottom, front or back. It is, essentially, a column, and a

column is never entirely sculpture nor architecture. The two towers of the World Trade Center and 432 Park share this quality. Tony Malkin, the chairman of the trust that owns the Empire State Building, connected this form to a compelling architectural precedent when he compared 432 Park to the austere medieval watchtowers built by wealthy Tuscan families "for protection and isolation from the city below." The best known of these watchtowers, the medieval Torri dei Salvucci in San Gimignano, are not one tower but two, rising side by side over the town's open central plaza. Tour guides in San Gimignano regularly cite the Torri dei Salvucci as the inspiration for the World Trade Center, though Yamasaki never seems to have made such a connection himself.

———

As occupancy fell to barely fifty percent and conditions were deteriorating precipitously, Pruitt-Igoe became a case study in failed housing policy. By the late 1960s there were more sociologists working at Pruitt-Igoe than maintenance workers. A major Washington University study, conducted in collaboration with Harvard sociologist Lee Rainwater, spanned over four years and was supported by more than $1 million in federal funding from the National Institutes of Health. Rainwater's research culminated in his book *Behind Ghetto Walls: Black Families in a Federal Slum*, which attempted to shift attention away from the failures of individual residents and the pathologizing of black culture to the overarching failure of society to adequately address the prevailing conditions of urban poverty. The study also produced a second book, *Tomorrow's Tomorrow*, written by one of Rainwater's researchers, Joyce Ladner, who was still a sociology student at the time. Ladner used her own

experience growing up in rural Mississippi to better understand the lives of the young mothers living in Pruitt-Igoe, and *Tomorrow's Tomorrow* is considered one of the first works of academic sociology to push back against the field's inherent biases by conducting a study from the perspective of the subject. But as well-intentioned as both analyses may have been, Rainwater's study, and the federal dollars used to support it, did little to help the people who lived there, and shortly after *Behind Ghetto Walls* was published, one resident told a reporter, "all you people do is come down here and meddle in our lives so you can get stories and master's degrees and write some damn book. It may do you some good, but what good does it do us?"

The book that had the most enduring impact on the story of Pruitt-Igoe, however, was the sociologist Oscar Newman's *Defensible Space: Crime Prevention through Urban Design.* Newman draws a direct link between the physical attributes of architecture and the resultant behavior of its occupants and explicitly blames Yamasaki's design for its failure to foster the sense of propriety and personal responsibility necessary to ensure a safe living environment. As local newspapers began to run headlines like "How an Impossible Dream for a High-Rise Public Housing Project Turned into a Ghastly Nightmare," Newman's story of an indefensible Pruitt-Igoe powerfully reinforced the idea that the complex was beyond salvation. While defensible space theory ostensibly blamed architecture for the failure of projects like Pruitt-Igoe, it also subtly shifted a share of that blame onto the residents by implying that their behavior needed to be defended against in the first place. This sentiment was reflected by an increasingly antagonistic Housing Authority, whose director reverted to a familiar metaphor, calling Pruitt-Igoe "a cancer within a cancer."

When the Housing Authority announced another significant rent increase in 1969, the remaining tenants of Pruitt-Igoe went on strike demanding reliable policing, lower rents, better maintenance, and tenant representation on the board. The strikes led to sustainable progressive tenant-run housing in other projects (notably Cochran Gardens, the smaller housing project also designed by Yamasaki), but the organizing of tenants at Pruitt-Igoe came too late. In January 1970, uninsulated pipes froze throughout the buildings, leaving residents without heat and water for days and causing widespread damage to the complex's beleaguered infrastructure. Newspapers ran images of icicles hanging from broken windows and a local television station described raw sewage bubbling from a ruptured sewer main like a "malevolent spring."

———

As the South Tower of the World Trade Center climbed to meet its twin, half of the buildings in Pruitt-Igoe were boarded up and only one in eight of the apartments remained occupied. With the same zeal as previous administrations had pointed to Pruitt-Igoe as a mascot of reform, the Nixon administration presented the project as a symbol of welfare state socialism and profligate government spending. In October 1971, George Romney, Nixon's secretary of Housing and Urban Development, ordered the complex torn down. Pruitt-Igoe would be one of the first instances of a disused building being destroyed by the controlled detonation of strategically placed explosives rather than by the wrecking balls that had been used to clear the same site barely twenty years earlier. Political advocates of housing reform recognized the opportunity to use the spectacle of

televised demolition as a referendum on misguided policy. The first three buildings came down on March 16, 1972 and April 21, 1972 and footage of the initial demolition was broadcast on national television. The *St. Louis Post-Dispatch* published a series of images of the April demolition, taken by Michael Baldridge, and these soon made their way onto the pages of other national newspapers. *Life* magazine published a spectacular two-page spread using photographs shot in color by Lee Balterman. Both sequences—distinguishable only by variations in perspective slight enough to suggest that the photographers on site that afternoon were standing shoulder to shoulder in the same adjacent apartment—show the structure sagging at its center, then buckling and folding into a cloud of dust and debris. Another photograph—a grainy image of the building in free fall, its sturdy corners lurching inward as the downward pressure pushes billows of smoke into the gaps between lamp posts and trees in the empty parking lot—was taken not by Baldridge or Balterman but by a third, uncredited, photographer working for the US Geological Survey. The cumulative force of these photographs, the image of the massive tower block reduced to rubble while the silver crest of Saarinen's Gateway Arch sat on the horizon like a setting sun, sealed the narrative of Pruitt-Igoe.

———

Nina tracks her headaches on a calendar taped to the refrigerator door among grocery lists and unpaid parking tickets. She updates the calendar every morning with an orange felt-tip marker—an empty circle when a headache responds to medicine, a solid circle when it does not, an arrow linking a rebound headache to the circle that

preceded it. Over the course of a month, it is plain to see how the circles cluster, how one headache precipitates another and, occasionally, how two pain-free days might beget a third. Nina had been on the new medicine for ten weeks and today there were five headacheless days in a row on the calendar. This would have been unimaginable six months ago. Now, as microscopic legions of engineered antibodies deployed across her neural pathways, simple predictable routines could once again unfold without interruption, and in those lucid, unencumbered moments her ideas for what might come next were growing increasingly ambitious. New plans began to take shape.

———

The World Trade Center officially opened on a rainy April morning in 1973, barely a year after the demolition of Pruitt-Igoe had begun. A faltering economy, falling tax revenue, labor strikes, and rampant crime had left New York in an unprecedented fiscal crisis, and early occupancy was low. As politicians sought to distance themselves from the project, neither Tobin, who was now retired, nor Mayor Lindsay, who had so vehemently opposed the project, attended the dedication ceremony. When a reporter later asked Tobin why he was not in attendance that morning, he said only, "because it was raining."

Awaiting the final reviews, Yamasaki had every reason to anticipate the support of Ada Louise Huxtable, whom he considered a friend and who had been an outspoken advocate of his work, but when it arrived, her review was a devastating rebuke. Huxtable had applauded the structural ingenuity of the initial proposal but later warned that the scale of the project might be received by the public

"more as monster than marvel." In her final assessment, titled "Big, But Not So Bold," the buildings had failed. "These are big buildings, but they are not great architecture," she wrote. "As a design, the World Trade Center is a conundrum. It is a contradiction in terms: the daintiest big buildings in the world." The lobbies are "pure schmaltz," the views "pure visual frustration." Yamasaki's team had tried for something special, but the result was nothing but "Disneyland fairytale blockbuster" and "General Motors Gothic"—her incisively branded adjectives carrying all the weight and force of an elite East Coast critic dismissing Yamasaki's work as populist, provincial, and corporate.

Yamasaki wrote a meticulous seven-page rebuttal to Huxtable's review composed in multiple drafts with the consultation of several colleagues, but his tone is defensive and his argument is as rambling as Huxtable's was precise. Yamasaki attempts to reconcile his vision of what the project meant to him with the reality of how it was received, but the letter feels desperate and defensive. He quotes Emerson extensively—"beauty rests on necessities"—as if a stroke of elegant engineering was enough to justify the existence of the tallest buildings in the world. He returns continually to the efficiency of the design without addressing the existential question of what is accomplished by using no unnecessary material in the construction of a building that was largely unnecessary in the first place.

It is a heartbreaking exchange. The dissonance between Yamasaki's intentions and his execution, between his vision of what the project could signify and the physical reality of what it had come to represent, reaches an uncomfortable climax in these seven pages. He closes the letter with a plaintive appeal to Huxtable that the success of the buildings will ultimately be determined by the people who

use them. In her measured response, addressed affectionately to "Yama," Huxtable explains, "I tried, in the brief space I had, to make it clear that you had a philosophical and structural rationale for your design; but I feel that the aesthetic effect is not really successful for buildings on this scale." She continues: "As engineering, they are extremely impressive. I suppose that it is design approach, or interpretation of structure, that is the issue, and that, admittedly, can be a very subjective matter." She signs off with a succinct, merciless valediction—"you are the architect and I am the critic and it is an honest parting of the ways."

———

The summer that followed the official opening of the World Trade Center brought a cascade of further bad news for Yamasaki. On a July night, the National Personnel Records Center, one of his first major projects in Missouri and the storage facility for the service records of over fifty-two million people in the military and federal civil service, burned out of control for twenty-two hours. The cause of the fire was never determined, but the Army Corps of Engineers' decision not to install sprinklers in the building proved to be a catastrophic mistake. By the time the fire was contained, the records of over sixteen million veterans were permanently lost. In September, the Sears Tower opened in Chicago, ending the World Trade Center's brief reign as the tallest buildings in the world. A month later, the members of OPEC declared an oil embargo against nations that supported Israel during the Yom Kippur War and the price of gasoline skyrocketed, sending the US economy into a tailspin. On the Friday evening after Thanksgiving, Yamasaki's car collided with a steel truck on

the freeway just north of his office. Police found him unconscious with a severe head injury and rushed him to the hospital in Royal Oak, where he remained for nearly a week.

Not long after Minoru and Teri remarried, they had finally been able to buy a property on a quiet wooded road in Bloomfield Hills, the affluent suburb that had spurned them when they first arrived in Detroit. Yamasaki had decided to stop designing houses many years earlier, but he made an exception for himself. He built a simple modernist house in an L-shaped plan with a flat roof and glass curtain walls. It is among his most conservative designs—devoid of the decorative élan of his mature work. It is clear, however, from the few candid photographs of Yama entertaining—tie off with a drunken shimmer in his eyes— or from clients' stories about their architect swimming naked in his indoor pool, that this is where he felt most at ease.

In the recession that followed the oil embargo, Minoru Yamasaki & Associates found a steady stream of work in the financial sector—the Colorado National Bank in Denver, the Bank of Oklahoma in Tulsa, the Federal Reserve Bank in Richmond, Virginia—but the designs were rote and formulaic. In a letter to Manfredi Nicoletti, Yamasaki complained about the slow pace of business. Recessions are rarely conducive to innovative architecture, but these projects seem to suggest a withdrawal from the energy and ambition of his mid-career work.

Briefly assuming the role of the critic in the spring of 1975, Yamasaki wrote Huxtable to let her know about a "terribly dense complex" under construction on the Detroit River. "How can you attack my work so violently in some of your recent reviews," he wrote, "when there are projects such as this one which, in my belief, do not enhance the city in any way?" The development to which he was referring was John

Portman's Renaissance Center. Yamasaki was right. The massive complex, so ironically named by its benefactor Henry Ford Jr., would only accelerate the demise of the city center. Huxtable does not appear to have replied.

———

Curved planes of steel constituting about two-thirds of Alexander Calder's *Bent Propeller*—a large red steel stabile—were pulled out of a pile of the debris at the Fresh Kills landfill on Staten Island in October 2001. There were other sculptural fragments—the bronze torso of one of Rodin's *Three Shades* was discovered lying face-down in the rubble—but the remainder of the Calder was never found. The Port Authority originally commissioned *Bent Propeller* for the small plaza between the west entrance at the foot of the North Tower and the elevated Westway. Calder wanted it to be one hundred and fifty feet tall, Yamasaki wanted it to be fifteen. They compromised at twenty-five. Not long after *Bent Propeller* was installed, a loaded dump truck fell through a pothole on the Westway near the Gansevoort Market and the highway was promptly shut down south of Forty-Second Street. The condemned trestle remained at the foot of the tower for nearly a decade because the city did not have enough money to take it down, and the Port Authority eventually moved *Bent Propeller* to an upper concourse. A combination of economic stagnation and plummeting tax revenue had mired New York in financial crisis. By 1975, the city had run out of money to pay for normal operating expenses and faced the prospect of defaulting on its obligations and declaring bankruptcy.

The World Trade Center languished through the financial crisis with more than a million square feet of vacant

office space. By the time the last remaining structures were being cleared from the Pruitt-Igoe site in St. Louis, the World Trade Center was losing $20 million a year. Despite these financial woes, the towers had become a symbol of excess at a time when the rest of the city was falling into disrepair. When Huxtable released her second edition of collected essays, *Kicked a Building Lately?*, it included none of her early praise of Yamasaki. Now she saw the towers only as an unwelcome presence on the horizon, rising, as she had originally written several years earlier, "aggressively over everything else, gleaming like newly minted money—the architecture of power." They gleamed during the day because weather and pollution had not yet dulled the reflective finish of their aluminum skin. They gleamed at night because they had been planned when energy was so inexpensive—"too cheap to meter"—that most of the offices in the complex were built out without light switches, meaning the 23,000 fluorescent lights would often remain on through the night despite the ongoing energy crisis. In November 1975, Robert Twombly speculated cynically in the *New York Times* that "if the World Trade Center were to suffer the fate of the Pruitt-Igoe housing project in St. Louis—death by dynamite—many of us would cheer, but good fortune comes rarely."

———

The most distinctive building from the end of Yamasaki's career was the Rainier Bank Tower in Seattle—a forty-one-story office block balanced precariously on a flared pedestal in a prominent downtown site diagonally across the street from the building he had designed for IBM a decade earlier. At street level, the pedestal is half the

width of the structure it supports, so that the building looks like the top half of an hourglass buried in the Seattle hillside. Skilling and Robertson considered Rainier Tower to be one of the safest structures they had ever engineered, but the design drew impassioned criticism in the seismically active city. Critics felt the audacity of the engineering contradicted the humanist aspirations of Yamasaki's early work. Paul Goldberger saw it as a "self-aggrandizing, narcissistic flamboyance," adding that it was "ironic indeed that the whole thing should be presented in the rhetoric of 'planning for people'." Huxtable thought it was "deadpan dreadful." She called it just another example of "scalelessness, discontinuity, inhumanity, and crimes against urban nature," before concluding that "some buildings are built, others, such as this, are perpetrated."

In what would be their last exchange, Yamasaki sent a final appeal to Huxtable. "There are truly so many dreadful buildings being built today that I honestly cannot understand why you choose to attack my work," he wrote. "I am bewildered at this emotional attitude you have taken toward me." This time she responded with a short, handwritten note on a personal card in which she briefly defended her position and concluded with a final poignant farewell: "don't ever consider it personal—our cause is the same and I admire your objectives, always."

———

The unanimous condemnation of Rainier suggests something about how the critical consensus surrounding Yamasaki's work had begun to calcify, but it was a single short paragraph in Charles Jencks' *The Language of Post-Modern Architecture*, published the same year, that had

the most enduring impact on Yamasaki's legacy. Jencks saw an opportunity in the images of Pruitt-Igoe's demolition to declare a decisive end to the modernist project's society-changing aspirations. Jencks opens part one of the book—"The Death of Modern Architecture"—with a reproduction of Balterman's photograph from *Life*, cropped and enlarged to fill the entire left page, followed by a detailed description of the definitive moment of modernism's downfall:

> Modern architecture died in St. Louis, Missouri on July 15, 1972 at 3:32 p.m. (or thereabouts) when the infamous Pruitt-Igoe scheme, or rather several of its slab blocks, were given the final *coup de grâce* by dynamite. Previously, it had been vandalized, mutilated, and defaced by its black inhabitants, and although millions of dollars were pumped back, trying to keep it alive (fixing the broken elevators, repairing smashed windows, repainting), it was finally put out of its misery. Boom, boom, boom.

The whole spread, despite being one of the most frequently referenced pieces of writing in the history of architecture, might also be one of the sloppiest. Balterman's photograph was taken in April, not July, and Jencks later admitted to making up the time of day for the sake of rhetorical flourish and impact (though he could have easily verified the exact details of the demolition with any of the dozens of press outlets that covered it). Further down on the same page, Jencks gets the height of the buildings wrong (they were eleven stories, not fourteen) and claims that Yamasaki won an award for the design from the American Institute of Architects (he did not). Jencks' retelling is willfully fictitious, his disregard for detail underlining the mythic nature of the event. A self-styled architectural semiotician, Jencks'

primary concern was language, and Pruitt-Igoe was the perfect metaphor—the details did not matter because the photograph said everything.

Architecture moves slowly, it rarely produces "events," but here was an image of a building in freefall, a moment of spectacular violence that seemed to confirm what users of architecture had long suspected, that the rhapsodic optimism of the modernist project had gone horribly awry. When Tom Wolfe retold the story in *From Bauhaus to Our House,* he repeated Jencks' inaccuracies and embellished the demolition scene with a mob of angry tenants chanting "blow it up." Pruitt-Igoe was not the only failed modernist project, but the photographs positioned it uniquely as a symbol of the failure of a generation of architects to deliver the social and political panacea they had promised. From that point forward, footage of the demolition looped endlessly in television programs like Robert Hughes' *The Shock of the New* and Oscar Newman's *Writing on the Wall,* and the still photographs of the crumbling tower block became a universal symbol of modernism buckling under the weight of its own ambition. Like a staged photograph of the statue of a dictator upended by the resistance, the image of Pruitt-Igoe crashing to the ground allowed people the satisfaction of pinpointing the exact moment (inexact as it may have been) when the promise of American modernism collapsed into a heap of rubble.

While Newman's theory of "defensible space" implied the role of residents in the failure of Pruitt-Igoe, Jencks made the connection explicit—the project failed not only because of its design, but also because "it had been vandalized, mutilated, and defaced by its black inhabitants" (in some subsequent publications Jencks removed the world "black," but the implication remains). Jencks' thesis

is that modernism could never work because there would never be a uniform set of rules, a "univalent code" capable of addressing a diversity of architectural problems and value systems. In other words, Pruitt-Igoe failed because the men who designed it failed to understand something about the people who lived there or to address their specific needs. As Yamasaki's former associate George Kassabaum later wrote, "you had middle class whites like myself designing for an entirely different group." This is an important idea, especially in a profession that continues to be so racially and culturally homogeneous, but it greatly oversimplifies what actually happened (Yamasaki, after all, was no stranger to political injustice and housing inequality). There is no doubt that the buildings failed, but no architectural solution could have overcome the larger social and political conditions that made the demise of Pruitt-Igoe, and so many projects like it, inevitable.

There have been a number of attempts to dispel the notion that architecture alone was responsible for the failure of the project. The most compelling among them is architectural historian Katharine Bristol's 1991 essay "The Pruitt-Igoe Myth," which outlines how changing demographics and local politics doomed the project from the beginning. Filmmaker Chad Freidrichs borrowed Bristol's title for a 2011 documentary focused on the lives of residents who lived happily in the complex, though ultimately, even within the context of a restorative retelling, the visceral footage of the vast, neglected, crumbling apartment blocks only seems to reinforce the myth the film set out to dismantle.

The remainder of the Pruitt-Igoe buildings were gradually demolished until the last block was cleared by conventional wrecking ball in 1976. In less than twenty-five years, the cleansing rhetoric of the tabula rasa had been

inverted—the land that had been bulldozed to make room for modern housing reform was being cleared again as part of a new agenda. Many of the residents who grew up on that land had seen their neighborhood razed not once but twice. With nowhere left to go, displaced residents spread out among the increasingly segregated northern suburbs of St. Louis where racial covenants and restrictive zoning were gradually drawing clear lines between black and white communities. When the last residents left Pruitt-Igoe, the St. Louis Housing Authority gave many of them vouchers to subsidize rentals in one northern suburb in particular—Ferguson. In August of 2014, when police in Ferguson shot and killed Michael Brown, St. Louis journalist and former Pruitt-Igoe resident Sylvester Brown drew a direct line to the failure of Pruitt-Igoe—"be it by design, accident, or benign neglect, the fuse that led to the explosion in Ferguson was lit in St. Louis more than sixty years ago."

———

Alamo was leaving in a week for graduate school in Germany and we had a dinner to see him off. I built a long, improvised table in the back yard and hung lights between trees. Zoe waited eagerly for Alamo's friends, leaping at the sound of the buzzer and then hiding behind my leg when I answered the door. With gentle drunkenness, Alamo presided over a long table crowded with food and friends. Nina had a glass of white wine, her first in nearly five years. As we ate, Zoe sat on my lap in rapt attention. She studied every detail—a covert application of lipstick, a cigarette held at arm's distance from the table, fuchsia nails tapping on a glowing phone, a tattoo beneath a shirt cuff. I watched her watch who put an arm around whom, how people laughed,

how one person looked at another. Alamo was exactly the same age I had been when I moved back to New York and now he and his friends were leaving, spiraling off in a millennial diaspora to Frankfurt, Detroit, and Brussels. They had collected all the cultural capital New York had to offer them for now and it was time to take it somewhere they could afford to live. I understood this, but I was amazed by the ease with which they could articulate it themselves.

—

Among the hanging gardens and indoor lagoons of John Portman's Bonaventure Hotel, it is easy to lose your bearings. The hotel's cavernous skylit lobby has no clear relationship to the street. It is nearly impossible to differentiate between the four mirrored cylindrical towers that rise symmetrically around the slightly larger mirrored cylindrical center. Every detail—the circular balconies, the ovoid sitting pods, the spinning rooftop bar—seems as willfully disorienting as a casino. It is only as the glass elevators (Portman, an artist as well as an architect and a developer, called them "kinetic sculptures") break through the atrium's glass ceiling and continue up the exterior of the facade that you are reminded that you are in downtown Los Angeles.

The first time I walked into the Bonaventure, the muscle at the hinge of my jaw cramped inexplicably. When I tried to open my mouth, I heard a spongy crackle in my inner ear and a pain shot across the right side of my face. I pressed my finger against the flesh below my earlobe and heard the same noise, like a knife pressing against dry toast, and felt a pulse of pain. I tried to swallow, to tilt my head slowly backward, but nothing helped. I sat on a bench in a flush of panic while a friend went to buy me a bottle of

water. By the time she got back, the pain was gone. I had moved to Los Angeles a few days earlier and I wrote the incident off as some kind of ontological vertigo, a physiological reaction to relocation—as if my body had not comprehended its own displacement until it was confronted by the vast expanse of Portman's vertiginous atrium.

This was, in retrospect, a reaction so obvious as to seem almost implausible. The Bonaventure is famous among architects not as a site of origination so much as a site of expunction, a distinction it owes primarily to its role as the sinister centerpiece of the opening chapter of Fredric Jameson's *Postmodernism, or, The Cultural Logic of Late Capitalism*. It was in this lobby that Jameson located the definitive "disjunction point between the body and its environment"—the precise moment at which architecture "finally succeeded in transcending the capacities of the individual human body to locate itself, to organize its immediate surroundings perceptually, and cognitively to map its position in a mappable external world." The point after which humanism is impossible.

> I am proposing the notion that we are here in the presence of something like a mutation in built space itself. My implication is that we ourselves, the human subjects who happen into this new space, have not kept pace with that evolution; there has been a mutation in the object unaccompanied as yet by any equivalent mutation in the subject. We do not yet possess the perceptual equipment to match this new hyperspace, as I will call it, in part because our perceptual habits were formed in that older kind of space I have called the space of high modernism. The newer architecture therefore ...stands as something like an imperative to grow new organs, to expand our sensorium and our body to some new, yet unimaginable, perhaps ultimately impossible, dimensions.

These characteristics of the Bonaventure—the illegibility of its reflective facades, the physical disorientation of its monotonous interior, its disregard for the urban context that surrounds it—are all equally present in the World Trade Center, which opened to the public at more or less the same time. In certain ways, the World Trade Center might have been even better suited than the Bonaventure to represent what Jameson describes as the incapacity of our minds "to map the great global multinational and decentered communicational network in which we find ourselves caught as individual subjects." The very idea of a "vertical port"—the foundational fallacy on which the project was built—situated the World Trade Center in a global context from its inception. Portman's isolationist megahotels turned their back on the downtowns they overlooked, but in strictly legal terms, the World Trade Center was not even *in* the city where it stood. It occupied, instead, an island within an island, a piece of land under the jurisdiction of the states of New York and New Jersey—a non-site surrounded by, but exterior to, the city it came to represent. And while the Bonaventure turns inward behind its mirrored skin, the World Trade Center achieved a more exquisite solipsism by doubling its own form and thereby eliminating any external point of reference other than itself. In *Simulations*, Jean Baudrillard described the towers as "the effigy of the capitalist system." The two "perfectly balanced and blind communicating vessels" signify "the end of all competition, the end of all original reference"—the embodiment of late capitalism in its most stable form, the duopoly. "They look one into the other as into a mirror and culminate in this prestige of similitude. What they project is the idea of the model that they are one for the other, and their twin altitude presents no longer any value of transcendence."

In the summer of 1976, a mysterious pneumonia-like disease killed twenty-nine guests attending an American Legion convention at the opulent Bellevue-Stratford Hotel—the Grande Dame of Broad Street—in downtown Philadelphia. The origin of what came to be known as Legionnaires disease would eventually be traced back to bacteria in the hotel's ventilation system which caused an infection that could only be contracted via the inhalation of aerosolized water into the lungs. The Bellevue-Stratford's air-conditioning—in effect the lungs of the old Grande Dame—served as both an incubator and a dispersal mechanism for a previously unknown bioaerosol contagion, demonstrating how a building could be instrumentalized in the spread of infection.

The modern electrical air-conditioning unit was first used as an industrial dehumidifier at a lithography and publishing company in Brooklyn in 1902, and early residential and commercial applications focused on the health hazards of humid air. In his definitive 1904 book *Reflections on Heating and Ventilating*, the New York heating consultant Konrad Meier warned of the dangers of "water vapor, sickly odors from respiratory organs, unclean teeth, perspiration, untidy clothing, and microbes." Ultimately, however, it was comfort, not hygiene, that made air-conditioning a primary engine of American expansion (just as the elevator allowed cities to grow upward, climate control allowed the country to sprawl southward and southwestward). By the time Legionnaires disease was discovered, the United States was using more air-conditioning than the rest of the world combined.

When Henry Miller returned to the United States after a decade in Paris, he spent a year driving across the country.

Like Ferdinand Bardamu in Céline's *Journey to the End of the Night*, Miller was disgusted by what he found. *The Air-Conditioned Nightmare*, Miller's account of the trip, was published in 1945. On its cover was a photograph taken by his friend Hubert Creekmore of an art deco skyscraper rising above a wooden shack in Jackson, Mississippi. That air-conditioning rose to titular importance among an exhaustive list of grievances is likely because it so perfectly embodies a distinctly American artificiality that was the object of Miller's vitriol. "Nowhere else in the world," Miller wrote, "is the divorce between man and nature so complete."

Miller was at the vanguard of a long line of architects and critics—Frank Lloyd Wright, Richard Neutra, Reyner Banham, Kenneth Frampton, Rem Koolhaas—who saw America's obsession with air-conditioning as unnatural (and yet a natural focus for critique). In this artificiality, the technology of climate control had something in common with the technology of tall buildings. In the same way that early skyscraper skeptics foresaw the dangers inherent in high-rise construction, Miller saw the nightmare of an air-conditioned America as evidence that "all our inventions and discoveries lead to annihilation."

———

Occasionally, buildings hurt people—a wall caves, a roof collapses, a cornice breaks free from a facade—such are the hazards of living in a material world. There are occasional historical precedents of buildings inflicting injury on the people who occupy them in subtler, more insidious ways as well—carbon monoxide poisoning from Victorian gaslights or neurotoxic reactions to mold (one theory holds that Charlotte Perkins Gilman's short story "The Yellow

Wallpaper" was, in fact, a detailed account of mycotoxin exposure). The outbreak at the Bellevue-Stratford, however, marked an inflection point in the consciousness of a public increasingly attuned to the dangers of environmental pollution. Against the backdrop of disasters in Chernobyl and Bhopal, Three Mile Island and Love Canal, a steadily growing number of people began reporting a wide range of physical and mental illnesses connected to the buildings where they worked. The symptoms— headache, fatigue, sore throat, eye irritation, nausea, and dizziness—were widely disregarded by doctors because they eluded the conventional understanding of occupational injuries, which had historically been associated with industrial accidents clearly identifiable by time and place. If you lose a hand in a machine accident on the factory floor or get black lung in a coal mine, the causal relationship is clear. Clean, open-plan, air-conditioned workplaces, however, were optimized for comfort and cleanliness, and while workers gradually began to draw connections too compelling to ignore between these unfamiliar symptoms and the environments where they worked, it was nearly impossible to link symptoms to a specific singular chemical exposure. Because symptoms did not fit established toxicological models (and, perhaps, because those symptoms were often reported by women, who held a significant majority of information economy jobs), they were largely disregarded by medical and legal professions with a long-standing tendency to dismiss as psychosomatic symptoms that could not be directly linked to an underlying condition.

These biases were further compounded by the fact that the very idea that a building could get you sick runs counter to our expectations of architecture. The legacy of humanism is the tacit understanding that the building

will support the body. To admit that a building could inflict harm on the people within it was to admit that the delicate equipoise of body and building was out of balance and that the anxiety and alienation one might associate with such a disequilibrium had begun to manifest physically.

———

Nina was standing on a dirt floor in a hardhat next to a squat Albanian man who was holding her handbag. They were both laughing at how ridiculous he looked. In her hands she held a long cylindrical core sample that had just been extracted from a foundation wall—a smooth pillar of cement and rebar, veined with rings of mortar and aggregate like a column of coarse sediment. An engineer nodded approvingly at the integrity of the sample, a gesture that clearly relieved the architects and contractors who stood in a circle around Nina. At their feet, a tendril of ivy grew through a crack in the cinderblock wall. The perfect circular hole left by the coring tool looked deep enough to hold an arm. Nina smiled when she saw me and raised the sample with exaggerated heft to show me its weight. I greeted everyone and offered to take the bag from the Albanian. The group had turned their attention to a set of plans laid out on a plywood table beneath a tangle of yellow work lights. For now, the building was still a shell, an empty volume of stale air that smelled of dirt and damp concrete. At the back of the space a mason's level projected an acid green plumbline just above the floor.

I stood back from the group, watching Nina as she marshaled plans to underpin foundations and shore walls. Her confidence and control were extraordinary. In the face of all of this potential, my immediate obsessions felt

so inconsequential—the small satisfaction of words or objects. Here Nina was making a mark on the landscape—changing something even if that meant leaving it more or less as she had found it.

———

The World Health Organization first used the term "sick building syndrome" in a 1984 report suggesting that up to thirty percent of new and remodeled buildings worldwide may be the subject of excessive complaints related to poor indoor air quality. The WHO considered a building to be sick when at least twenty percent of the occupants complained of "multiple chronic health problems that did not suggest any single medical diagnosis or causative agent."

Following a similar logic, the Environmental Protection Agency introduced three criteria for diagnosing the syndrome—a building is sick when occupants complain of symptoms associated with acute discomfort, most of the symptoms dissipate soon after leaving the building, and the cause of the symptoms is unknown. While the naming of the syndrome helped raise awareness, both definitions lacked specificity, leaving the condition awash in the anxiety of an illness not yet understood. The circular logic of the EPA's final criterion made it essentially impossible to diagnose. As historian Michelle Murphy explains in *Sick Building Syndrome and the Problem of Uncertainty*, the logical conundrum at the center of any discussion of sick buildings is that as soon as a causal agent is connected to a specific symptom, that symptom is no longer proof that the syndrome exists. If the definition of a disease requires that the cause be unknown, then any logical or legal attempt to definitively link the syndrome to a building will fail.

One reason the causes of building-related illnesses are so difficult to locate is that the symptoms are often the result of the synergistic impact of a variety of chemicals in an environment. Like a migraine, sick building syndrome is rarely caused by a single mechanism. It results instead from a convergence of overlapping conditions and exposures. A combination of chemicals might trigger an attack in an environment where the level of any single chemical is not over the "maximum allowable concentration" standards set by government and industry. As a result, the technologies designed to monitor exposure to specific chemicals are incapable of measuring cumulative body loads. The only conclusive means of measuring the "sickness" of a building is with the body itself.

———

Several blocks southwest of the Bonaventure, on the other side of the Harbor Freeway, there used to be an encampment of twenty white fiberglass domes on a dusty undeveloped downtown lot. The domes were designed by the architect Craig Chamberlain, a former student of Buckminster Fuller, and they were installed on the lot as a self-governing community for people unable or unwilling to live in traditional homeless shelters. Todd Haynes used one of Chamberlain's polyester domes, passing for porcelain, in the final scene of his first feature film *Safe*. Set in 1987, the film tells the story of Carol White—a version of Jameson's human subject incapable of locating herself—played, with a voice as thin and tremulous as glassine, by Julianne Moore. Set against a backdrop of Southern Californian privilege and prosperity, Carol's chemical sensitivity is revealed through a sequence of vertiginous dolly

shots of increasingly violent toxicological reactions as her world collapses around her. When doctors and therapists fail to identify any discernable disease beyond an allergy to milk, Carol finds a support group of similarly sensitive patients at a commune in the New Mexico desert. It is there that Carol encounters Chamberlin's dome, the "porcelain" safe house occupied by the commune's most infirm resident. When an ambulance comes to take him away, Carol takes his place inside, symptom-free but no safer and no better understood. In an ironic coda to the film's ending, Moore recounted in a commentary recorded years later that she felt closest to Carol White while filming that final scene in part because the air inside the fiberglass dome had become almost unbearably toxic in the desert sun.

In *Illness as Metaphor* Susan Sontag writes that "any important disease whose causality is murky, and for which treatment is ineffectual, tends to be awash in significance. First, the subjects of deepest dread (corruption, decay, pollution, anomie, weakness) are identified with the disease, then the disease itself becomes a metaphor." Sick building syndrome is, of course, both an illness *and* a metaphor. Its own name collapses any boundary between the condition and the object on which that condition might be imposed. Both the body and the building are sick. In a way that has rarely been accounted for in architectural discourse, the symptoms associated with sick building syndrome seem to mark a physical response in the bodies of occupants to a change in the built environment that is usually described only in theoretical terms—the moment when the promise of humane architecture became impossible to reconcile with the reality of what was being built. The very idea of a building falling ill introduced the possibility that architecture, which since Vitruvius had been organized around

the principle that the building was modeled on the body or conceived of as a technology at the service of the body, could turn against the occupant and fail in its implicit obligation to do no harm.

At the same time, the sick building metaphor also works at another, far more concrete level (all really successful metaphors, Sontag suggests, are rich enough to provide for two contradictory applications). The buildings really were sick. The cause of nearly all of the ailments associated with the condition during the peak years of the late 1980s can largely be explained by the convergence of two very specific conditions intrinsic to postwar architecture particularly, though not exclusively, in the United States—new construction materials and closed building systems.

In the decade following the Second World War, the American construction industry quadrupled. New materials invented or improved during wartime—wood composites, adhesives, substrates, plastics, insulation—transitioned seamlessly to commercial and residential construction. Plywood was introduced to the civilian economy through ingenious military applications, like the lightweight leg splint Charles and Ray Eames designed for the US Navy (a medical device whose conceptual origins can be traced directly back to furniture from the Paimio Sanatorium). The health risks associated with the chemical ingredients of these new materials were largely untested and unknown and, in the booming economy, there was little incentive to exercise due diligence. Plywood, for example, contained dangerous levels of formaldehyde, a potent mucous membrane irritant that can cause nausea, headaches, asthma, and nasopharyngeal cancer, but was not identified as a source of indoor air pollution until 1982, decades after it was put into widespread use.

When the energy crisis arrived in the 1970s, cost-conscious architects and engineers responded by making buildings as airtight as possible to prevent conditioned air from escaping. In 1974 the American Society of Heating, Refrigerating & Air-Conditioning Engineers responded to rising energy costs by dramatically lowering workplace ventilation standards for the first time since the Great Depression, cutting the required amount of outside air circulation per occupant from fifteen cubic feet per minute to five. As buildings became more securely sealed—"tight" in industry jargon—and ventilation standards were minimized, toxins from new materials began to accumulate at dangerous levels. At room temperature, the formaldehyde-based adhesives that hold together plywood walls, particleboard subfloors, and nylon carpeting, for example, can slowly off-gas chemical vapors into interior spaces through a process called sublimation. As the environmental scientist Nicholas Shapiro notes in his writing on the toxicity of formaldehyde, this chemical sublime inverts the philosophical sublime by creating encounters of potentially grave physical danger to which the subject is entirely oblivious. Without adequate ventilation, sublimated chemical microemissions slowly accrue within the building envelope where they can be absorbed into the body through the lungs, skin, and gastrointestinal tract. This is how a building becomes sick.

These conditions proliferated amidst what Sontag called the "toxic effluvia of the industrial economy." When Ronald Reagan was elected in 1980 on a platform of widespread government deregulation, his administration gutted the Environmental Protection Agency and appointed the aggressively proindustry lawyer Anne Gorsuch (known to her subjects as the "Ice Queen") as its head. With

insufficient funding, the agency's own headquarters deteriorated so precipitously that researchers found themselves working in conditions that one scientist compared to a "third world public hospital." When the agency installed new carpeting and cubicles in 1987, over sixty employees immediately reported acute symptoms, including burning lungs and debilitating headaches. In 1988, the same year the EPA officially recognized the role of building materials in sick building syndrome, a group of agency scientists and employees sued the agency over neurological, respiratory, and immunological illnesses directly related to chemical exposure at the headquarters. The District of Columbia Superior Court ultimately rejected the claims, ruling that "the building's owner could not be held responsible for psychogenic illnesses."

———

When New York's financial crisis put the development plan for Battery Park City on hold, the landfill west of the World Trade Center was covered with sand dredged from the bottom of the Lower Bay. The empty expanse became an ersatz beach, an off-limits, otherworldly landscape at the western boundary of the financial district. Photographs taken over the years that the site remained undeveloped show the two towers, immaculate and inert, looming over 92 acres of coarse sand and scrub grass. In the architectural journal *Skyline*, the critic and activist Craig Owens described the sandy overburden as a "fragmentary evidence of past human presence"—"small bits of broken asphalt mix with the gray, sandlike charred remains" that seem to "testify to some forgotten disaster." Like Smithson's "monument of minute particles," the

239

"millions of grains of sand suggest the dissolution of entire continents, the drying up of oceans." It is difficult to look at these images and not conjure a landscape of apocalyptic science fiction—the Statue of Liberty emerging from the sand at the end of *Planet of the Apes* or, more precisely, Arthur C. Clarke and Stanley Kubrick's monolith—an artifact of both past and future—appearing inauspiciously on the African savanna in the beginning of *2001*.

In one of several photographs taken by Fred R. Conrad during his first spring at the *New York Times*, a young couple is pictured lying in the sun on a floral bedsheet stretched between canvas shoes—the pair of oversized towers rising over them seem preposterously out of scale. It was May 1977. New York had narrowly escaped bankruptcy, but the retrenchment had led to severe cuts in services. Tens of thousands of police officers and sanitation workers had been laid off and dozens of fire stations were closed. The first "Son of Sam" letter, left at a murder scene in Baychester several weeks earlier, had the city on edge. Tensions would reach a boiling point several weeks later on a steamy July night when a citywide blackout led to looting and arson after thousands of off-duty police officers ignored orders to report to work. Buildings in the South Bronx burned out of control throughout the summer as destitute landlords resorted to arson to claim insurance money. By the end of the 1970s, forty percent of the South Bronx had been destroyed by fire, seven census tracts had lost over ninety-seven percent of their buildings to abandonment or arson, and a quarter of a million people had lost their homes. But for now, things were quiet. It was Sunday morning and the skyline in the distance, its derelict highway and blank office buildings, looked abandoned. This couple could be the last two humans on earth, ecstatic and

oblivious, deserted on a beach that seems to stretch to the distant stanchions of the Verrazzano Bridge on the horizon.

Two years later, a photograph on the cover of the *Daily News*, like a collage of two images of irreconcilable scale, showed two hundred thousand activists gathered on the beach for a concert in opposition to nuclear energy, Jane Fonda, Jackson Brown, Gil Scott Heron, and others achieving, if only for one afternoon, some of the grand democratic aspirations Yamasaki once had for his plaza. *Sous les pavés, la plage.*

Throughout the early 1980s, artists like Fred Wilson, Nancy Holt, Dennis Oppenheim, and Simone Forti occupied the landfill through the public art nonprofit Creative Time's ongoing Art on the Beach program. Bill T. Jones led a group of dancers gathered amongst the scrub grass, Nancy Rubins assembled scavenged appliances, and Alice Aycock turned away from an unfinished installation to look defiantly back at the camera. Further south, Agnes Denes grew one thousand pounds of wheat on two neat acres of land just below what would soon become the World Financial Center.

In the summer of 1983, the *New York Times* ran a photograph of another couple, David Vanden-Eynden and Chris Calori, sitting in the makeshift shade of a Chinatown parasol lashed to a camera tripod weighed down with a leather duffle bag. The elevated Westway was gone and the new Marriott stood at the foot of the World Trade Center. The first buildings in Battery Park City were visible on the horizon, and soon the remainder of the beach would be paved over. The New York economy was beginning to show signs of recovery—in seven transformative years, a city of industry had emerged from financial crisis ready to embrace the information economy. The Port Authority reinterpreted

its mandate to rent only to businesses "involved in world trade" to include those servicing the burgeoning global financial sector, and revenues tripled between 1978 and 1983. By abandoning the pretense of a "vertical port," the Port Authority had finally transformed the towers' image from government boondoggle to an international icon of 1980s bright lights, big city excess.

For the final incarnation of Art on the Beach in 1985, Sun Ra performed in *Delta Spirit*, a pyramid-shaped shack built with discarded lumber by David Hammons, Angela Valerio, and Jerry Barr on what remained of the undeveloped land. As construction consumed what remained of the beach, Alvin Baltrop, the informal amanuensis of the Hudson waterfront, took one of the last photographs of the barren landscape looking out toward the river—just an undulating line of slatted fencing running across the sand, as if there were no city there at all.

———

Detroit's economy, and with it the Fordist model of industry-driven American economic growth, was slower to recover. As the oil embargo drove gas prices up, fuel-efficient Japanese cars flooded the American market and devastated Detroit's automotive industry. Factories closed, and the anti-Japanese racism that had gradually waned in the years since the Yamasakis moved to Michigan had an abrupt and ugly resurgence. Unemployment in the city peaked in 1982 and racially motivated violence reached a climax that summer when Vincent Chin, a Chinese American man, was assaulted outside a nightclub. His assailants were a Chrysler plant superintendent, Ronald Ebens, and his stepson, Michael Nitz, who had

been laid off when Chrysler began importing cars built by Mitsubishi in Japan. Witnesses alleged that the two men told Chin, whom they mistook for Japanese, "it's because of you little motherfuckers that we're out of work," before they attacked him with baseball bats. Chin died in a coma five days later at Henry Ford Hospital.

When a Wayne County judge sentenced Ebens and Nitz to three years of probation and a $3,000 fine, protesters in Detroit took to the streets. In the face of growing public outrage, the US Department of Justice pursued charges and in November 1983, a federal grand jury indicted Ebens and Nitz for violating Chin's civil rights. Nitz was acquitted and Ebens was sentenced to twenty-five years in prison, before a federal appeals court overturned his conviction on a legal technicality. Ebens' case would eventually return to federal court in Cincinnati where he was fully exonerated in 1987. Neither man served any time in prison.

———

As ventilation standards gradually improved and the construction industry slowly introduced more robust material regulations, sick building syndrome began to recede from public consciousness. By the late 1990s, public health organizations and medical journals began advising against the use of the term because it made a judgment on causation. As an alternative, they suggested vaguer terms like Idiopathic Environmental Intolerance, which was defined—if language so willfully nonspecific can fairly be called a definition—by the WHO as "an acquired disorder with multiple symptoms, associated with diverse environmental factors, tolerated by the majority of people, and not explained by any known medical or psychiatric/psychological disorder."

This shift in language pushed chemically sensitive patients further to the margins and severed any direct diagnostic tie between illness and architecture, but there are still unwell buildings—buildings with hidden strata of lead paint, creeping blooms of black mold, wooly tufts of asbestos. There are still air-conditioners circulating airborne bacteria and elevators pumping contaminated air through buildings like pistons in an engine. In June 2017, seventy-one people died when improperly regulated sheathing fueled a fire that engulfed London's Grenfell Tower in minutes. Formaldehyde-laced FEMA trailers from New Orleans have been found as far north as the Dakotas, and many new green buildings are built so tight that even naturally occurring toxins cannot escape. Like the toxic dust that blanketed downtown New York when the World Trade Center collapsed, the impact of many of these materials on public health is still not well understood.

Decades after Pruitt-Igoe was torn down, research revealed that the US Army Chemical Corps had used the site for a series of Cold War-era weapons tests specifically because the architecture so closely resembled that of the massive housing complexes of the Soviet Union. The tests included the spraying of over a ton of aerosolized chemicals laced with fluorescent dyes from the roofs of Pruitt-Igoe in order to simulate the airborne dispersion of biological weapons, deliberately exposing ten thousand residents, seventy percent of whom were children under the age of twelve, to potentially toxic levels of zinc cadmium sulfide without their knowledge or consent.

———

By 1985, Yamasaki's health was deteriorating. In December he had a major operation at Sloan-Kettering Cancer Center in New York where he had been undergoing regular treatments. His correspondence from the time suggests he was still active and had every intention of carrying on with work at the office when he got home, but his body was failing. He returned to Detroit to recover, but by late January he was back at Henry Ford Hospital. He died there on February 6, 1986 from complications related to stomach cancer. He was seventy-three.

Yamasaki's obituaries tell the success story of a child of immigrants with humble beginnings and a career marked by spectacular accomplishments and humiliating defeats—the early critical acclaim of the Lambert Airport Terminal, the devastating failure of Pruitt-Igoe, the unexpected selection to design the World Trade Center, and the critical rebuke the towers ultimately received. Many of the obituaries describe a career in numbers—the $40 in his pocket when he first arrived in New York or the World Trade Center's ten million square feet of office space. The Detroit-area papers tended to celebrate his accomplishments and focus on the happy ending of his improbable reunion with Teri, while the more design-minded remembrances, like Sara Rimer's obituary in the *New York Times*, broached the question of legacy, calling Yamasaki an "early crusader against the coldness of modern architecture," who "railed against the glass cubes and boxes that were transforming the skyline of American cities."

After Yamasaki's death, his office continued under the leadership of several long-time employees, including his younger son Kim, who had joined the firm in 1980. While the oil embargo decimated the economic infrastructure of Detroit, it was a windfall for one of Yamasaki's most

admiring clients—the Saudi royal family—who commissioned a number of projects, including work on the Eastern Province International Airport and the Jeddah Airport. The office also oversaw the completion of Yamasaki's Torre Picasso in Madrid and pursued new work in Azerbaijan, Brazil, China, India, South Korea, and Turkey. In 2009 Yamasaki & Associates abruptly ceased operations amid multiple recriminations and millions of dollars in default judgments after a court ruled against them in a lawsuit stemming from disputes with an engineering contractor relating to work done on the Qatar Convention Center. If historians and archivists had not interceded at the last possible moment, all of Yamasaki's remaining drawings would have been shredded by the Oakland County Sheriff's Office.

———

I arrived in Seattle and took a car from the airport to the Science Pavilion on the city's north side. The buildings looked tired, dreary under the colorless Seattle sky. Like the remains of so much exposition architecture, Yamasaki's pavilion (and the Space Needle that rises above it) have aged poorly. It was never intended to be a permanent structure. Standing alone under the decorative arches, I had the sympathetic sense that it would have been better to tear it down after the exposition, as originally planned, than to let it live on as proof that the future it predicted was so far from what has come to pass. The arches are frivolous—they lack any relationship to material, function, or structure—and the buildings sit inertly on the site like a collection of suburban movie theaters. A recurring if largely unfair refrain among Yamasaki's detractors is that he merely used ornament to decorate boxes, but in this case that is exactly what he did.

Nina and Zoe and I were visiting friends in California and I had flown up to Seattle for the day to see the three buildings Yamasaki had designed for the city where he was born. I walked downtown. The sun broke through the clouds, illuminating the city like a spotlight switched on a stage set as I reached the corner of University Street and Fifth Avenue, where Rainier Tower and the IBM Building face each other on opposite corners of the intersection. Rainier Tower is so much less imposing in person than it is in photographs that I could not help but wonder if the East Coast critics had even bothered to come out and see it before writing it off. Huxtable, I learned later, had not. The building is neither simple nor inhumane. The domestic penny tile surface on the massive stem that supports the structure where it emerges from the ground like a mushroom gives the building a surprisingly human scale.

In Seattle, unlike in New York or Los Angeles, you can walk into a building, casually nod to the doorman, and take an elevator anywhere you like, so I wandered from floor to floor imagining how it might feel to come to work here every day as an analyst or an accountant. Like so many of Yamasaki's buildings, the interior of Rainier Tower feels smaller and more intimate than you would imagine from the outside. A glass corridor off the rear lobby looks down into an enormous excavation that awaits the foundation of a massive new building next door. Soon this tower, once maligned as an unnatural aberration of scale, will seem quaint in comparison to its bombastic new neighbor.

Three blocks south, along the same contour line of the steeply inclined Seattle grid, is the Seattle Central Library, designed by Rem Koolhaas and his Office for Metropolitan Architecture—a warmly lit glass-and-steel polyhedron that unfolds over a steeply graded full city block. The library's

exterior is an angular shell, a vast greenhouse of faceted diamond-patterned planes. The landscaping transitions seamlessly from living plants outside to carpets and curtains printed with images of foliage inside. Safety-yellow escalators switchback through the library's core. The building is populated, like so many urban libraries, primarily by people without homes or internet access (a constituency growing in numbers under the pressure of Seattle's housing shortage), which gives it the worn-in feel of a piece of well-used municipal infrastructure. I wound my way slowly up the escalators toward the special collections room on the top floor, given pride of place directly below a sweeping span of glazed roof. There I found a small catalog from a 1974 retrospective of Yamasaki's work that I had not been able to find anywhere else. Looking at Korab's now familiar photograph of the lobby of the McGregor Conference Center, I was struck by the similarity of Yamasaki's space-frame skylight to the massive steel-and-glass shell encasing the library where I sat. I held the catalog above my head and the pattern of the diamonds on the page interlocked with the library's powder-blue steel mullions. With my phone held awkwardly against my chest with my right hand I texted a photograph to Nina.

Yamasaki was born in what used to be known as Yesler Hill, the crowded neighborhood of tenements that lined the original "skid row"—the steeply sloped dirt road where cut logs were skidded down the hillside to Henry Yesler's waterfront mill, the city's first center of industry. I worked my way through the old maps and photographs in the library's collection. Images of Yesler Hill show a thriving Japanese community, comprising a third of the families in the neighborhood, most of whom likely arrived in search of work after the Chinese Exclusion Act of 1882 blocked entry to Chinese

laborers and led to an influx of immigration from Japan. I looked at a photograph of a crowd of children standing in front of a school that would have been just blocks from where the library now stood. These students would soon be displaced, first when the Seattle Housing Authority announced plans to raze forty-three acres of Yesler's Hill to create new public housing in 1939 and again when posters went up on telephone poles in 1942 telling anyone of Japanese descent that they had one week to dismantle their lives and leave the West Coast with only what they could carry. Nearly all of these children would spend three years living in internment at the Minidoka Relocation Center.

———

Just weeks before he wrote his scathing elegy for the Eastern Airlines Terminal in 1993, *Boston Globe* architecture critic Robert Campbell interviewed Ada Louise Huxtable for *Architectural Record*. She was seventy-two. He opened the conversation with a question about how the built world had changed over the course of her career, to which she responded:

> I think it has changed in a very basic and fascinating way. It's changed from a world of optimism to a world of profound pessimism. In the time since I started my career, which was really right after the Second World War, I've seen this change from believing that we can solve the world's problems, that we can make the world a better place, that architecture and design had a very powerful and positive role in helping people to live better. In the intervening years, we lost that belief. In fact, we've lost an entire belief system. This wasn't just something that depended on design or architecture or postwar optimism. It was part of modernism, part of the spirit of

249

the twentieth century. We truly believed that the horizons of technology, the horizons of art were going to lead us to a better place and make us better people. We became very disillusioned. We found this wasn't true. We became overwhelmed by problems no technology can solve.

It is a powerful and pithy summary of fifty years of American architecture and one that maps as neatly onto the arc of Yamasaki's career as it does onto Huxtable's. Later in the interview, Campbell asks if there were any critical judgments she seriously regretted. "Only one," she said. "The only thing I think I screwed up on was Yamasaki."

———

In 1979 a Japanese imprint had published Yamasaki's *A Life in Architecture*, a large, illustrated autobiography with Balthazar Korab's photograph of the World Trade Center rising over the spire of Trinity Church on its cover. Closer in tone to an apologia than a memoir, the text (which he had been preparing in draft form for years) is punctuated with acknowledgments of his early tendency to "overdesign and overdecorate" buildings and contrite dismissals of the projects that were "just plain bad." There is no mention of Pruitt-Igoe. Humble as it may have been, *A Life in Architecture* was Yamasaki's final attempt to regain control of the narrative of his career and profess his steadfast belief in architecture's ability to do good.

For nearly forty years, *A Life in Architecture*, now long out of print, was the only comprehensive book on Yamasaki's work published in English. Then, in 2017, Yale University Press published *Minoru Yamasaki: Humanist Architecture for a Modernist World,* by Dale Allen Gyure,

a straightforward but thoroughly researched and beautifully illustrated study of the full breadth of Yamasaki's body of work. The text largely refrains from interpretive analysis, but as the book draws to a close, Gyure raises the question of how Yamasaki's career was impacted by what the author describes as a "pattern of passive acceptance of inadequate or unfair treatment." It is a fair question, but one that might play too simply into Yamasaki's own self-effacing personal narrative. It is also a question that might as easily be inverted—how was it that Yamasaki had accomplished everything that he had under such adverse circumstances?

Martin Filler began his review of Gyure's book in the *New York Review of Books* with a confession of the "shameful secret" that he used to love Yamasaki's work. Even as a long overdue compendium of Yamasaki's career was entering the world, Filler felt it was necessary to preface his review with a reminder that Yamasaki remains outside the acceptable boundaries of architectural taste. He went on to reveal that he was disabused of this "youthful infatuation" with Yamasaki by a charismatic young professor who had studied with the "legendary architectural historian Vincent Scully." Acknowledging what has already been implied, he confesses that "although it is often assumed that taste is innate, it most certainly can be taught, particularly to the young and impressionable." What Filler means when he says that he *used* to love Yamasaki's work is that he loved it until he was *taught* not to.

What is striking about Filler's confession is how much it explains about the ways in which Yamasaki has been remembered or, more aptly, forgotten. When the *Detroit Free Press* asked Paul Goldberger, perhaps Scully's most prolific disciple, for a comment to include in Yamasaki's

obituary, he told them that "he did a number of very prominent buildings, even if they didn't change the course of architecture." It is a cold, almost defensive, response, as if the question itself were an affront to an established order.

Time may have proven Goldberger wrong. Neither Pruitt-Igoe nor the World Trade Center will be remembered as masterpieces, nor should they, but it is hard to imagine another pair of buildings which in their lifespan— from conception to construction to spectacular, violent destruction—have exerted a greater influence on the course of American architecture. It is difficult to imagine any story that has shaped the culture and politics of architecture in the last eighty years *more* than those told by the handful of photographs of Pruitt-Igoe tumbling to the ground and the thousands of images of the towers of the World Trade Center collapsing under their own weight.

———

The first time I managed to get inside 432 Park, it was still under construction. I signed in, put on a high-visibility neon hardhat, and walked down a long plywood corridor through what is now the Fifty-Sixth Street entrance. The interior was half-finished and lists of lunch orders and phone numbers were scribbled on unpainted purple sheet-rock walls. Bales of insulation were piled in the hallways and rectangles of tape marked the locations of appliances still bound in translucent blue stretch-wrap. A skull wearing a Yankees cap was drawn in the dust on a pile of marble slabs. The unfinished walls were just defined enough for me to understand the extent to which the interior spaces were limited by the intractable exterior—it is, in every way, a building designed from the outside in.

Navigating the tower is complicated because the soaring ceiling heights necessitate a double-numbering system that gives each apartment one number that locates it in relationship to the other floors of the building and a second number that represents the elevation of that floor based on traditionally proportioned stories. Everywhere on the site, floor numbers were written in marker on blue tape as cryptic fractions—79/96 is the six-bedroom penthouse that is in reality on the seventy-ninth floor of the building but is listed as the ninety-sixth because that is what its equivalent would be (if there were an equivalent) in a neighboring building. There are two indices of status—numerator and denominator, interior and exterior. This odd numbering system is yet another way in which 432 Park more explicitly resembles a ruler than any other building in New York. It is a measuring device, as in *the measure of the man, made to measure*, or *how do I measure up?*, or even *desperate times call for desperate measures*.

When Jean-Paul Sartre visited Manhattan for the first time, he wrote of a "great American desert" under an icy sky—"a city for the farsighted" where "there is nothing to focus upon except the vanishing point." Outside of 432 Park's north-facing windows, which are glazed with the same ultraclear glass as Taniguchi's Novartis laboratory, the entirety of Central Park unfolds before you and the parallel axes of Park and Madison avenues recede toward a vanishing point beyond the Harlem River. These perspectival lines converge in New York's fifteenth congressional district, which covers most of the South Bronx and is the poorest per-capita district in the country. New York's twelfth congressional district, which covers most of the Upper East Side, including this building, is the richest in the country. The two neighborhoods are separated by less than

ten miles. In under thirty minutes the Lexington Avenue express will take you from the doormen of the highest-average-net-worth individuals in the country to the door-steps of the lowest. This slender tower makes it possible to take in both ends of a vast financial spectrum. On a clear day you can see as far as Trenton, New Jersey, a capital city the entire eight square miles of which contain less total real estate value than this single address.

Standing in the window, you get the sense that it was designed with two actions in mind above all others—to be looked up to and to be looked down on. In a comment that implies more about power structures than building struc-tures, Harry Macklowe said, "it's almost like the *Mona Lisa*, except instead of it looking at you, you're looking at it wherever you are. You can't escape it." In the margin of a sketch of the half-finished World Trade Center, Gordon Matta-Clark wrote, "the importance of an event such as the world trade center is the sum total of its oversights." Matta-Clark's deliberately self-contradictory "oversight" evokes both the view afforded by Yamasaki's towers and the lack of vision contained within the Port Authority's grand plan. The sum total of an event such as 432 Park, I thought, is the importance of its oversights.

———

Late one clear September afternoon, after I had finished teaching for the week, I decided to walk home. I headed south on Park Avenue past the corbeled towers of the armory and an inflatable rat standing sentinel among a crowd of steamfitters picketing outside a limestone apart-ment building. On the corner of Fifty-Sixth Street, at the foot of 432 Park, an aluminum plaque announces the

exact contents of the small public plaza—two hundred thirty-one linear feet of seating, forty chairs, ten tables, fourteen birch trees, one evergreen hedge, one drinking fountain, and two bike racks. It failed to account, on this particular day, for the man reading a newspaper and the woman impatiently smoking a cigarette. In the northwest corner of this little park, you can touch the southeast corner of the tower. Close up, the facade still smells of damp concrete and the surface reveals its imperfections—rust spots, pour lines, and bugholes. Residents say the structure moans and creeks like the hull of an old ship.

From a distance 432 Park looks impossibly tall, but face to face like this it is unremarkable. Cement that looks like marble from a block away feels rough to the touch. The scale of the windows, shades drawn against the afternoon sun, undermines the building's superlative height. I pressed my chin against the concrete and looked upward and I could see a slight wobble in the rising edge of the facade's southeast corner where the wet concrete had bulged against its plywood form.

It is impossible to continue directly west from this point because the next block is barricaded at both ends with bollards and counterterrorism officers assigned to secure the forty-fifth president's eponymous tower. Skirting the blockade, I passed Carnegie Hall and continued on a southwestern trajectory to avoid Times Square. I came to the water at the end of Thirty-Fourth Street where, under the glass ceiling of the Javits Center, Hillary Clinton's presidential campaign came to an end. In the center of the block, between idling buses, a gate opened to the northern terminus of the High Line, which hooks like the crook of a question mark around the vast windswept excess of Hudson Yards. I followed the path of the elevated park south against a current

of tourists until Twenty-Eighth Street, where I descended a staircase and walked west toward the storefront that had once been Nina and Danielle's gallery.

Uber is now the largest renter in the Terminal Stores building and the space that had once been the gallery is occupied by a startup that sells bespoke 3D-printed insoles for running shoes. I opened the map on my phone and tapped the small street view icon in the corner. Holding the phone at eye level, I spun the viewer clockwise with my index finger until the image on the screen, which seemed to have been taken at the same time of day several years earlier, matched the blue brick facade of the building in front of me. On the screen, Nina was sitting alone at the desk in the gallery window. Her hair was longer. My old pickup truck was parked outside on the cobblestone street. I recognized the show, partially visible though the front door, as one of their last. Soon she would be locking up, using the full weight of her body to pull the rusty roll gate closed.

I put the phone back in my pocket and doubled back through Chelsea past the brick warehouse where the uranium was stored for the Manhattan Project, back under the High Line and south on Tenth Avenue through a forest of new construction. Small beads of foam insulation were blowing off of a scaffold like the downy parachutes of cottonwood seeds. I met the water and continued downtown along the Hudson. It was dark now and the tractor beams of the *Tribute in Light* shone like a distress signal against the low clouds over Battery Park. A canvas sign luffing on the facade of a new residential building in Tribeca read Rent. Repent. Repeat. I crossed the island on Chambers Street and walked through City Hall Park and up onto the Brooklyn Bridge. I stopped where the bridge peaks at its

center, midway between its sandstone towers, and looked north. 432 Park towered over the wave of verticals, but now new towers, taller and thinner, were rising nearby. A barge passed under the bridge. I turned to watch as its empty hull moved southward between Governors Island and Red Hook, into the Narrows and the Lower Bay beyond, where it disappeared from view.

A Note on Source Materials

Sandfuture is based on extensive research from a wide variety of sources. While I have done my best to acknowledge references where they appear in the text, there are some instances that call for further elaboration.

For information on Yamasaki's life, I relied heavily on documents from the Minoru Yamasaki Papers at the Archives of Labor and Urban Affairs in the Walter P. Reuther Library at Wayne State University in Detroit. The greatest insights into Yamasaki's life came from his own writings and those of Ada Louise Huxtable. Many of the former can be found in Yamasaki's autobiography *A Life in Architecture* (1979) as well as the pair of articles he wrote for *Architectural Record*: "Visual Delight in Architecture" (August 1955) and "Toward an Architecture of Enjoyment" (November 1955). Huxtable's reviews of Yamasaki's work, of which there were many, are widely available from the *New York Times* and in various collections of her writings, including the incomparable *Kicked a Building Lately?* (1976). Some highlights include "Minoru Yamasaki's Recent Buildings" (*Art in America*, Winter 1962), "Who's Afraid of the Big, Bad Buildings?" (*New York Times*, May 29, 1966), and "Big but Not So Bold" (*New York Times*, April 5, 1973). The *Time* magazine cover feature on Yamasaki, "Road to Xanadu" (January 18, 1963), gives a comprehensive summary of his early career, and John Gallagher's *Yamasaki in Detroit: A Search for Serenity* (2015) provides an overview of his built work in Detroit. Balthazar Korab's photographs of Yamasaki's buildings contain more information than any book and conversations with Katie Yamasaki helped broaden my understanding of her grandfather's extraordinary life.

Dale Allen Guyre's monograph *Minoru Yamasaki: Humanist Architecture for a Modernist World* (2017), published while I was writing this book, is an essential resource and one that I would recommend to anyone interested in learning more about Yamasaki's work. Robert Campbell's interview with Ada Louise Huxtable was published in the April 1993 issue of *Architectural Record* (*Record Houses*), and his critique of the Eastern Airlines Terminal was published in the *Boston Globe* on August 13 of the same year. Martin Filler's review "Architectural Tragedies: *Minoru Yamasaki: Humanist Architecture for a Modernist World* by Dale Allen Guyre" appeared in the *New York Review of Books* on May 10, 2018. Paul Goldberger wrote "The New Rainier Square: Seattle's Balance of Terror" for the *New York Times*, where it appeared on March 25, 1977. He is also quoted in Roddy Ray and Marsha Miro's obituary, "Minoru Yamasaki: Architect as Sensitive Creator" (*Detroit Free Press*, February 9, 1986). I first encountered Isamu Noguchi's essay "I Became a Nisei" in the exhibition *Self-Interned, 1942: Noguchi in Poston War Relocation Center* at the Noguchi Museum in 2017. Michelle Andonian took the photograph of Andy Warhol in Detroit in 1984.

In addition to the books and films mentioned in the text, my understanding of the profoundly complicated life of the Pruitt-Igoe apartments and their residents was informed by the images and anecdotes compiled in Bob Hansman's *Images of America: Pruitt-Igoe* (2017), Walter Johnson's *The Broken Heart of America: St. Louis and the Violent History of the United States* (2020), and the thoughtful writing of Sylvester Brown Jr., particularly his September 22, 2014 blog post, "The Long Fuse to Ferguson: How the City of St. Louis Sparked the Explosion." A pair of articles in *Architectural Forum*—"Slum Surgery in St. Louis" (uncredited, April 1951) and "The Case History of a Failure" (James Bailey, December 1965)—capture the stark contrast between the early optimism and late outrage of Pruitt-Igoe's reception. Katharine Bristol's exceptional essay "The

Pruitt-Igoe Myth" was published in the *Journal of Architectural Education* in May 1991. Chad Freidrichs' documentary *The Pruitt-Igoe Myth* was released in 2011.

My descriptions of the history of the World Trade Center relied heavily on several books, including James Glanz and Eric Lipton's excellent *City in the Sky: The Rise and Fall of the World Trade Center* (2003), Eric Darton's, *Divided We Stand: A Biography of the World Trade Center* (1999), and Karl Koch III's *Men of Steel: The Story of the Family that Built the World Trade Center* (2002) as well as documents included in Anthony W. Robins' *The World Trade Center* (1987) and the research collective CLOG's *World Trade Center* (2014). Gordon Matta-Clark quotations come from Frances Richard's *Gordon Matta-Clark: Physical Poetics* (2019). Robert Smithson's essay "The Monuments of Passaic" was published in *Artforum* in December 1967. In addition to those referenced by name in the text, I allude to paintings and photographs depicting the World Trade Center including Paul Thek's *Untitled (Sodom & Gomorrah with Hot Potatoes)* (1970–71), Jean-Michel Basquiat's *Untitled (World Trade Towers)* (1981), Gordon Matta-Clark's *Anarchitecture: World Trade Center Towers* (1974), and Thomas Struth's *Dey Street, Financial District, New York* (1978). Jonas Mekas is quoted from *Tell Me Something Good: Artist Interviews from The Brooklyn Rail* (2017). Alexander Calder's *Bent Propeller* (1970) was originally titled *World Trade Center Stabile.*

My research on the relationship between buildings and bodies and sick building syndrome covered a wide range of material, though Susan Sontag's *Illness as Metaphor* (1977) has been a particularly important source of both information and inspiration. The discussion of tuberculosis sanatoriums was informed by Margaret Campbell's essay "What Tuberculosis Did for Modernism" (*Medical History*, 2005) and Beatriz Colomina's extensive writings on the subject of illness and architecture, particularly her essay "X-Screens: Röntgen Architecture" (*e-flux journal*, 2015), which became the 2019 book *X-Ray Architecture.*

There are many books on the subject of sick building syndrome, but none as rigorous and insightful as Michelle Murphy's *Sick Building Syndrome and the Problem of Uncertainty* (1996). Nicholas Shapiro's "Attuning to the Chemosphere: Domestic Formaldehyde, Bodily Reasoning, and the Chemical Sublime" (*Cultural Anthropology*, 2015) is another great text on the subject.

Much of the information about the Novartis campus comes from books produced by the company, including *Novartis Campus—Fabrikstrasse 10: Yoshio Taniguchi* (2010), *Novartis Campus—Virchow 6: Álvaro Siza* (2012), and *Novartis: How a Leader in Healthcare was Created out of Ciba, Geigy, and Sandoz* (2014), as well as a virtual tour of the Novartis campus in Basel which is no longer available on the company's website. Dan Fagin's *Toms River: A Story of Science and Salvation* (2013) and Siddhartha Mukherjee's *Emperor of All Maladies* (2010) also provided valuable insight into the history of synthetic dye and pharmaceutical production. Paul Preciado's "Notre Dame of Ruin" appeared on artforum.com on April 12, 2019. John Updike's review of Taniguchi's MoMA renovation, "Invisible Cathedral: A Walk Through the New Modern," was published in the *New Yorker* on November 15, 2004. The excerpt from Victor Hugo's *Notre-Dame de Paris* is from John Sturrock's 2004 Penguin translation, and the term "footnote of the flesh" is from Maud Ellmann's writing on James Joyce. The full texts of Frank Lloyd Wright's lectures "The Cardboard House" and "To a Young Man in Architecture" appear in *Frank Lloyd Wright: Collected Writings* (1992). Rembrandt painted *The Anatomy Lesson of Dr. Nicolaes Tulp* in 1632.

There is an extraordinary amount of sharp journalism on the subject of 432 Park Avenue. Some of the highlights include Paul Goldberger's "Too Rich, Too Thin, Too Tall?" (*Vanity Fair*, May 2014), Matt Chaban's "New Manhattan Tower Is Now the Tallest, if Not the Fairest, of Them All" (*New York Times*, October 22, 2014), Caitlin Blanchfield's "High Lines" (*Artforum*, March 2015), and Martin Filler's "New York: Conspicuous Construction"

(*New York Review of Books*, April 2, 2015). Several other articles that informed this portion of the book are "The $179 Million Picasso that Explains Global Inequality" by Neil Irwin (*New York Times*, May 13, 2015), "Up and Then Down" by Nick Paumgarten (*New Yorker*, April 21, 2008), and "Fendi Vidi Vici: When Fashion Flirts with Fascism" by Owen Hatherley (*Architectural Review*, March 3, 2015). "The Great American Dessert" by Jean-Paul Sartre was published by *Town and Country* in 1946.

I first read about the Battery Park beach in Holland Cotter's article "My City: Remembrance of Downtown Past" (*New York Times*, September 1, 2006). Alice Aycock's *Large Scale Dis/ Integration of Microelectric Memories (A Newly Revised Shantytown)* and Nancy Rubins' *Untitled* were both commissioned by Creative Time in 1980. Agnes Denes' *Wheatfield— A Confrontation* was planted in the spring of 1982. The photograph by Alvin Baltrop is *Dune at World Financial Center, New York City* (1985–1988). *Muheconnetuk* is one of many English transliterations of the Machican word meaning "river that flows both ways."

Tony Rosenthal made *Alamo* in 1967 and Sister Corita Kent's *Untitled* (better known as the *Rainbow Swash*) was painted in 1971. Gaylen Gerber's *Support* consists of oil paint on a Butz Choquin Optimal, Model 121 pipe designed by Joe Colombo in 1969. James Tarmy's article "Why Do So Many Art Galleries Lose Money?" was published on Bloomberg.com on July 30, 2015. My description of art damaged in the 2012 storm surge also includes specific references to sculptures from Martha Friedman's 2012 exhibition *Caught* and Kate Costello's 2008 exhibition *Tattooed Ladies*.

Finally, I owe my understanding of migraine primarily to a life shared with Jane Hait. I have read countless texts on migraine and the two best are, without question, Oliver Sacks' book *Migraine* (1970) and Joan Didion's essay "In Bed" (1968). Novartis' migraine medication Amivog was approved for use in the United States in May 2018.

A Note on the Type

Sandfuture is typeset in Aluminia, a 2017 revival by Jim Parkinson of W. A. Dwiggins' Electra. As Dwiggins tells it, with characteristic idiosyncrasy, Electra emerged out of a series of conversations he had with the spirit of the first-century Buddhist monk, poet, and calligrapher Kōbō-Daishi, who encouraged him to make a new modern typeface to suggest "electricity...sparks, energy—high-speed steel—metal shavings coming off a lathe." Aluminia is the name of a foil-covered marionette Dwiggins made around the time Electra was first issued by Linotype in 1935. The revival type is named after her. In *Sandfuture*, Aluminia is complemented by section breaks that use a thin triangle—a shape not unlike a metal shaving coming off a lathe—borrowed from Dwiggins' extensive compendium of graphic elements.

Acknowledgments

Thank you, Rosie, for a perfect title.

This book would not exist without the wisdom and support of Thomas Weaver and Erica Funkhouser. Thank you, Tom, for having the confidence to publish it. Thank you, mom, for giving me the confidence to write it. Thank you both for the countless hours devoted to making it better.

I am particularly grateful for early conversations with Tom Emerson, Rem Koolhaas, and Chris Calhoun, and for the thoughtful perspective of Katie Yamasaki. Thank you to Graham Hamilton and Amelia Stein for all of your help and to Nathan Carter, Miko McGinty, Kelly Taxter, Rob Davis, Howard and Nancy Marks, and Marcia Brudy for your support through a turbulent year.

I am grateful to everyone who gave me notes including Cynthia Davidson, Richard Meyer, Percival Everett, Aram Moshayedi, Sohrab Mohebi, Steve Lehman, Thaddeus Beal, Sophia Beal, Vishal Jugdeo, Alexander Tilney, Jesse Willenbring, Nichole Caruso, Cassie Griffin, Jesse Wine, Drew Heitzler, Monique Mouton, Kelly Nipper, and Rebecca Chapman. I am grateful for connections made by Amy Sillman and Marnie Mueller and for advice from Tynan Kogane, Leslie Falk, and Carolyn Savarese. Thank you also to Janine Foeller and all the artists of Wallspace Gallery.

I am immensely appreciative of the graphic acumen of John Morgan, Adrien Vasquez, and Florence Meunier and for help obtaining images from Gina Bronze and Christian Korab. Thank you also to Matthew Abbate, Gabriela Bueno Gibbs, Sam Kelly, and everyone at the MIT Press. I am thankful for the generous support of the Robert B. Silvers Foundation and the Wyeth Foundation for American Art Publication. Parts of this book were improved by a pair of workshops organized by Jenny Jaskey at the Artists Institute in New York. Thank you especially to the Walter P. Reuther Library, Archives of Labor and Urban Affairs, Wayne State University for access to the Minoru Yamasaki Papers.

Finally, Sam.

Sandfuture Justin Beal

Designed by John Morgan studio
and typeset in Aluminia

Cover: Battery Park Beach, May 15, 1977
Fred R. Conrad, courtesy *The New York Times*/Redux

Page 259: Minoru Yamasaki (undated)
John Peter Associates, photographer, courtesy Walter P. Reuther
Library, Archives of Labor and Urban Affairs, Wayne State University

Printed and bound in Germany

Library of Congress Cataloging-in-Publication Data

Names: Beal, Justin, 1978– author.
Title: Sandfuture / Justin Beal.
Description: Cambridge, Massachusetts :
The MIT Press, 2021
Identifiers: LCCN 2021001815 |
ISBN 9780262543095 (paperback)
Subjects: LCSH: Yamasaki, Minoru, 1912–1986. |
Architecture and society. |
LCGFT: Creative nonfiction.
Classification: LCC NA737.Y3 B43 2021 |
DDC 720.1/03–dc23
LC record available at https://lccn.loc.gov/2021001815

10 9 8 7 6 5 4 3 2 1

Publication of this book has been aided by
a grant from the Wyeth Foundation for American
Art Publication Fund of CAA